WORLD PRESS PHOTO

 Thames & Hudson

Contents >

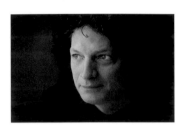

*Anthony Suau was born in Illinois,
USA, in 1956 and after graduating
worked for six years as staff
photographer for the* Chicago
Sun-Times *and the* Denver Post.
*He moved to New York in 1985,
working with the Black Star photo
agency. In 1991 he became a
contract photographer for* Time
*magazine. Between 1987 and 2008
Suau was based in Europe.*

*Suau's publications include books
on Chechnya, the genocide in
Rwanda, and the US invasion of
Iraq. In 1999 he completed 'Beyond
the Fall', a project documenting the
transformation of the former Soviet
bloc. This led to a book, and an
exhibition in London, New York,
Washington and more than a
dozen cities throughout Europe.
His awards include a Pulitzer Prize
for his images of famine in
Ethiopia and a Robert Capa Gold
Medal for his coverage of the war
in Chechnya. Suau is a previous
winner of the World Press Photo of
the Year, in 1987.*

What drives you as a photographer?
I'm drawn to political, social and economic issues that
address international concerns. Cultural issues also interest
me photographically as part of social subjects. Although
I work on a shoot for a few days at a time, I prefer to return
to places again and again to create a larger body of work.
Over time this becomes a more documentary approach.

*You've had a long and varied career. Is there any part of it
that particularly stands out for you?*
The book and exhibitions, *Beyond the Fall*, documenting
the first ten years of the transformation of the former Soviet
bloc have become a cornerstone in my career. In a way it
defined me as a photographer, and continues to do so.

*After spending almost two decades in Europe, you returned
to live in the USA in 2008. Was there a professional impetus
behind this?*
I'd been working on a project in the United States that
began with the inauguration of George W. Bush in 2001, and
it didn't seem practical to do this from Europe any longer.
After covering the inauguration, I became fascinated with
the situation here. America had become a sole superpower,
and when the Bush administration took office many
dramatic changes began to take place. In the same way that
Russia and the Eastern countries attracted me in the 1990s,
America has become very interesting over the past eight or
nine years — in the way that it has changed, and continues
to change, affecting the rest of the world. The fact that the
economy has gone into a tailspin since September 2007 is
a further fallout from failed government policies over the
past eight years. When I returned to the States last year, it
had become the obvious story to focus on.

How did it feel coming back?
The move was personally interesting for me because I'd
been away from my country for so long. Although I grew
up in America, it is a country that changes quickly and in
my absence I had established a distinct distance, so that
on the surface I didn't understand it very well. At the same
time there was an extreme familiarity and profound
understanding, having been born and raised here, and so
in effect those two issues conflicted within me. Yet the
distance helped me to see and evaluate it with a fresh eye.

Also, this is one of the first times that I was actually living in
the country I was photographing. I'd had an apartment in
Moscow and was traveling back and forth from Paris during
the *Beyond the Fall* years, but I wasn't Russian or European.
When it's your own country and you see people suffering,
it becomes that much more personal. My house is just as
vulnerable to devaluation as anyone's. The economic crisis
affects everyone: workers in Detroit, people on Wall Street
but also photojournalists. It's a dramatic time.

*Can you describe the circumstances that led up to the
winning photo?*
The economic story is part of the larger project that I'd been
working on about the US. Already, in the first months of
2008 I'd heard that the mortgage crisis was particularly
acute in Cleveland, and when I arrived there in March I was
overwhelmed. The situation was enormous. Thousands of
homes had been boarded up after foreclosure to prevent
vandals, squatters and junkies from breaking in. In East
Cleveland there were few streets that didn't have at least
one such house. Certain streets were entirely boarded up.
It gave you a powerful visual and dramatic idea of how
severe the mortgage crisis was.

I had hooked up with the sheriff's department, which
handled evictions following foreclosure. They had to ensure
that people had left the homes. If a house had already been
vacated, they had to go in and check, at gunpoint, to make
sure it was secure, that there weren't people squatting there
or any weapons. The officer allowed me to ride along with
him, and I was able to work at fairly close range. The couple
that lived in this particular house had moved out some
weeks before we arrived, and the home had been heavily
vandalized. There was evidence that there had been guns in
the house, which must now be on the streets of Cleveland.

It was extremely tense when we went in to vacant homes,
and things moved fast. There was always the danger that
somebody would be there and become aggressive or
violent. When you come around a corner into a dark room
or a basement, and the house has been vandalized, you
never know what you will find. You have to be prepared for
almost anything. It is a particular type of war zone.

Detective Robert Kole of the Cuyahoga County Sheriff's Office enters a home in Cleveland, Ohio, on March 26, following mortgage foreclosure and eviction. He needs to check that the owners have vacated the premises, and that no weapons have been left lying around. Officers go in at gunpoint as a precaution, as many houses have been vandalized or occupied by squatters or drug addicts.

Daily Life > **Anthony Suau** > USA, for Time > 2nd Prize Stories

World Press Photo of the Year 2008 >

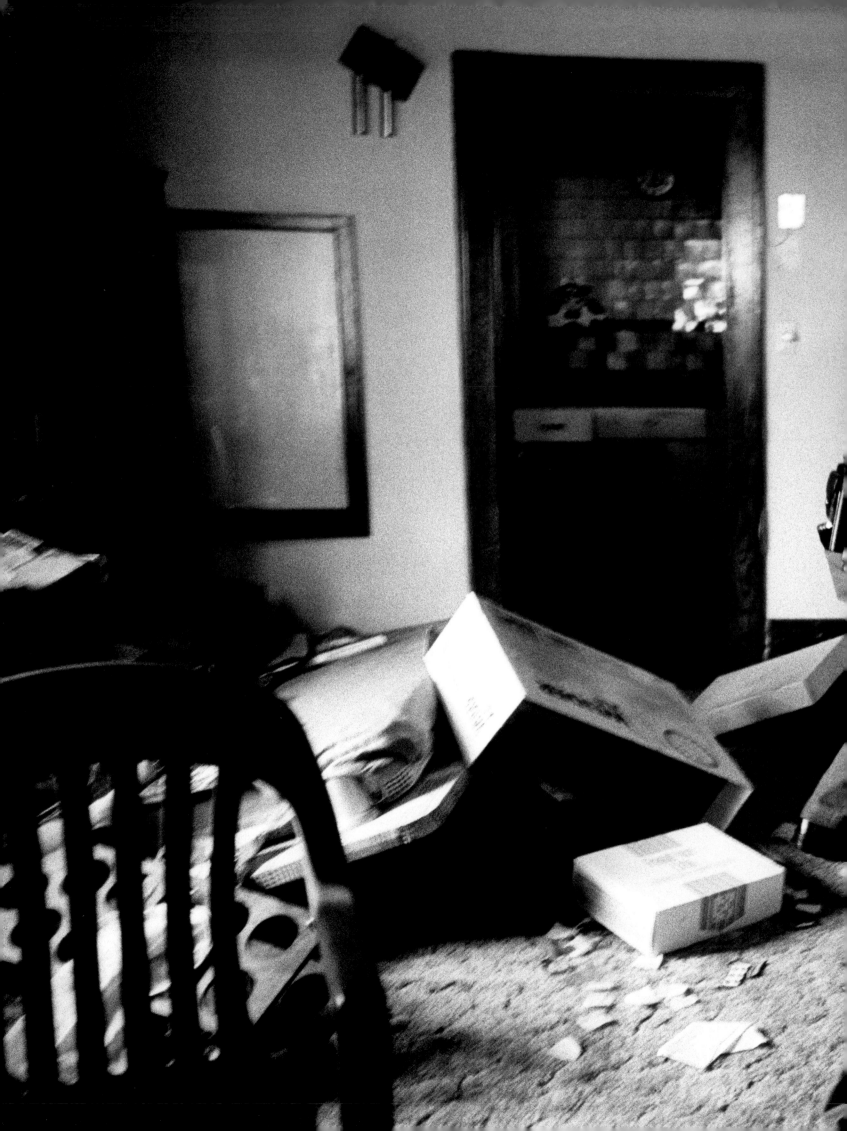

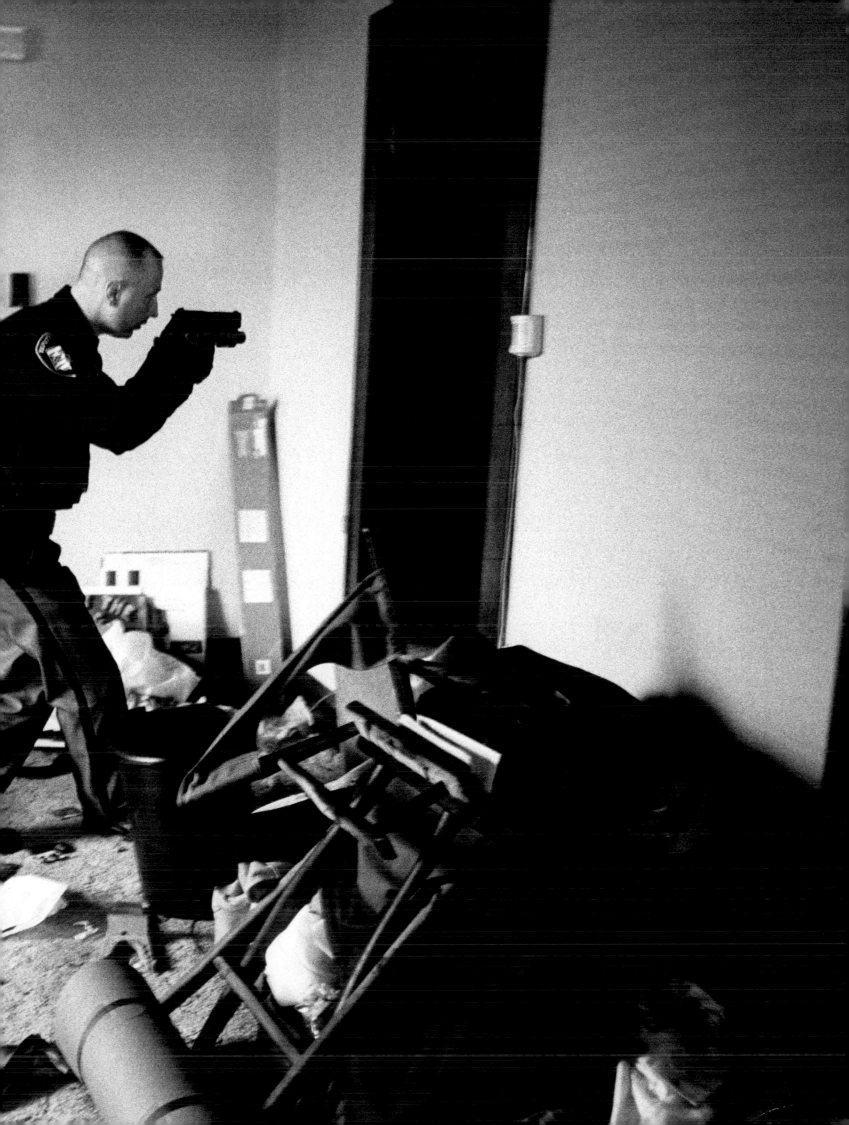

This year, the World Press Photo contest surpassed all previous records, with 96,268 images submitted by 5,508 photographers bearing 124 different nationalities. This is an extraordinary set of numbers by any measure. How can anyone believe that photojournalism is dying? The truth is that photojournalism is experiencing a period of extraordinary growth in new markets and cultures, and in new forms of media. News imagery has never been so immediate, so vital, so readily available and omnipresent. Documentary photography is alive and well and breathing new life into all of us, through the pages of this book and in the exhibition that will travel the globe.

For more than half a century, dedicated international photography professionals have gathered as one jury in Amsterdam to attempt the nearly impossible task of finding a single image, among tens of thousands, that can represent the whole world. The seriousness of this task, and the long hours over many days that it takes to complete, has most likely always been a simultaneously exhilarating and exhausting experience, as it was for us. This year's jury was not much different from its predecessors in following the long-tested procedures that result ultimately in the picture of the year. But today the world of press photography is different. This jury was acutely aware of the changes that are emerging in our professional landscape.

The winning photograph by Anthony Suau is a perfect example of the complexity that a professional can infuse into a single image. The current world financial crisis is epic in scale, with serious implications for all of us. At first, we think we know what we see in this classic black-and-white picture: a uniformed officer with a raised gun stands in the center of a chaotic room inside someone's home. This scenario is familiar, as it has related before to war, to crime, or to drug trafficking. This time, however, the unseen victims are guilty of nothing more than being unable to pay their bills. The mystery of the picture is revealed in its caption. The jury agreed that great journalistic photography should encourage viewers to think, and should raise as many questions as it provides answers — as this photograph does. The image is an ominous one. A new kind of war, a war of economics, has arrived to invade our lives and our homes.

The evidence of more traditional war, waged by people or by nature, is widely represented in the 2008 winning selections. The massive earthquake in China, the cyclone in Myanmar, the conflict between Russia and Georgia, and even a dragon-like volcanic eruption in Chile all make appearances. Not all photographs have to scare us, although news is often frightening. In the portrait, nature, sports, and arts and entertainment categories, we are treated to the vibrant colors and cultures of our world. It is our hope that as you look through these images, you will be as shocked, delighted, and intrigued by the richness of today's press photography as we were as a jury.

We are as encouraged for the future as we are humbled, by the stunning visual history that has been recorded permanently for us here.

Daily Life

SINGLES

1st Prize
Lissette Lemus

2nd Prize
Mattia Insolera

3rd Prize
Tomasz Wiech

Honorable Mention
Eraldo Peres

STORIES

1st Prize
Brenda Ann Kenneally

2nd Prize
Anthony Suau

3rd Prize
Gen Yamaguchi

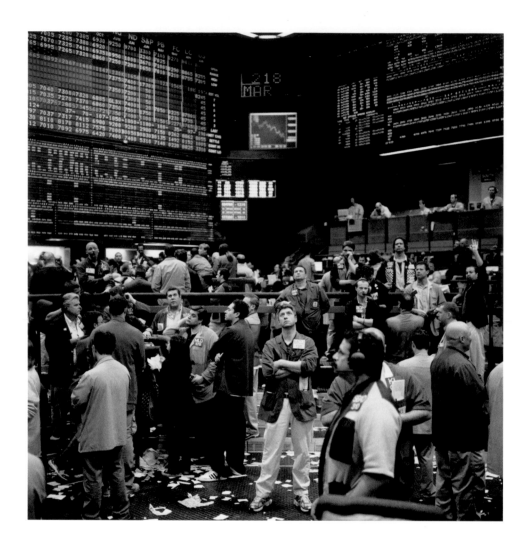

Toward the end of 2007, the severity of losses to banks incurred over sub-prime mortgages — high risk loans to clients with no or poor credit histories — was beginning to emerge. In the first months of 2008, rising US interest rates together with increasing unemployment and a slowdown in the housing market meant that many such borrowers could no longer afford payments on their homes. On a deeper financial level, banks involved heavily in such debts were threatened with collapse amidst uncertainty as to how to assess the extent of their losses. The lack of financial liquidity undercut banks' confidence in doing business with each other, crucial to the normal functioning of the country's economy. Above: Traders on the floor of the Chicago Mercantile Exchange on March 28 work as markets swing wildly each day amidst uncertainty in the banking sector. Facing page, top: Chairman of the board of governors of the US Federal Reserve Ben Bernanke talks in his office in Washington DC with vice-chairman Donald L. Kohn on March 17, after intervening to rescue troubled investment bank Bear Stearns. Below: Johnny Nicholson (40) looks for work as a welder or auto mechanic at a Cleveland employment office, on March 27. (continues)

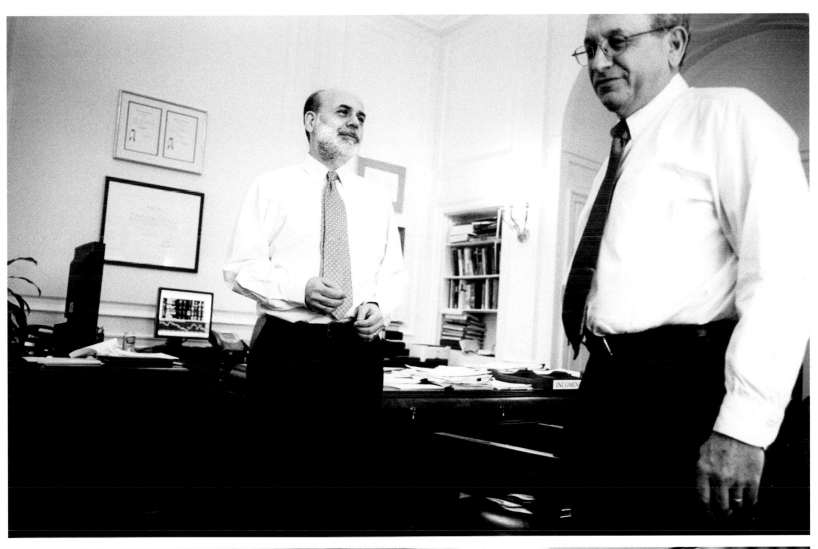
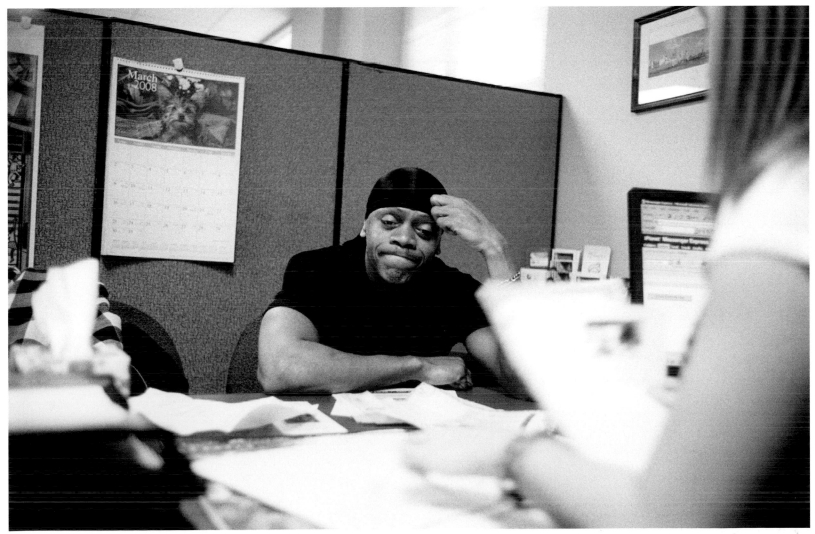

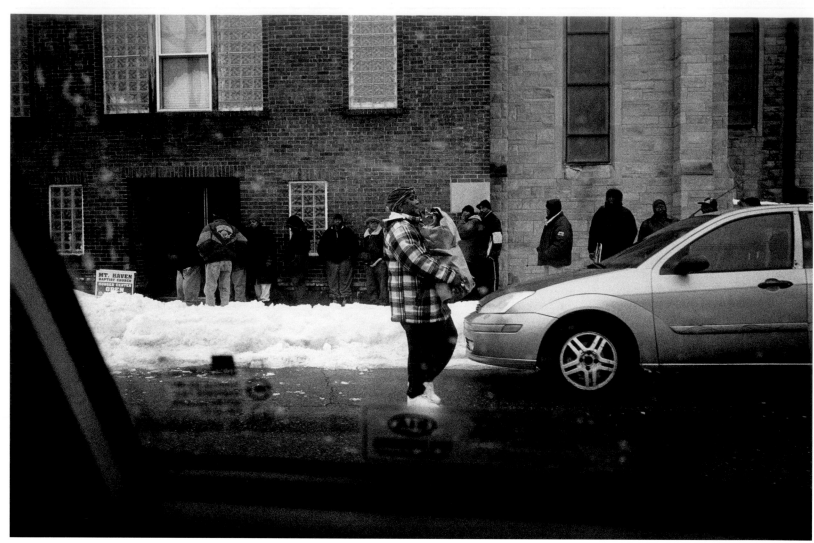

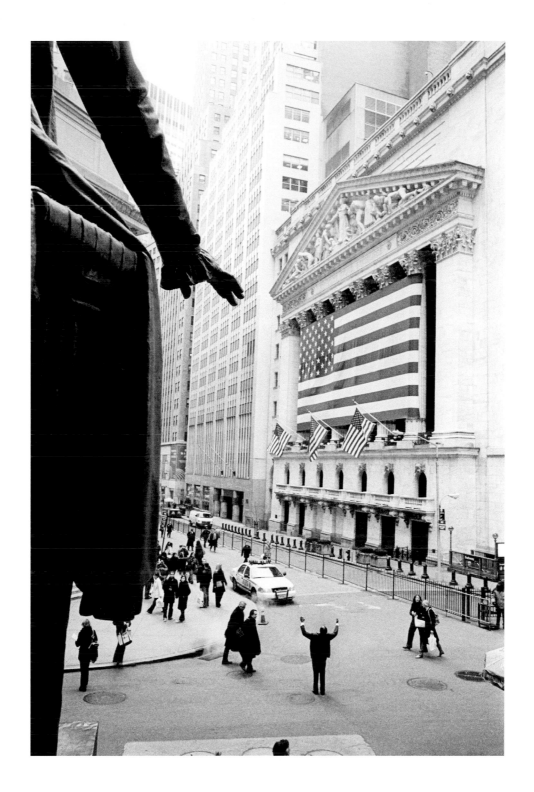

(continued) Debt foreclosure and repossession of homes were an early part of the sub-prime mortgage crisis. In July 2008, US financial authorities had to step in to support Freddie Mac and Fannie Mae, America's two largest mortgage lenders. The financial crisis spread worldwide. By the end of the year, following the collapse of some leading banks and bail-out packages for others, economists were talking of the worst global recession since the 1930s. Facing page, top: People queue for free food distribution at the Mount Haven Baptist Church in Cleveland, Ohio, on March 11. Below: By the end of March there were streets in East Cleveland in which almost every home was boarded up following foreclosure. Above: A man gestures outside the New York Stock Exchange on Wall Street on March 14, the day that shares in Bear Stearns bank fell by some 50 percent.

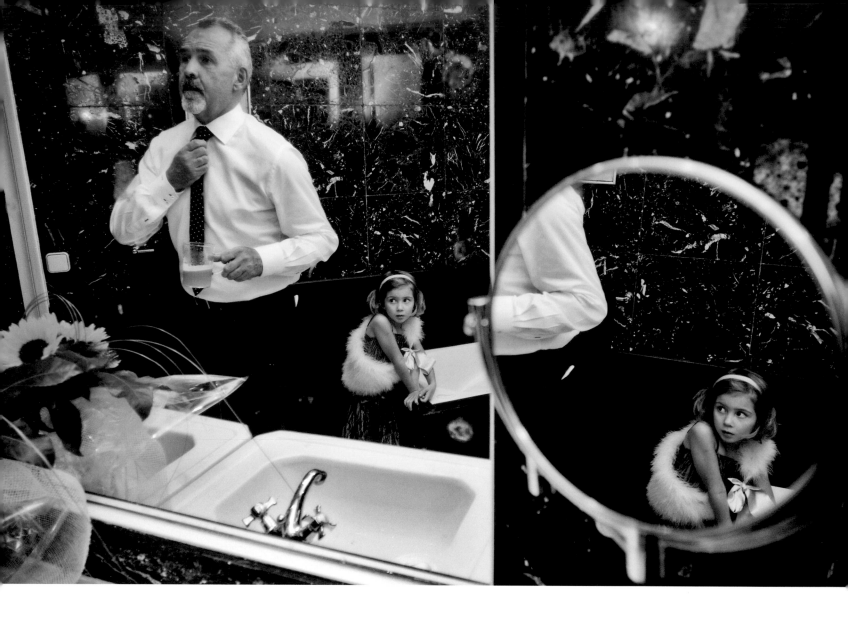

Will and his adopted daughter Stassa get ready for Will's marriage to his male partner, in Barcelona, Spain, in October. Will and his partner originally lived in California, where they legally adopted Stassa. They were wedded in early 2004, when the mayor of San Francisco began to make marriage licenses available to same-sex couples in apparent defiance of state law. The Supreme Court of California later declared these unions void. Will moved with his partner and daughter to live in Barcelona, where resident same-sex foreigners may legally marry. In 2005 Spain became the third country in the world, after the Netherlands and Belgium, to legalize gay marriage.

An employee at Cap Gemini's office in Krakow, Poland, makes himself breakfast at the office before the working day starts.

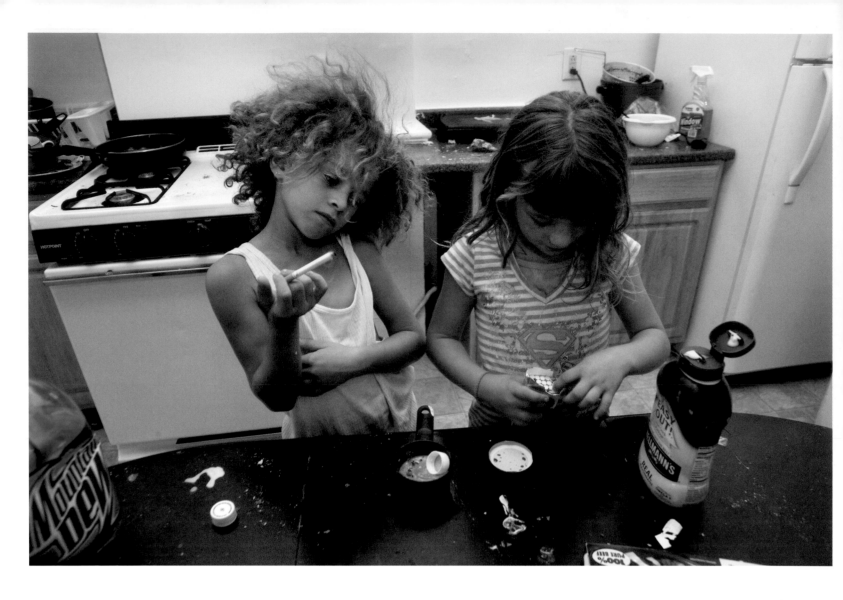

Diana Jarron is a single mother with seven children, four of whom live with her at home in Troy, New York. Above: Darla (8) and Debbie (9) pretend to smoke in the kitchen. Their mother has smoked since she was twelve. Facing page: Diana relaxes at home with four of her children. (continues)

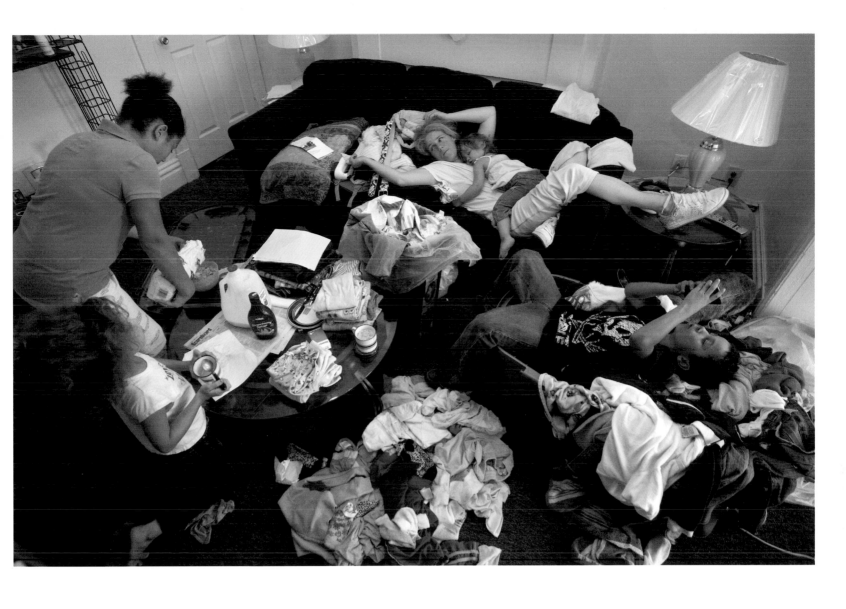

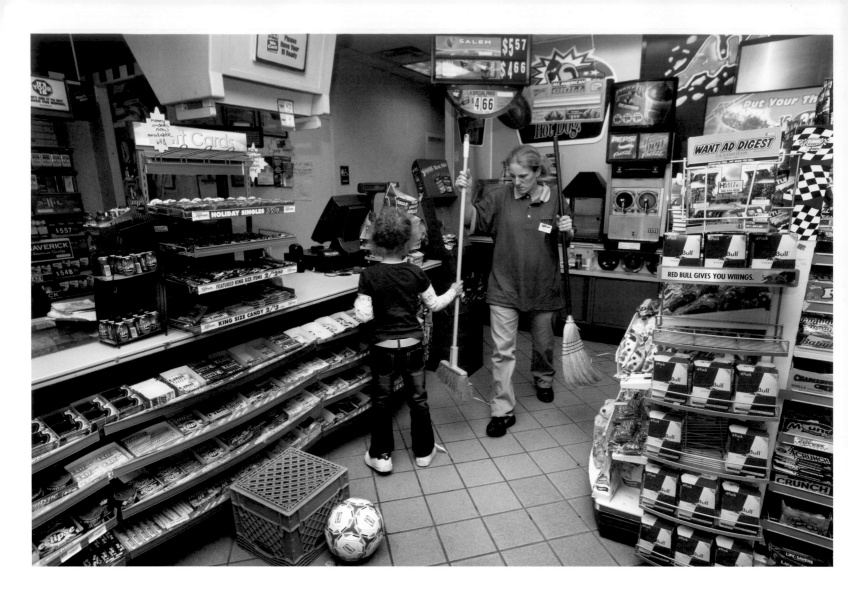

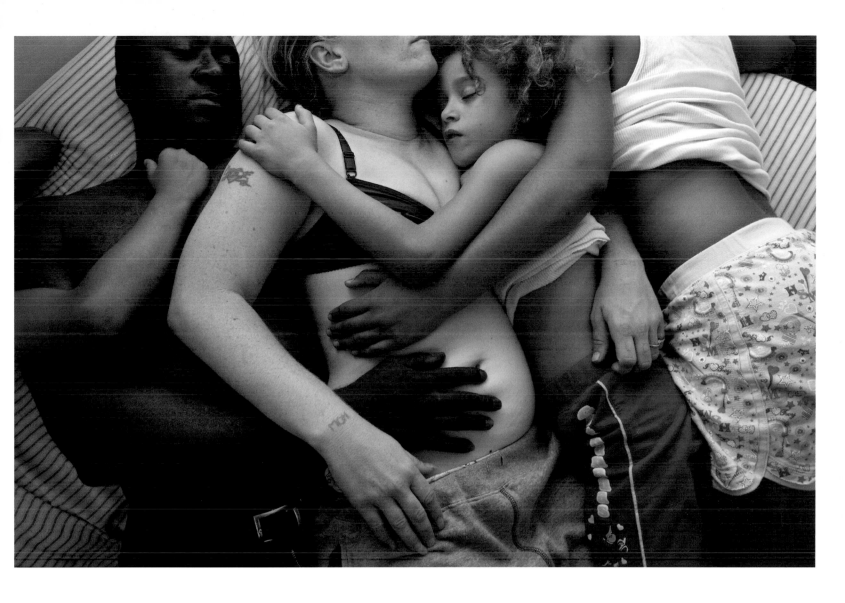

(continued) Diana supports her family by working in a convenience store at a nearby gas station. Facing page: Darla, who suffers from separation anxiety, sometimes wins her battle to go with her mother to work.

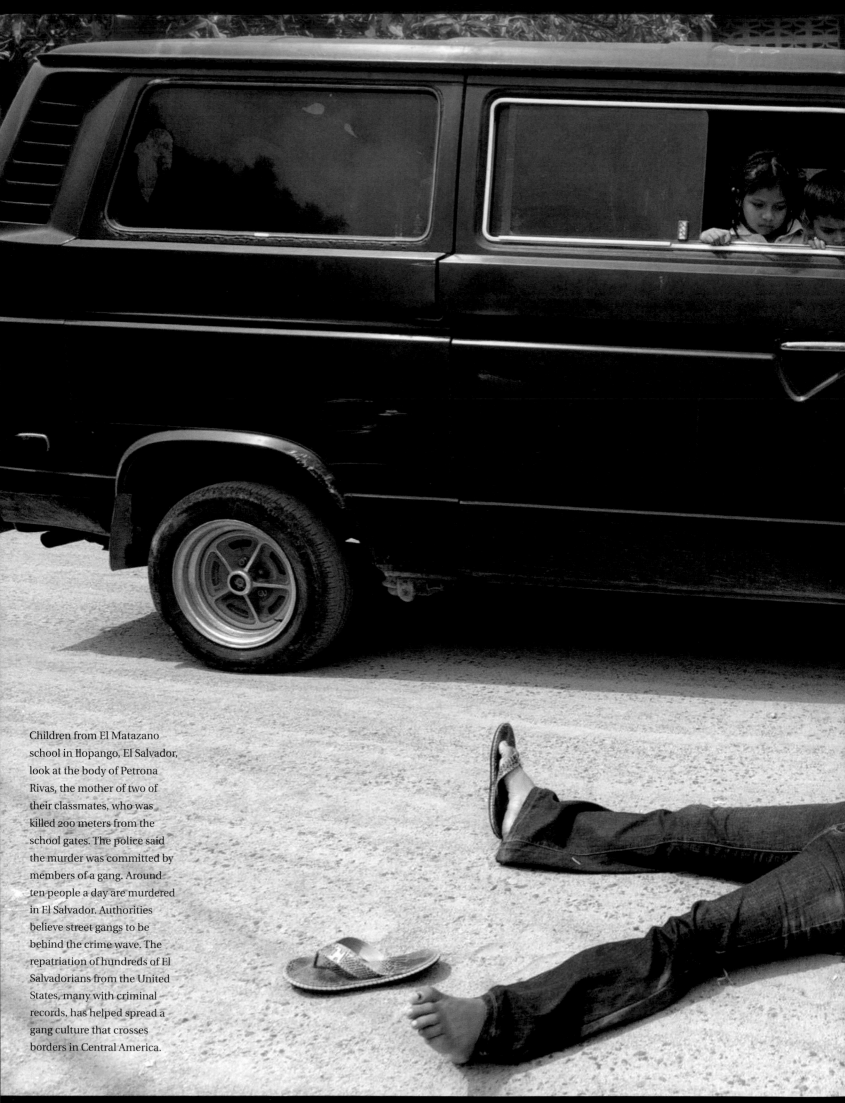

Children from El Matazano school in Hopango, El Salvador, look at the body of Petrona Rivas, the mother of two of their classmates, who was killed 200 meters from the school gates. The police said the murder was committed by members of a gang. Around ten people a day are murdered in El Salvador. Authorities believe street gangs to be behind the crime wave. The repatriation of hundreds of El Salvadorians from the United States, many with criminal records, has helped spread a gang culture that crosses borders in Central America.

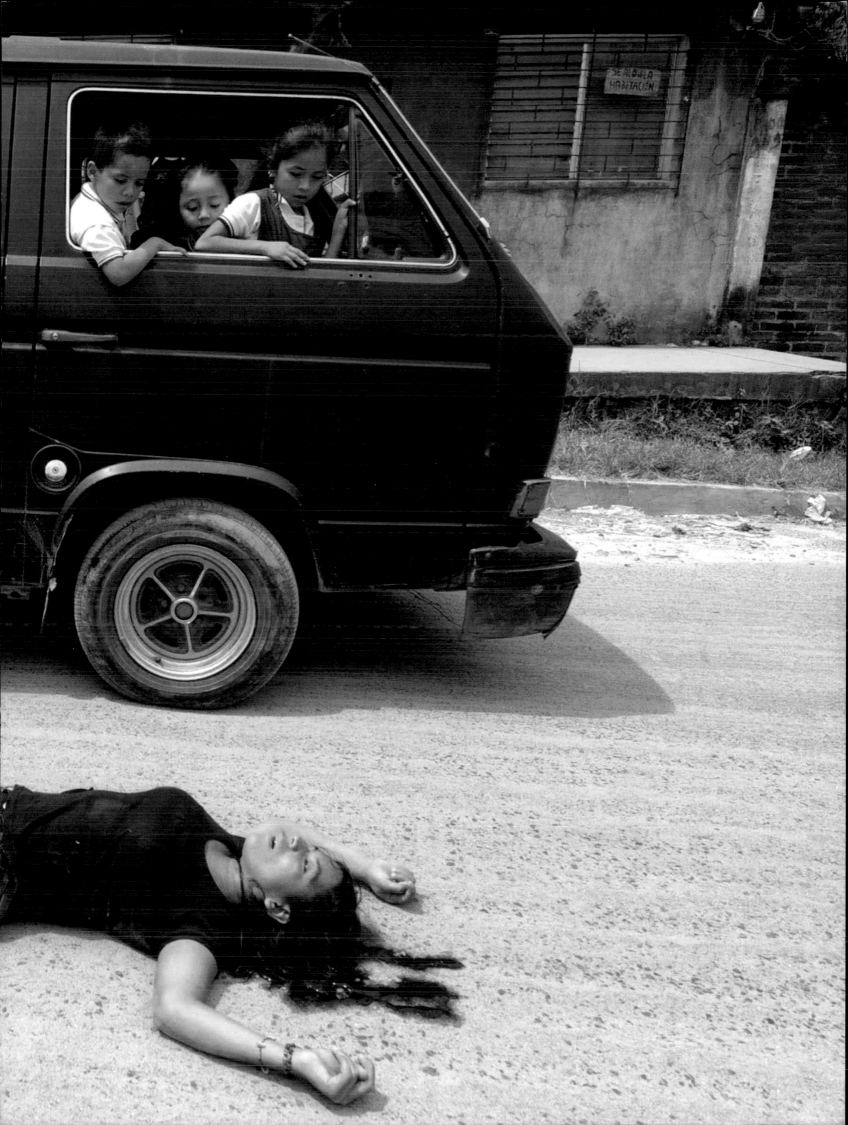

Janet McDonald is raising nine-year-old triplets on her own, following the death of her husband four years ago. Two of the children are autistic. Autism is one of a group of disorders associated with difficulties in communication and social interaction. The causes are not fully understood. Janet's daughter Nikki is at the severe end of the autistic spectrum. She cannot express herself in words, often makes repetitive actions, and sometimes bangs her head so hard that she harms herself. Nikki's brother Dougie has a milder form of the disorder, and does have some vocabulary. The third child Alex does not display any signs of autism, and often has to take care of herself or help her mother look after her siblings. Left to right, from top left: Nikki sits quietly on a swing in the family's backyard in Tampa, Florida, USA. Janet helps Nikki point out letters of a word as she has her lunch. Dougie cries for an unknown reason. Janet and a helper carry Nikki to her bedroom after she has hurt herself. Janet seeks advice from friends in the backyard of the family home. Janet speaks to school officials about Nikki's autistic behavior. Janet snatches a little rest in bed alongside Nikki, as Alex eats Halloween candy. Nikki hangs over the edge of the bathtub. As she has no language, she cannot communicate to Janet why she behaves in certain ways.

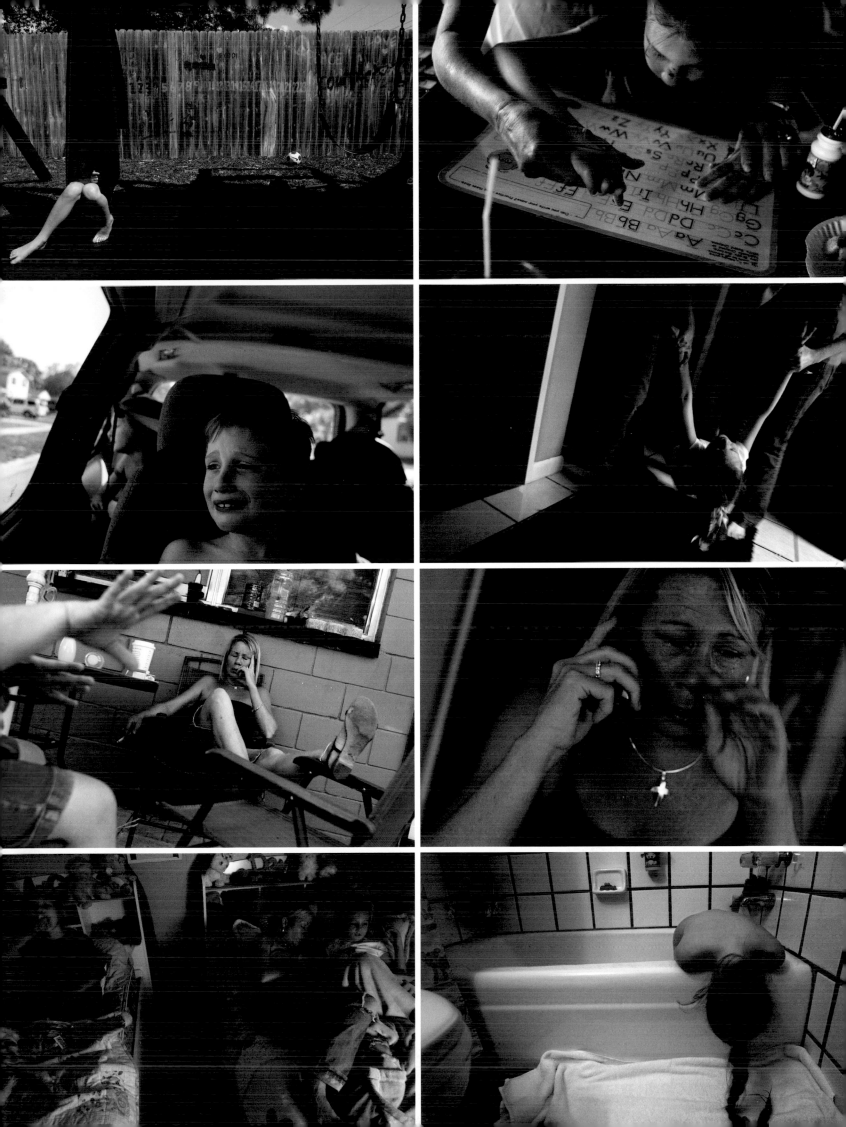

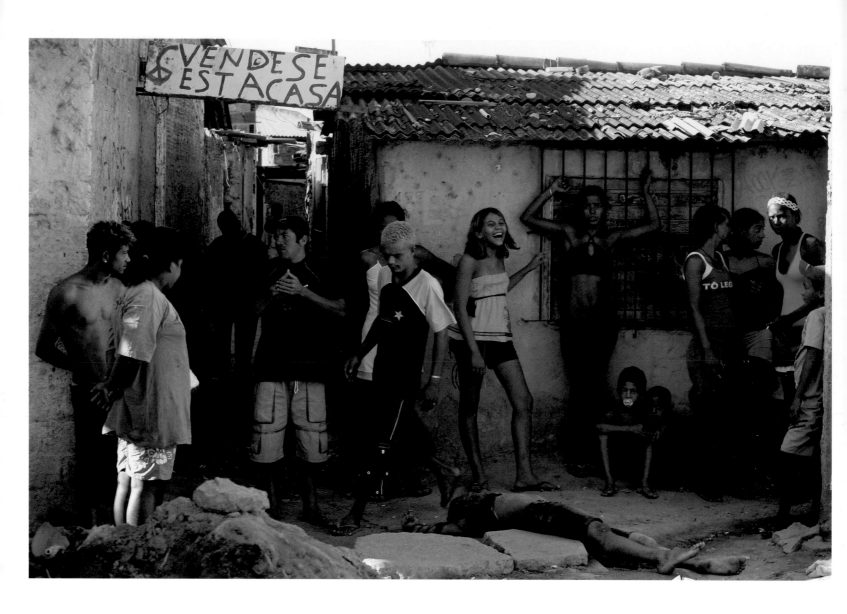

People gather around the body of Thiago Franklino de Lima (21), who was killed in the Coque slum in Recife, northeastern Brazil, on January 22. With around 90 homicides per 100,000 of its population, Recife is more than twice as deadly as Rio de Janeiro. Many of the murders are committed by vigilante death squads, aiming to rid the city of undesirable elements, though in the poor area of Coque young people have been known to kill each other for control over strategic areas from which to rob motorists.

People in the News

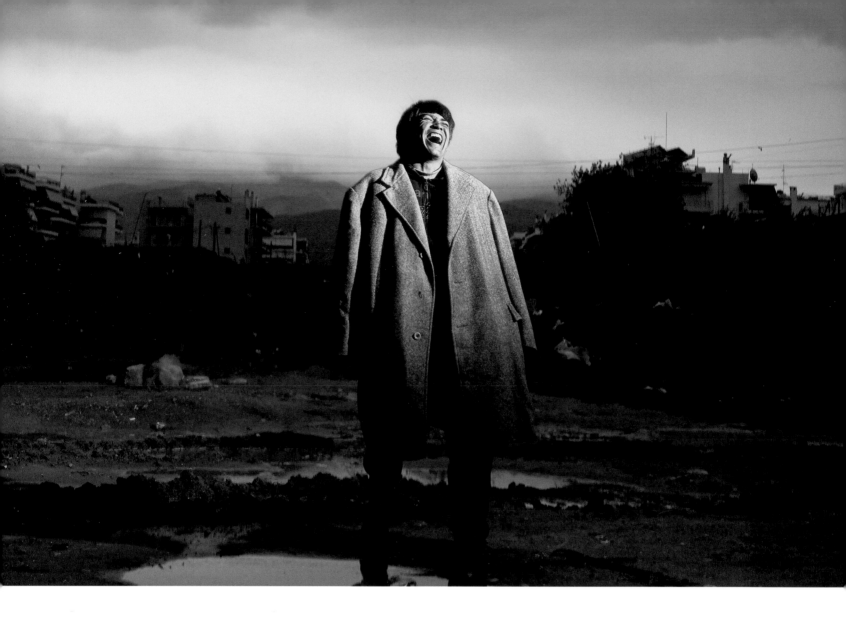

Hachim (20), from the Afghan province of Razni, entered Greece illegally and has spent two months in the port of Patras on the western coast. He lives with 500 other migrants on a building site that takes the overflow from a camp holding over 2,000 people. He has made eight unsuccessful attempts to cross to Italy by ferry. Throughout the year, increasing numbers of immigrants made their way from Iraq, Afghanistan, and the Caucasus via Turkey to the eastern Greek islands. Greece grants asylum to only a tiny proportion of applicants, so many attempt to leave for other parts of the European Union, where opportunities are perceived to be greater.

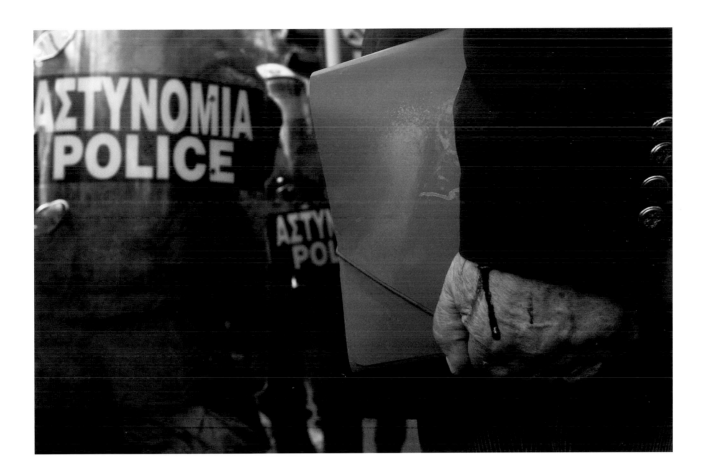

A man's hand drips blood as he stands in front of riot police at a demonstration outside the Greek parliament in Athens, on December 9. Hundreds of protestors threw stones and bottles during anti-government clashes, triggered when a 15-year-old boy was killed by a police bullet in an incident in the city three days earlier. Initial protests at the shooting soon widened to include expressions of grievance against government handling of the situation as well as broader educational and political issues. The demonstrations continued for weeks, in what became Greece's worst rioting in decades.

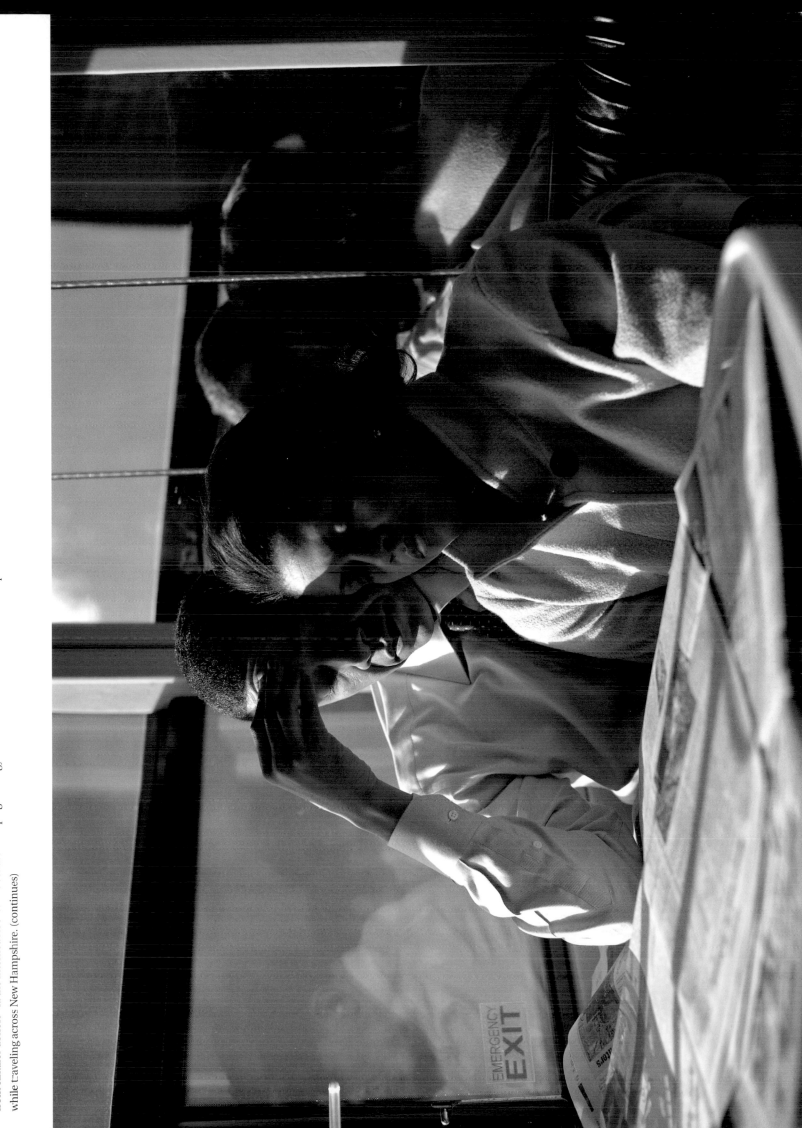

In his bid for the US Democratic Party presidential candidacy Senator Barack Obama broke all fundraising records, largely by harnessing support from smaller donors via the internet. Above: The senator campaigns in a gym in Iowa. Below: Michelle Obama naps on her husband's shoulder while traveling across New Hampshire. (continues)

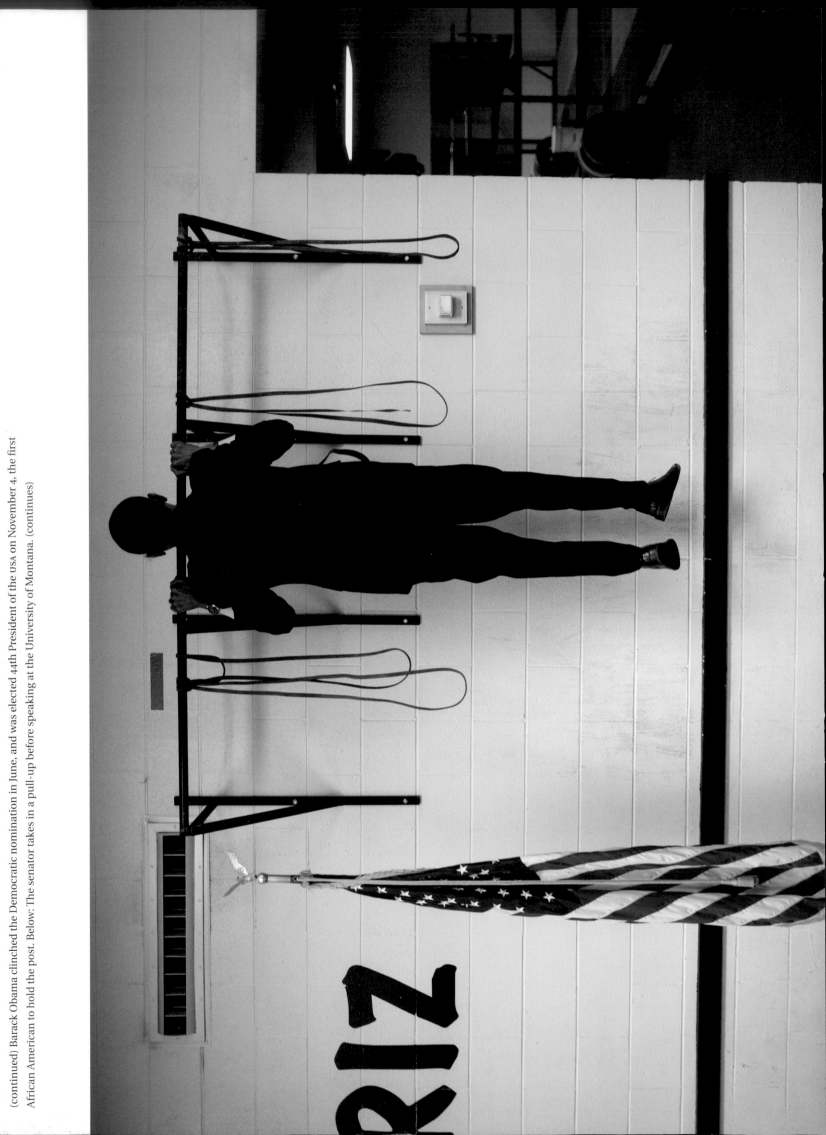

(continued) Barack Obama clinched the Democratic nomination in June, and was elected 44th President of the USA on November 4, the first African American to hold the post. Below: The senator takes in a pull-up before speaking at the University of Montana. (continues)

(continues) Two young supporters wait to meet Obama at the Martin Luther King Day Rally in Columbia.

Fighting broke out between the Georgian army and separatist forces in the breakaway region of South Ossetia, in August. Russian troops entered the region, which is home to many ethnic Russians, in support of the separatists. As the conflict spread beyond the borders of South Ossetia, people fled their homes. Left to right, from top left: Residents of Gori, in Georgia, survey bombed apartment buildings in the town on August 9. Elderly residents of the village of Dzarcumi arrive in Gori, following a day's walk after their village was burned. Women wait beside the road between Gori and the capital Tbilisi, after Ossetians had entered the village of Patara-Garedzhvari detaining the men, but allowing women, children and the elderly to leave. Women from Kurta, a South Ossetian village with a largely ethnic Georgian population, hitch a ride in a humanitarian-aid bus provided by the Georgian government, having walked for three days after leaving the village. A family flees Gori after Russian tanks entered the town on August 13. Residents of the Georgian village of Karaleti stand outdoors after their village has been bombed. Male residents of the village of Patara-Garedzhvari stand near a Russian tank. Men were allowed to leave the village two days after women and children. Ketevan Surabali went to South Ossetia as a refugee from Abkhazia, another breakaway province, in 1992, and in 2008 was again forced to flee her home.

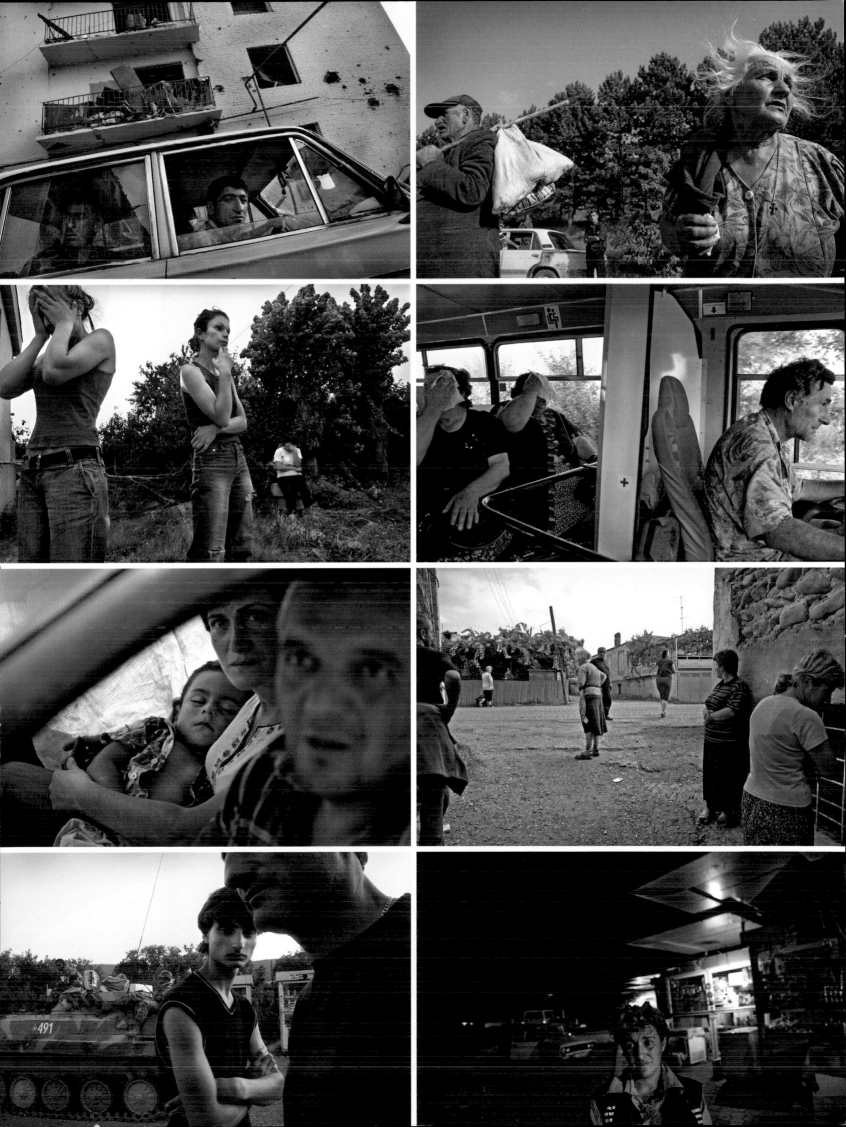

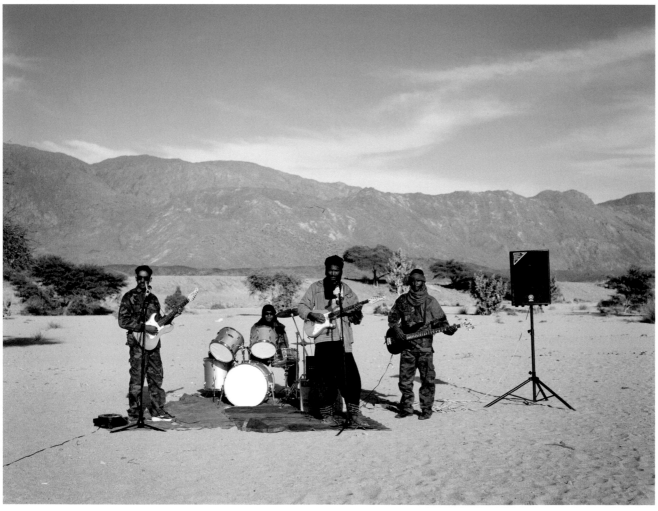

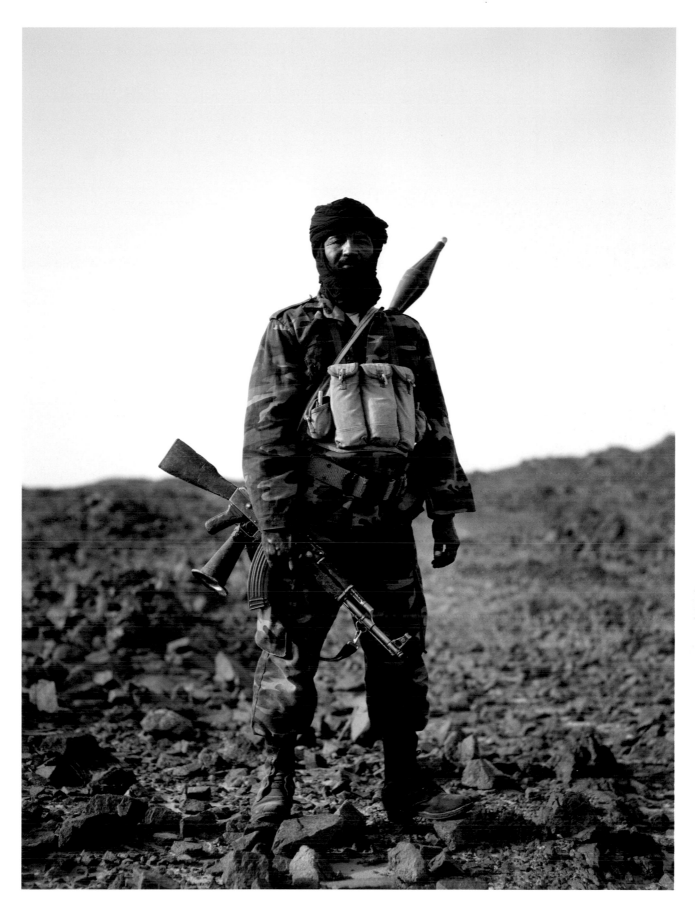

The Tuareg are a nomadic people descended from the Berbers of North Africa. At the end of French colonial rule in the 1960s, they found the area in which they lived divided between a number of independent countries, including Mali and Niger. Today's Tuareg complain that they are marginalized, lack adequate government representation, and that income from lucrative mining concessions in the area does not reach local communities. A 2006 peace agreement aimed at ending decades of sporadic Tuareg revolt collapsed, with former combatants apparently resenting continued inequality. Organized rebel groups formed in both Niger and neighboring Mali, attacking government facilities and taking scores of prisoners. By the end of 2008, up to 400 people had been killed in these clashes. Facing page, top: A unit of the Democratic Alliance for Change (ADC) awaits orders near the village of Boughessa in Northern Mali. Below: A band formed by members of the Niger Movement for Justice helps spread the Tuareg's message throughout the region. This page: Moussa Ag Ibrahim (44) joined the ADC in April 2008.

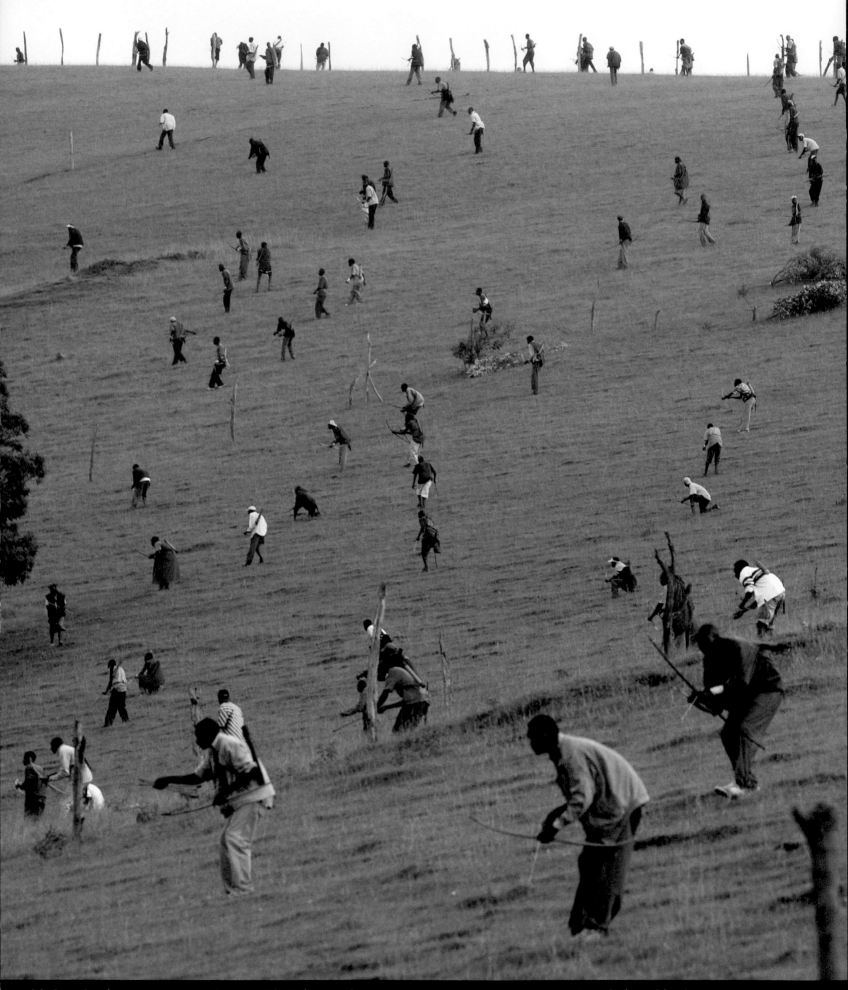

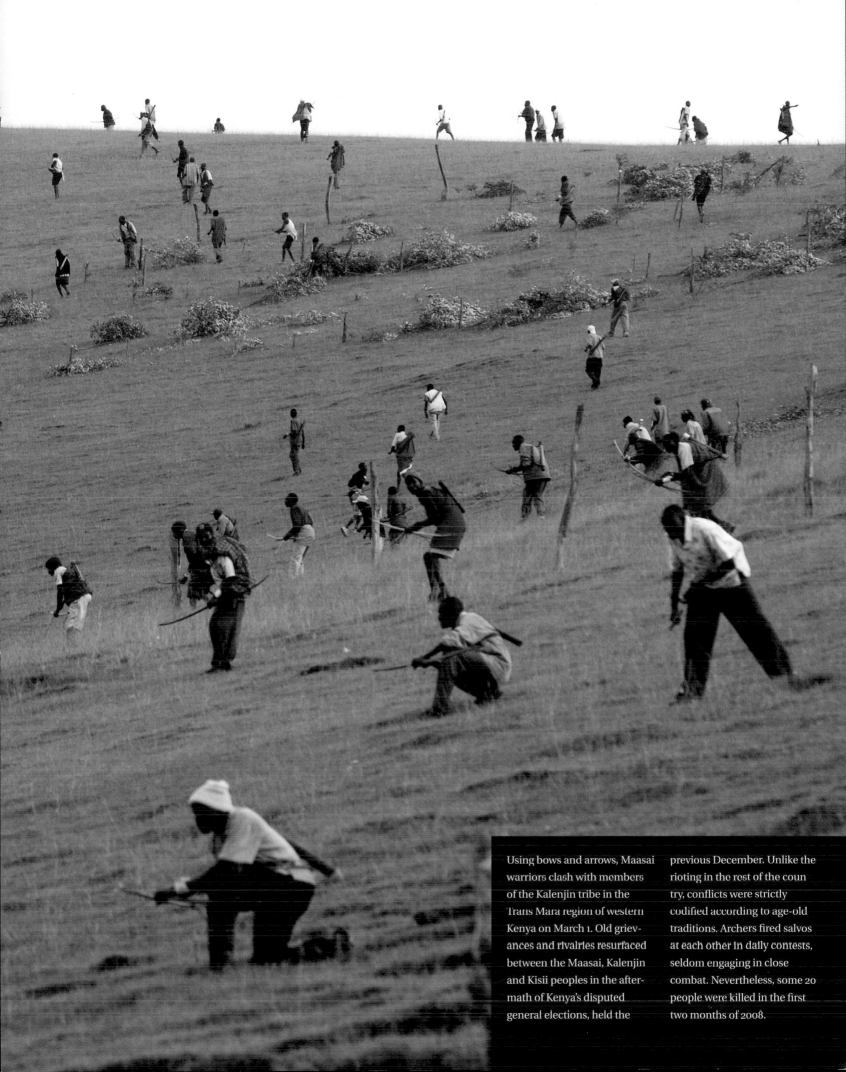

Using bows and arrows, Maasai warriors clash with members of the Kalenjin tribe in the Trans Mara region of western Kenya on March 1. Old grievances and rivalries resurfaced between the Maasai, Kalenjin and Kisii peoples in the aftermath of Kenya's disputed general elections, held the previous December. Unlike the rioting in the rest of the country, conflicts were strictly codified according to age-old traditions. Archers fired salvos at each other in daily contests, seldom engaging in close combat. Nevertheless, some 20 people were killed in the first two months of 2008.

Spot News

SINGLES
1st Prize
Chen Qinggang
2nd Prize
Henk Kruger
3rd Prize
Gleb Garanich
STORIES
1st Prize
Walter Astrada
2nd Prize
Bo Bor
3rd Prize
Wojciech Grzedzinski
Honorable Mention
Sebastian D'Souza

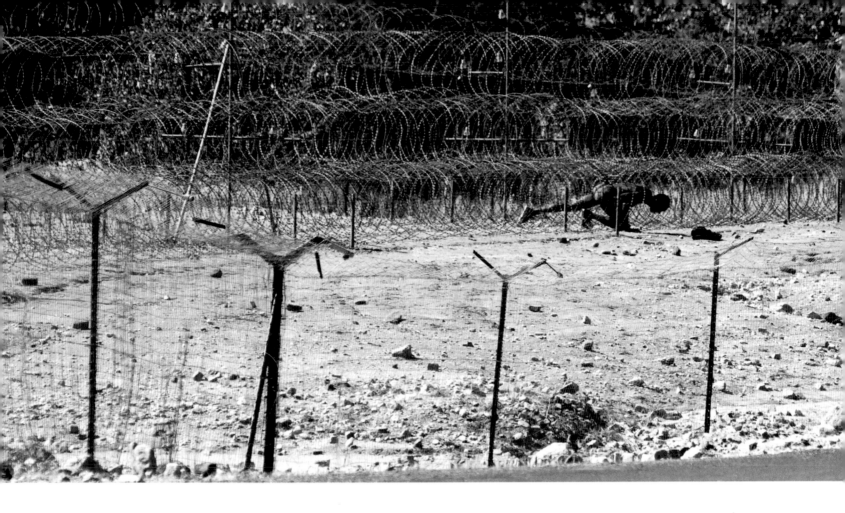

A Zimbabwean man crawls through the border fence from Zimbabwe into South Africa, close to Beit Bridge, on May 21. Zimbabwe was experiencing spiraling hyperinflation and critical unemployment. Official figures set immigration to South Africa at an average of 96,000 per month, not taking illegal migrants into account. In May, xenophobic violence broke out in Gauteng province, around Johannesburg. Attacks against migrants accused of taking homes and jobs from locals went on for several weeks, leaving around 60 people dead.

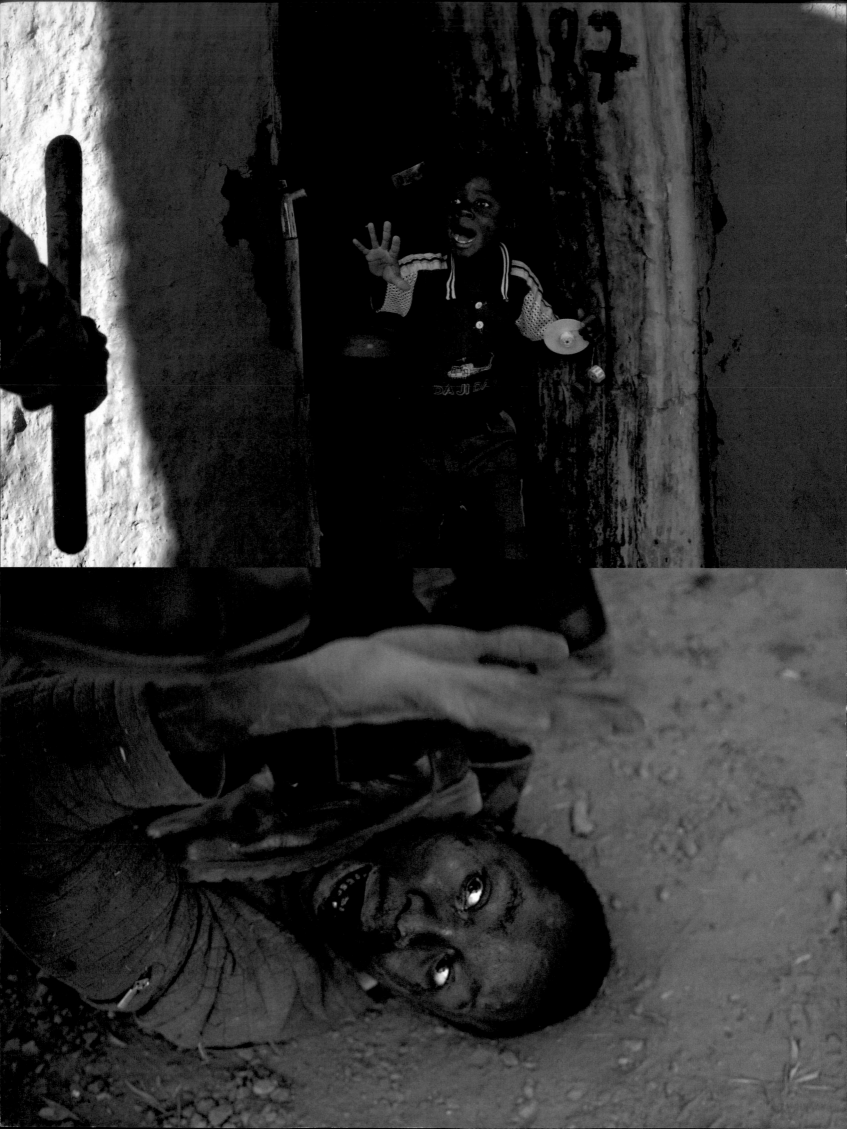

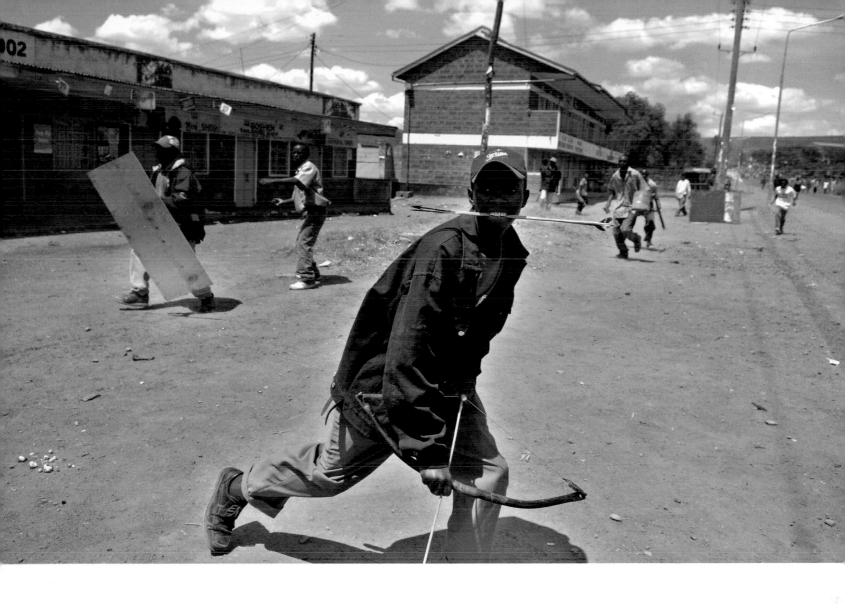

The ethnic violence that erupted in Kenya following disputed elections in December 2007 carried on until February. Much of the fighting was between members of the Kikuyu community, who were supporters of incumbent president Mwai Kibaki, and the Luo ethnic group, supporters of opposition candidate Raila Odinga, who said the elections had been rigged. In February, the two leaders reached a power-sharing deal after talks brokered by former UN secretary general Kofi Annan. Facing page, top: Monday Lawiland (7) screams as a policeman approaches his home, in the opposition stronghold of Kibera, in Nairobi, on January 17. Below: A man accused of looting is tackled by private guards in the central Kenyan town of Nakuru. Above: Holding a spare arrow in his teeth, a man checks the street during ethnic clashes in Nakuru in January.

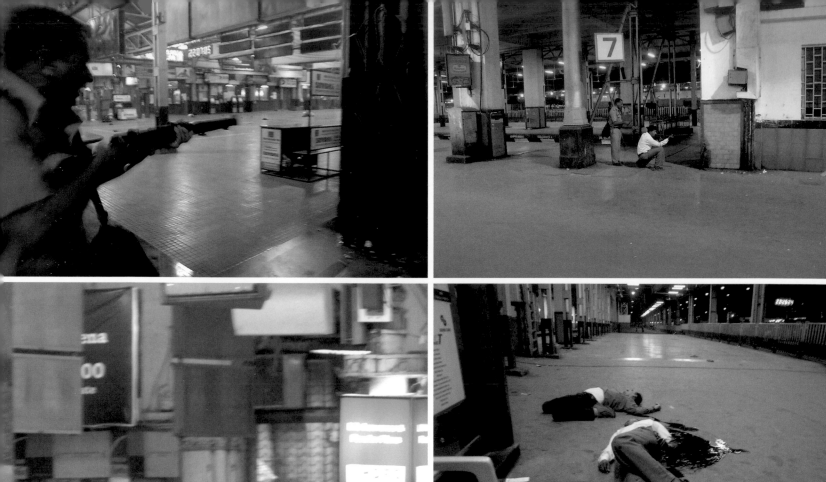

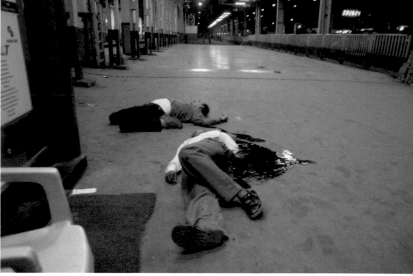

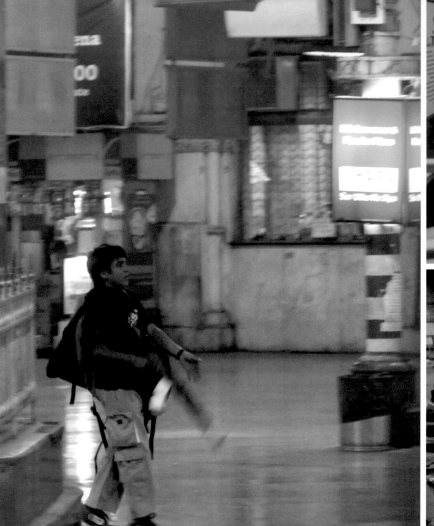

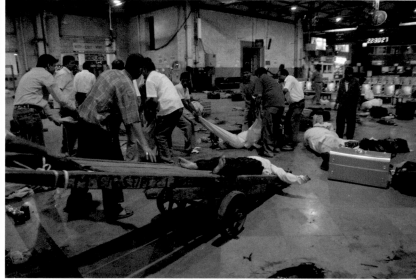

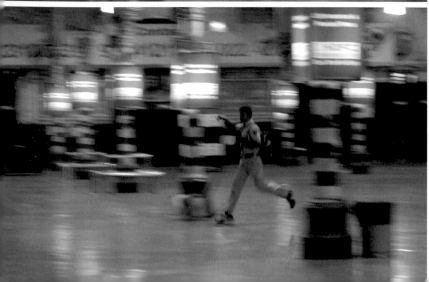

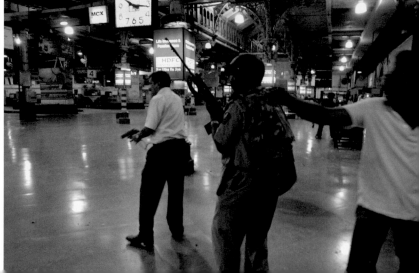

At 21h20 on November 26, two men armed with guns and grenades launched an indiscriminate attack on the Chhatrapati Shivaji Terminus railway station, in Mumbai, India. The station is one of the busiest in the country, and the onslaught resulted in 58 deaths, with scores more injured. The incident was one of a number of simultaneous attacks, targeting two luxury hotels as well as other Mumbai landmarks. Police and security forces countered the attacks, but it was three days before the situation was completely under control. Overall, 173 people were killed, including nine of the ten attackers. Left to right, from top left: Police constable Sudam Pandarkar takes a shot at two armed gunmen inside the railway terminus. Sudam Pandarkar and fellow constable Ambadas Pawar get ready to fire at gunmen in the station. Armed gunman Ajmal Amir strides across the concourse firing at police. Government Railway Police officers Sheshank Shinde and Ambadas Pawar were shot during the attack. Plainclothes police and commuters help transport the injured to hospital. A police officer runs for safety. Police break cover to follow the two attackers, after they had left the scene. One was killed, and Ajmal Amir was captured.

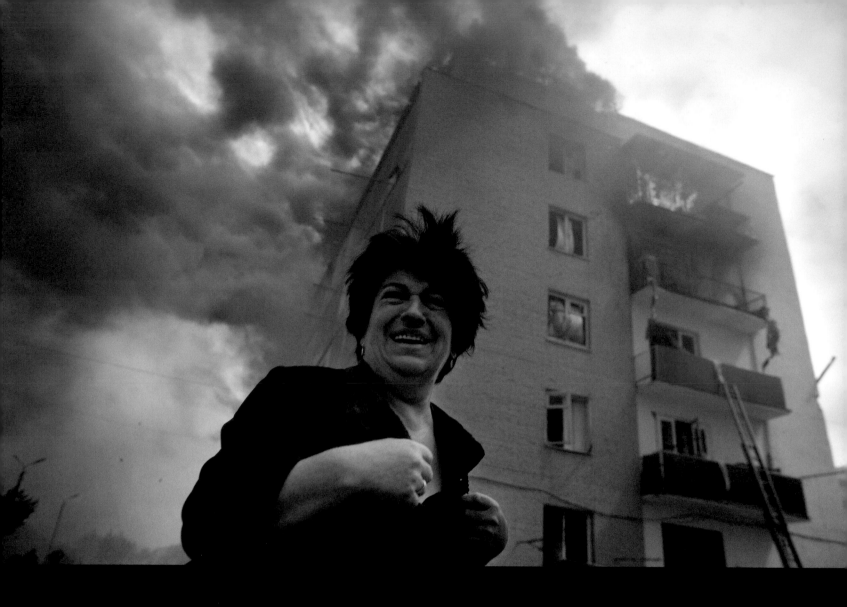

Full-scale military conflict broke out between Russia and Georgia in August over the breakaway region of South Ossetia. On August 7, Georgia launched a ground and air attack on South Ossetia, reportedly reaching the capital Tskhinvali, saying its aim was to restore constitutional order. Russia sent troops into South Ossetia in support of the separatist militia, and on August 9 staged an air attack on Gori, a Georgian town near the South Ossetian border. Russian troops later occupied the area around Gori, but pulled back under a ceasefire brokered by President Nicolas Sarkozy of France, which held the rotating European Union presidency at the time. Above: A woman cries as an apartment block burns, following the Russian air strike on Gori on August 9. Facing page, top: A Russian soldier lights a cigarette just outside Gori, on August 13. Below: Residents of Gori examine the body of a dead neighbor following the air attack.

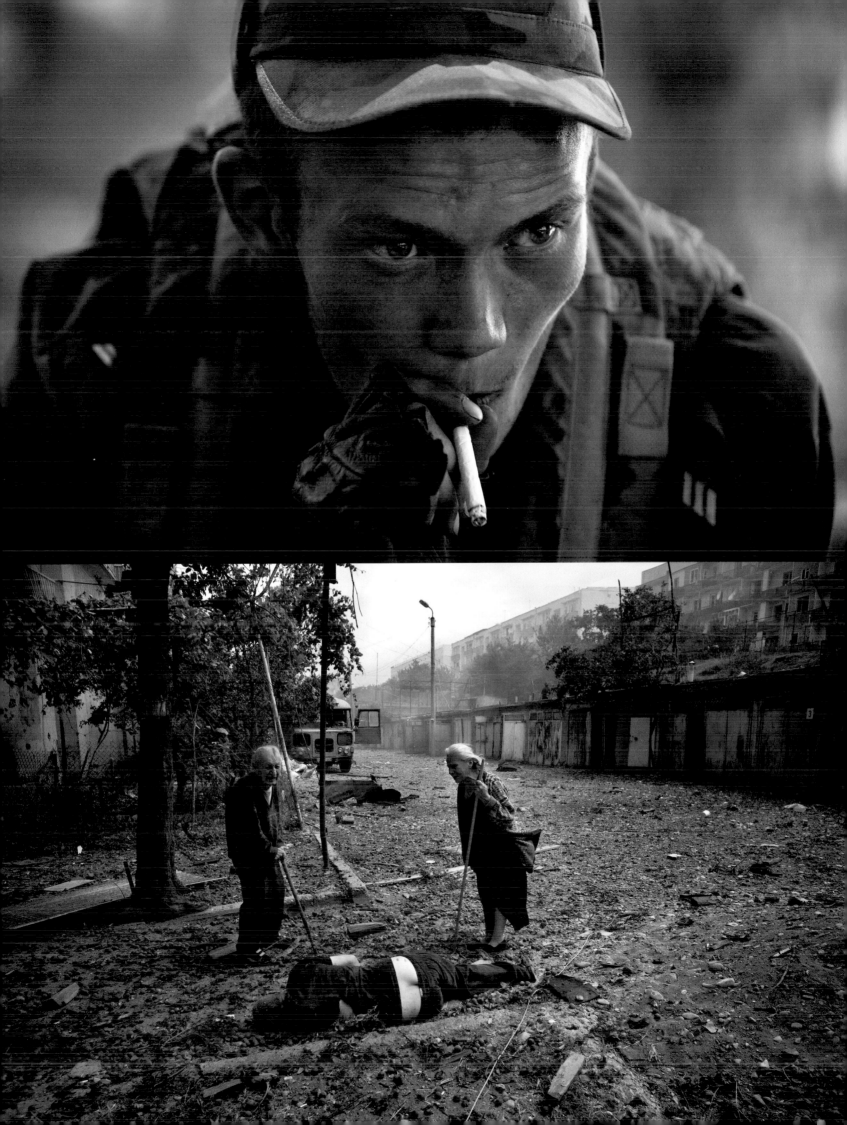

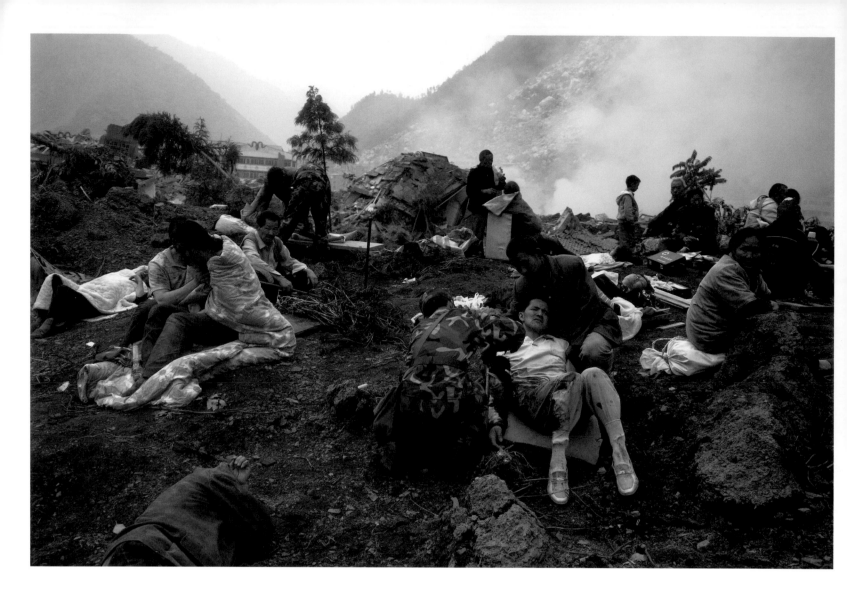

An earthquake measuring 7.9 on the Richter scale hit Beichuan county, in the province of Sichuan, China on May 12. Chinese authorities immediately poured troops into the region in a massive rescue attempt. Above: Injured victims sit amongst rubble in Beichuan County, the region worst affected by the quake, on May 13. Facing page: Soldiers carry a survivor from a destroyed home in Beichuan, on May 13. (continues)

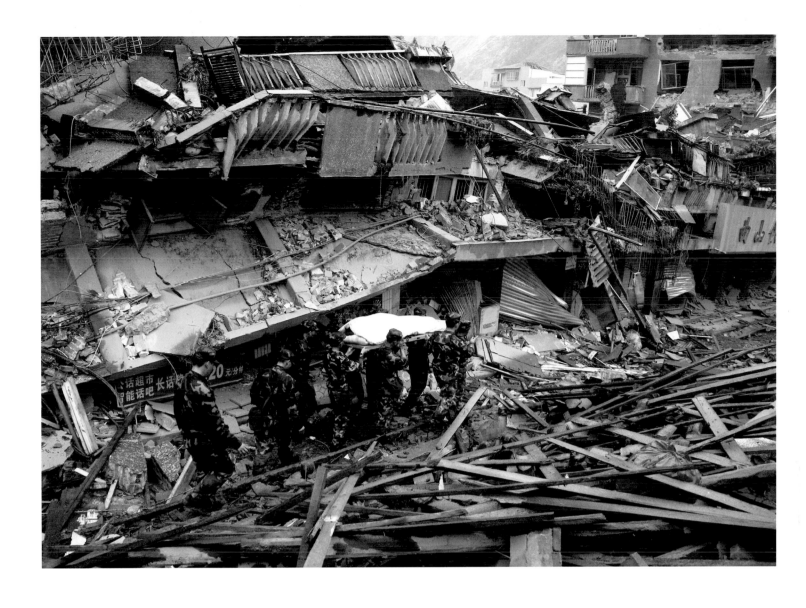

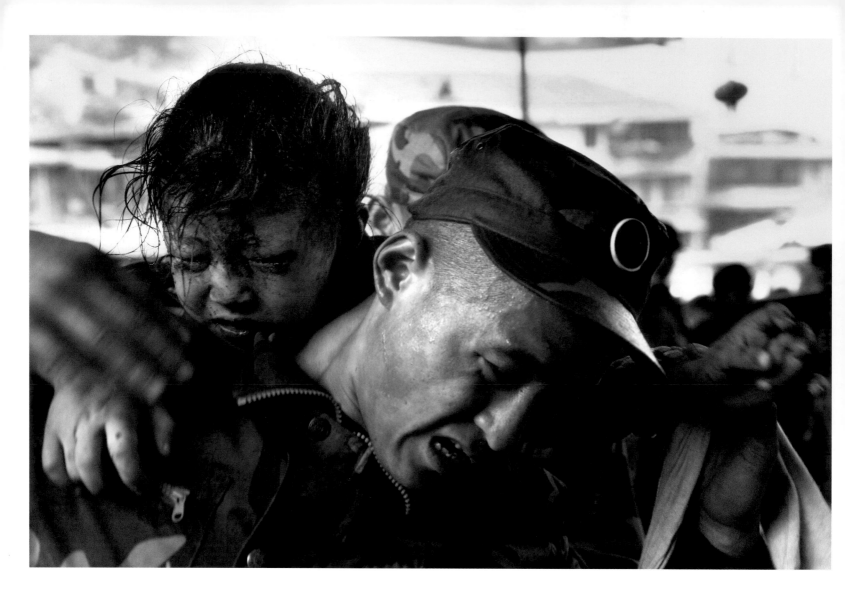

(continued) The earthquake was the worst to hit China since 1976, and tremors were felt as far as Bangkok, over 3,000 kilometers away. Nearly 70,000 people were killed, and more than 4.5 million made homeless by the quake. Above: A soldier carries an injured child after rescuing her on May 13. Facing page: A body lies covered in the remains of a destroyed building in Beichuan city, on May 15.

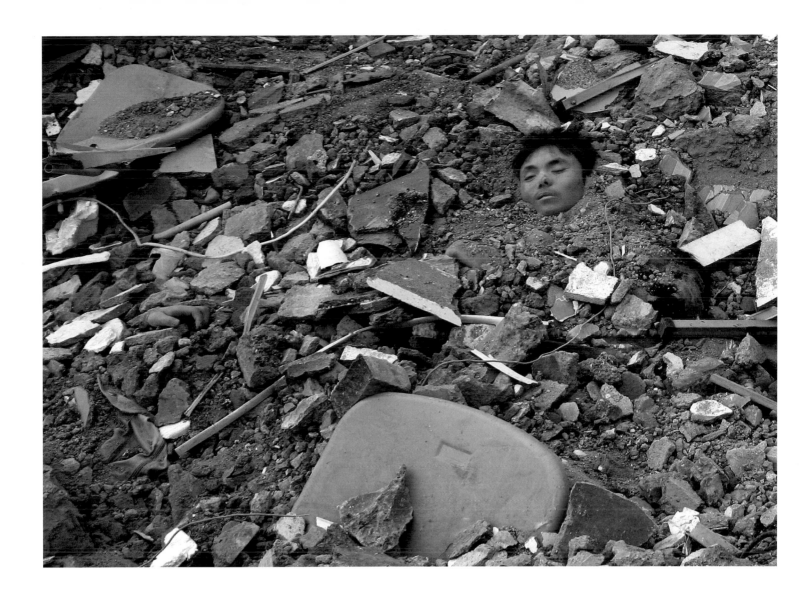

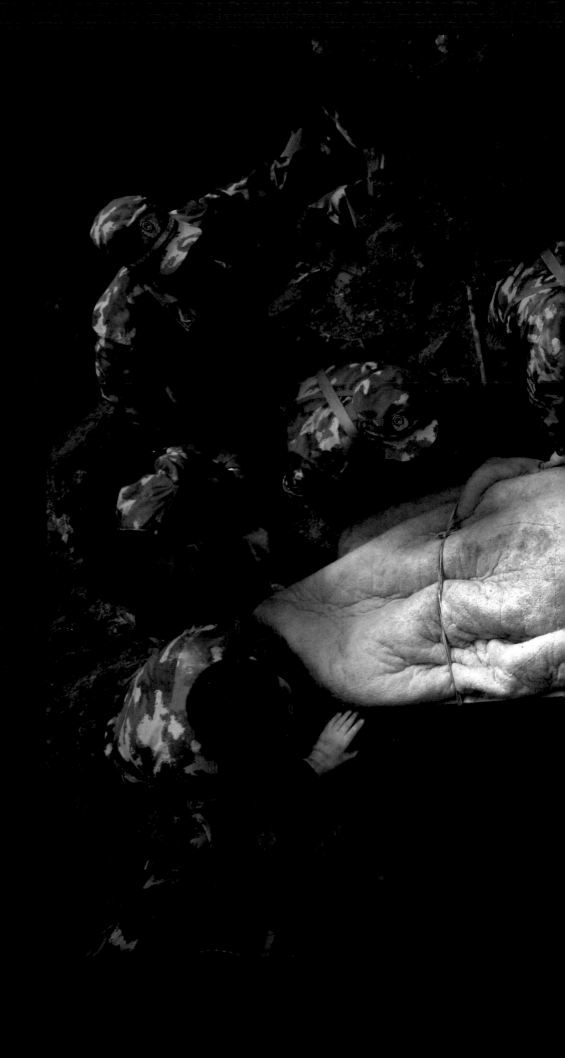

Rescue crews carry a survivor through the rubble of collapsed buildings in Beichuan city, two days after the May 12 earthquake that devastated parts of central China. Officials said that 80 percent of the old part of the city was destroyed.

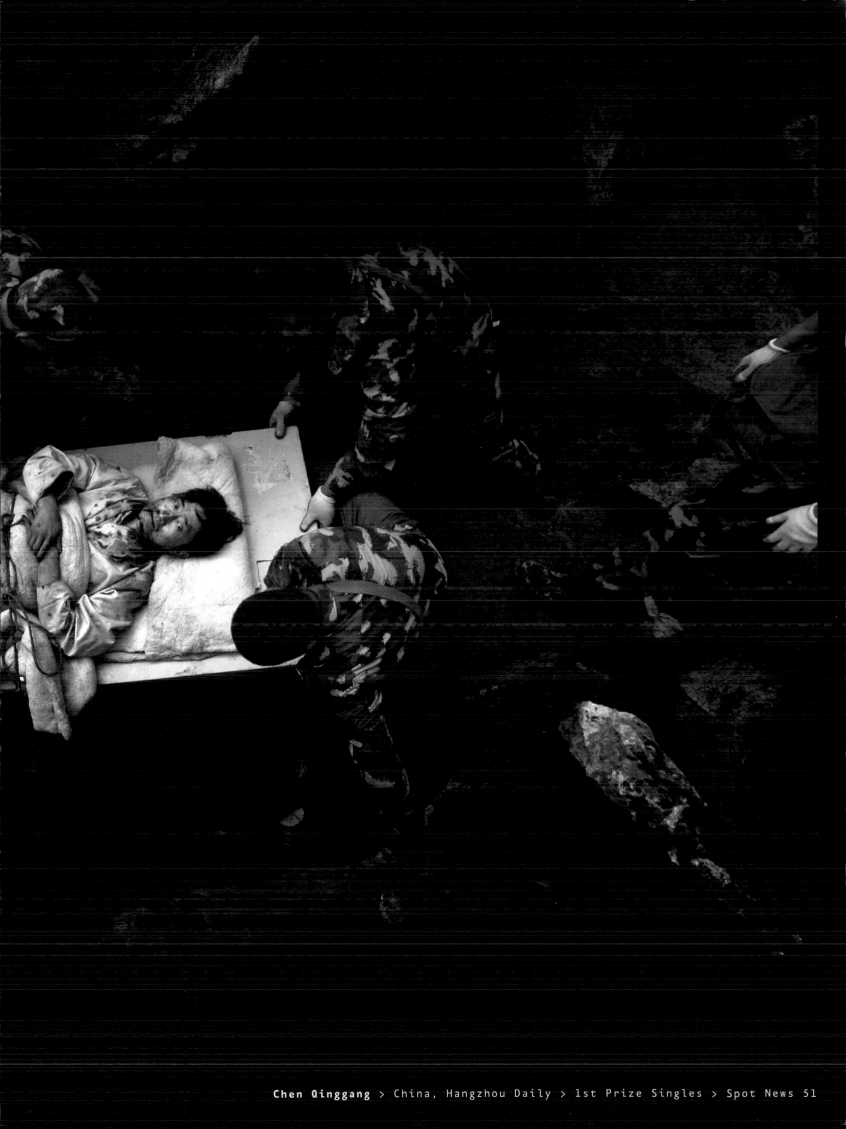

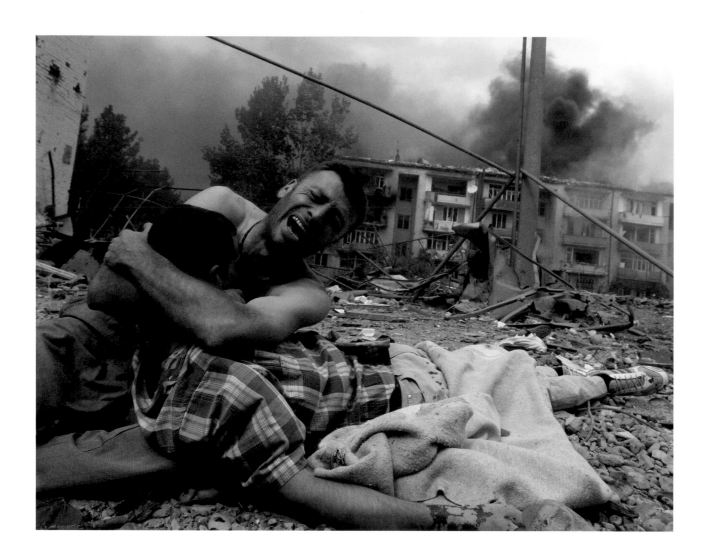

A man cries as he cradles the body of his brother following the bombardment of Gori in Georgia on August 9. The city came under air attack from Russian forces as tension between Russia and Georgia, focused on the breakaway region of South Ossetia, escalated into full-scale military conflict.

General News

In early August, tension between the Georgian military and separatist forces in South Ossetia erupted in full-scale conflict. The region declared its autonomy in 1989, and its status has been in dispute ever since. Many people living in South Ossetia are ethnic Russians, and part of the bid for independence from Georgia involves the establishment of closer ties with Russia. In March 2008, the Russian parliament urged the Kremlin to recognize South Ossetia's independence. Following the escalation in fighting between Georgian and South Ossetian forces in August, Russian troops intervened and for a while occupied parts of Georgia outside of South Ossetia. Facing page, top: Georgian soldiers travel near the city of Gori, close to the South Ossetian border. Below: Following a Russian air attack on Gori, the blood of a casualty lies in a pool on the street.

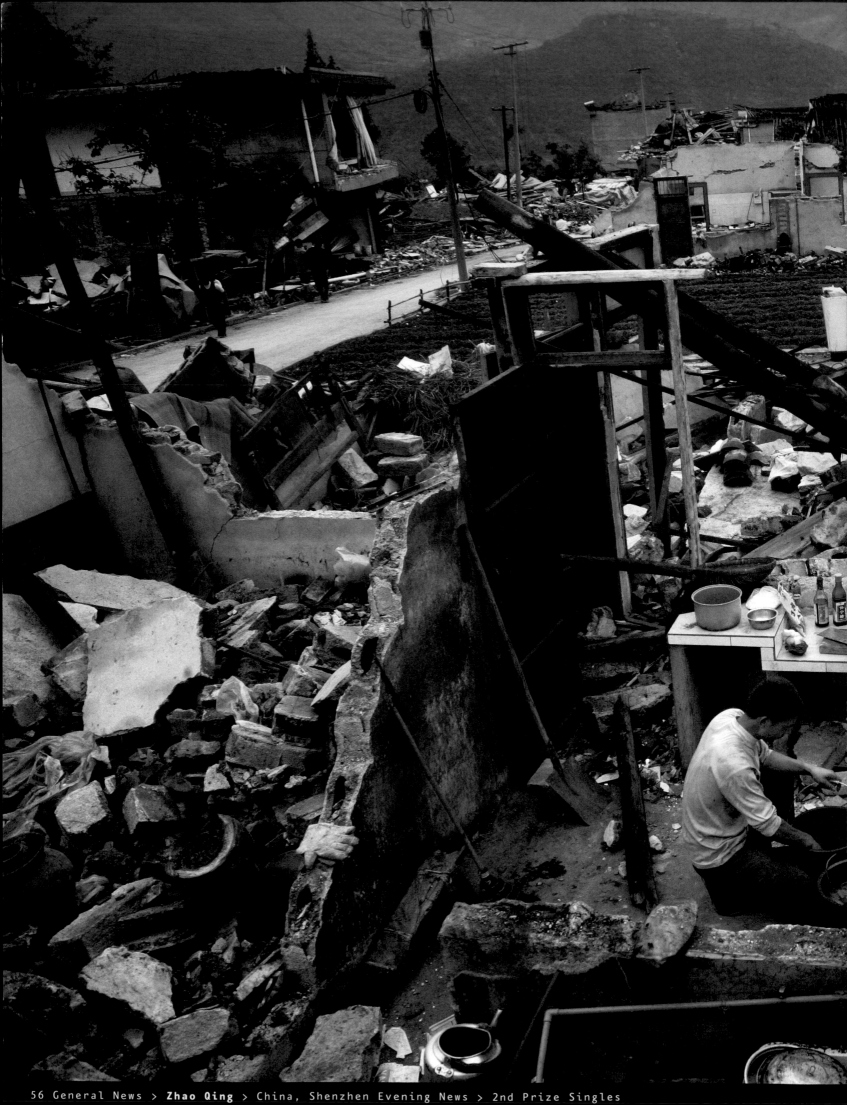

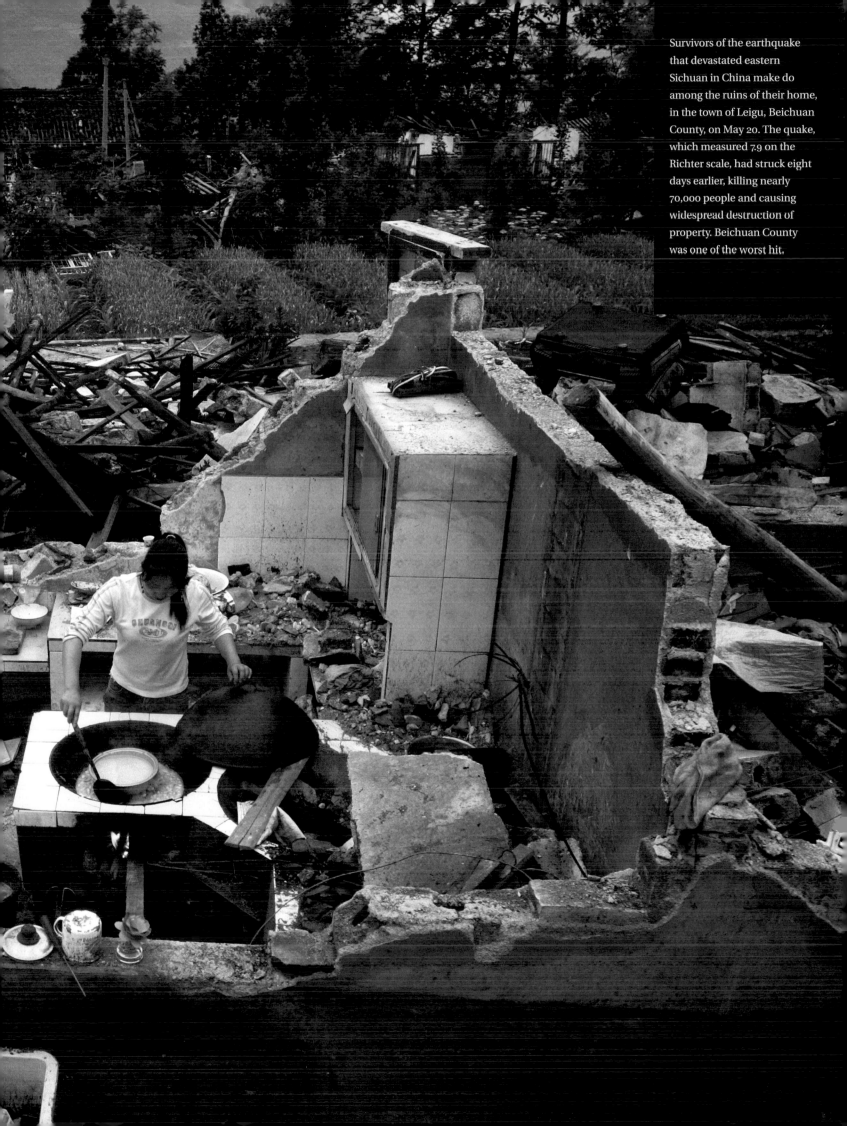

Survivors of the earthquake that devastated eastern Sichuan in China make do among the ruins of their home, in the town of Leigu, Beichuan County, on May 20. The quake, which measured 7.9 on the Richter scale, had struck eight days earlier, killing nearly 70,000 people and causing widespread destruction of property. Beichuan County was one of the worst hit.

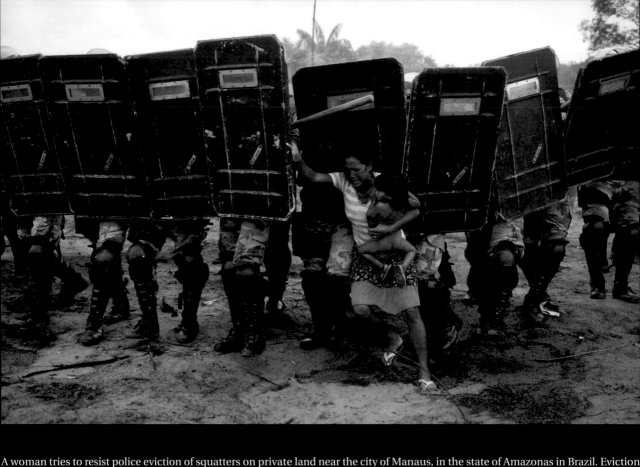

A woman tries to resist police eviction of squatters on private land near the city of Manaus, in the state of Amazonas in Brazil. Eviction notices had been served on families living on the land some days earlier, and when military police arrived to enforce the order they met with stone-throwing and shots from bows and arrows. They responded with rubber bullets and tear gas. The squatters, who were protesting against lack of housing in Manaus, were evicted after a clash that lasted two hours.

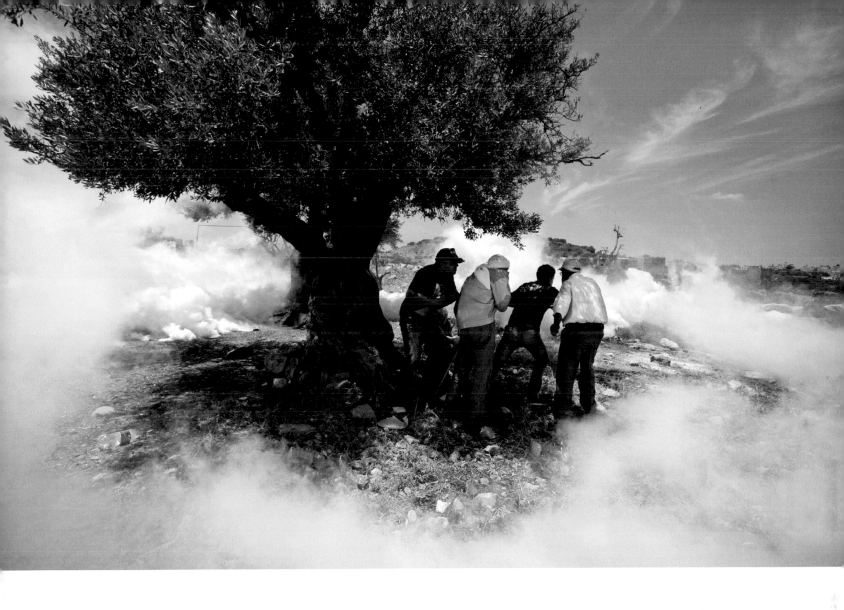

Palestinian protestors take cover behind an olive tree as they get caught in tear gas fired by Israeli troops, in the West Bank village of Ni'lin, near Ramallah, in May. Residents of the village began staging weekly demonstrations in May against Israel's extension of a barrier which would cut off part of their farmland.

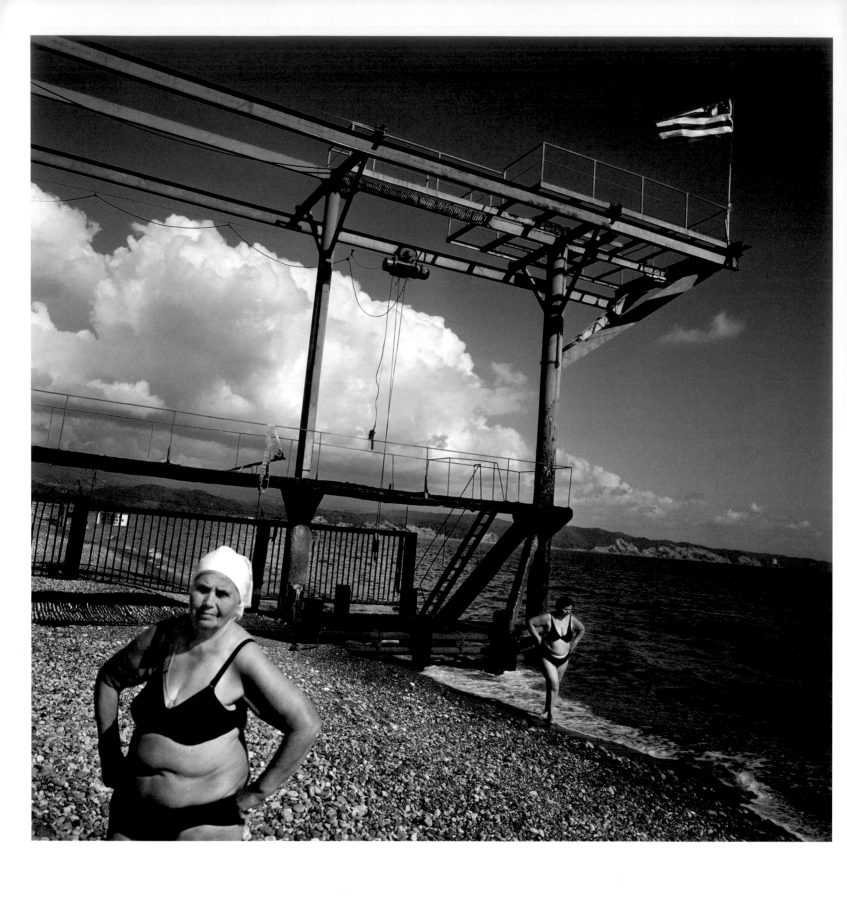

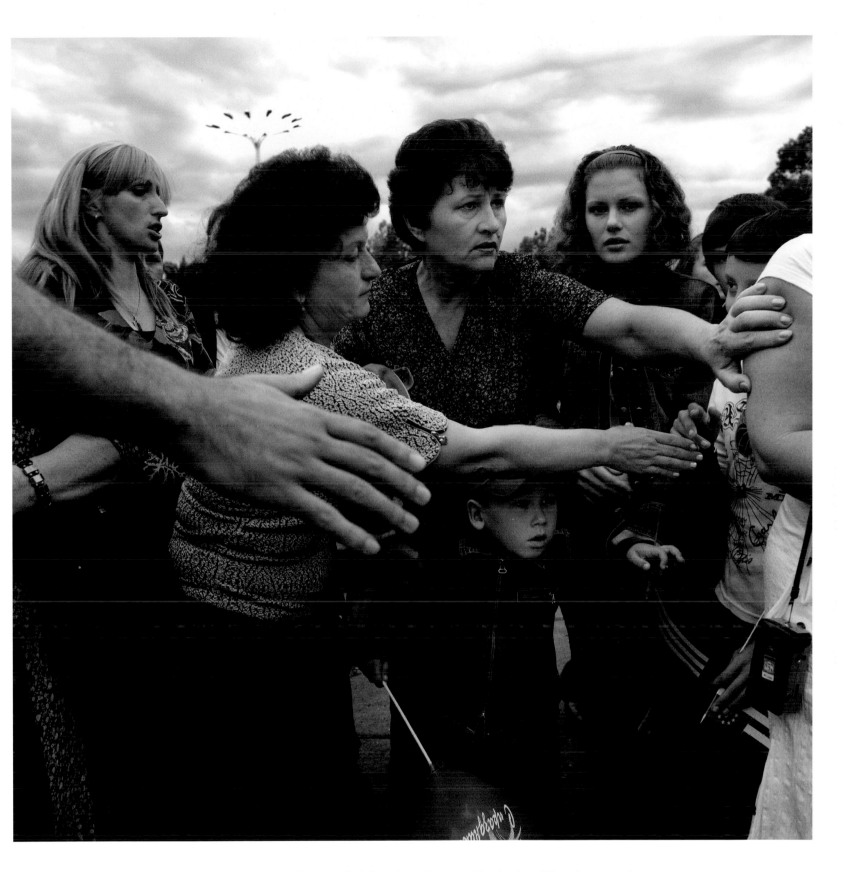

In October, people in Abkhazia marked the 15th anniversary of the ejection of Georgian troops from their territory. At the same time they celebrated Russian recognition of their independence, announced in August in the wake of the conflict between Russia and Georgia over a second breakaway state, South Ossetia. This was the first international recognition after Abkhazia's unilateral declaration of independence nearly a decade earlier. Facing page: Women bathe on Pitzunda beach, on the Black Sea coast. Situated between the Black Sea and the Caucasus mountains, Abkhazia was once popular as a holiday destination for the Soviet elite. Above: People greet the Abkhazian president during the October celebration parade. (continues)

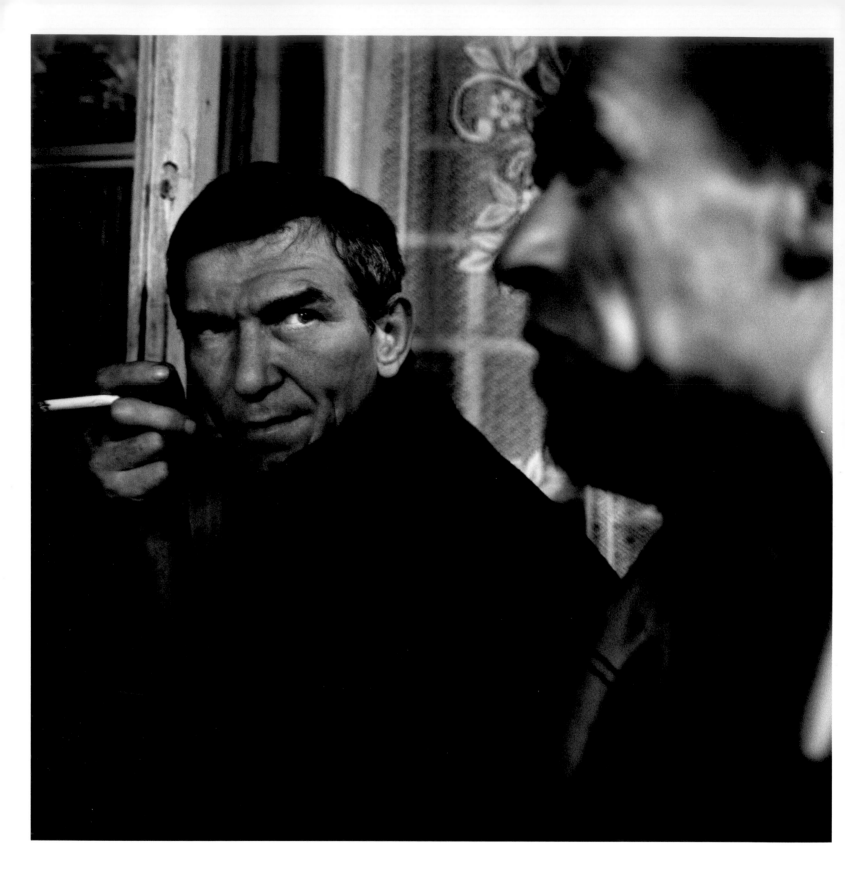

(continued) Following the expulsion of the Georgian army in 1993, a largely Russian peacekeeping force was stationed in Abkhazia. Moscow relaxed passport rules, making it easy for people in Abkhazia to take out Russian citizenship. Above: Men sit in a coffee bar in the Abkhaz capital Sukhumi. Facing page: The Kodori Valley in the north of Abkhazia was one of the last areas of the territory to remain in Georgian hands, with Abkhazian forces fully taking over only after August 2008.

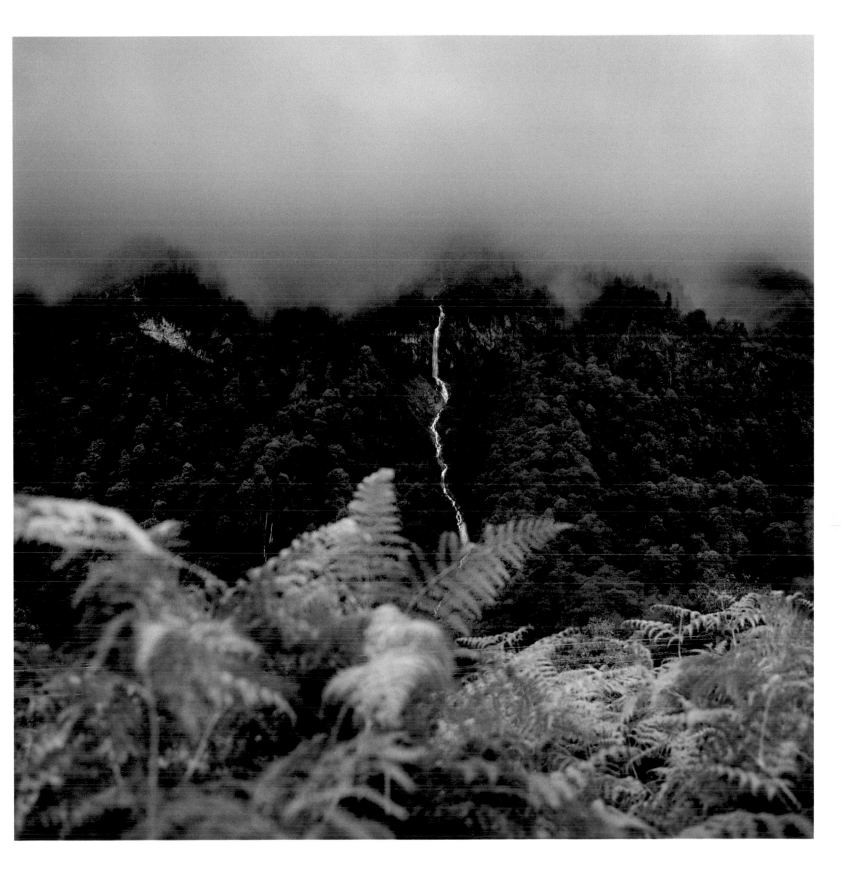

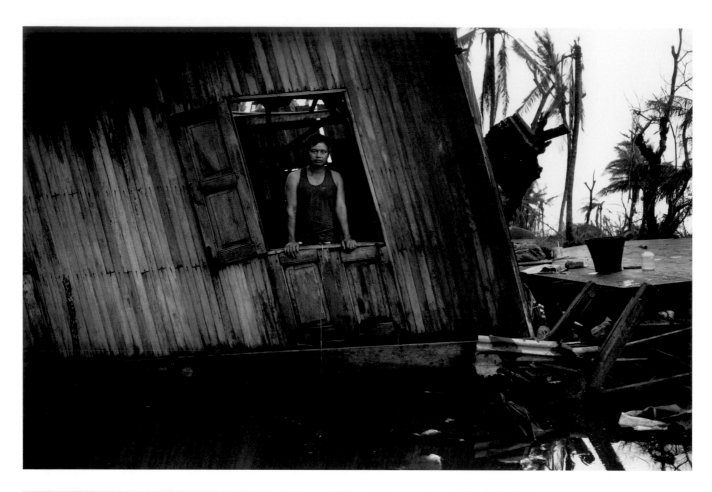

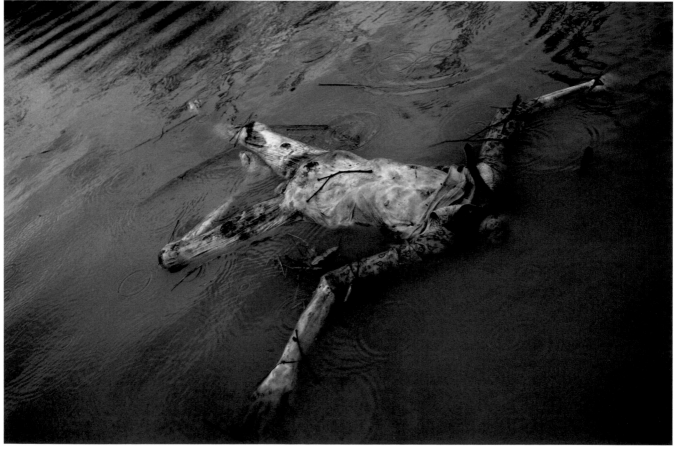

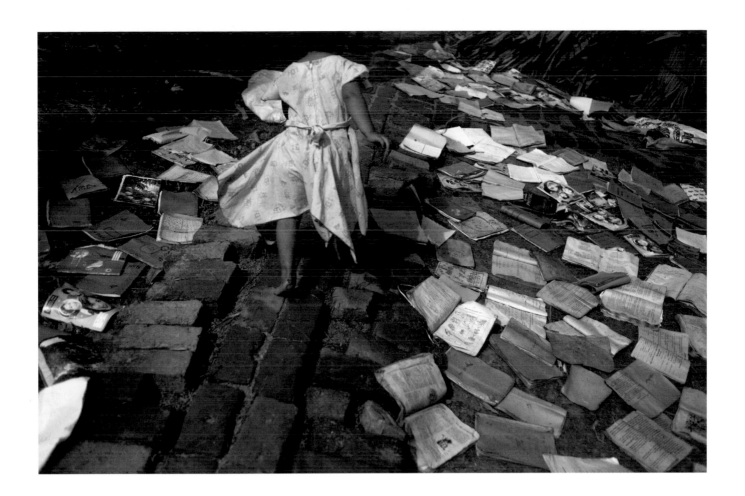

Cyclone Nargis made landfall in southern Myanmar (Burma) on May 2, wiping away entire villages and submerging swathes of land under floodwater, in the worst natural disaster the country had experienced in recorded history. The storm is believed to have left over 130,000 people dead and 450,000 homes destroyed. Many affected areas were extremely isolated, reachable only by boat. Local relief efforts were slow in getting underway, and in the crucial days following the disaster the Burmese authorities were resistant to help from outside organizations. As late as May 21, UN secretary general Ban Ki-moon was still trying to persuade the leader of the Burmese junta to accept full-scale international relief operations. Facing page, top: Saw Htu, who lost all his cattle in the cyclone, stands in his damaged house in the village of Denongho in the Irrawaddy Delta. Below: The corpse of a cyclone victim floats in a river near Pyapon, in the Irrawaddy Delta. Above: A girl runs beside books laid out in the sun to dry, to receive food dropped from a passing boat, on May 23.

Nature

SINGLES
1st Prize
Carlos F. Gutiérrez
2nd Prize
Jeremy Lock
3rd Prize
Alexey Bushov
STORIES
1st Prize
Steve Winter
2nd Prize
Fu Yongjun
3rd Prize
Heidi & Hans-Jürgen Koch

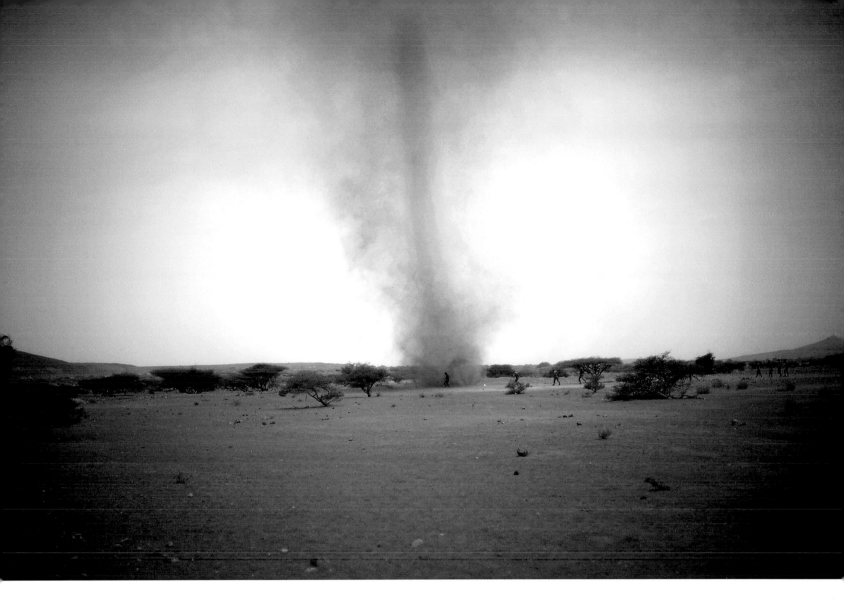

French soldiers chase after papers scattered by a dust whirlwind that passed through their camp in Djibouti, a country strategically located at the entrance to the Red Sea. French Marines were giving a survival training course to members of the us military in the desert outside the capital city. The us maintains its only African military base in Djibouti, as part of an effort to counter terrorism in the region.

Electrical discharges sparked by the heat of ash plumes light the night sky above Chaitén volcano in the Patagonia region of Chile. The volcano began erupting in early May, for the first time in 9,400 years. Ash billowing from the crater was visible from some 200 kilometers away and even caused disruption in neighboring Argentina. Thousands of people were evacuated from the surrounding area, with relatively few casualties.

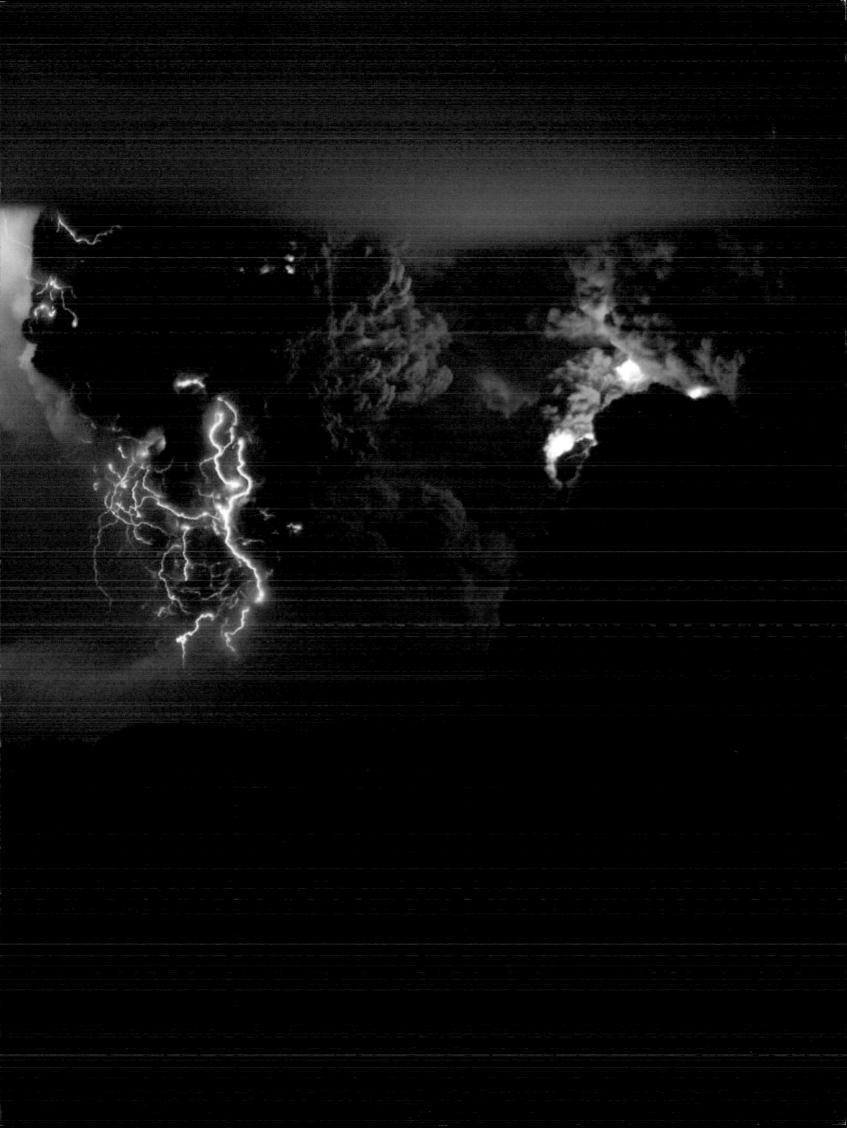

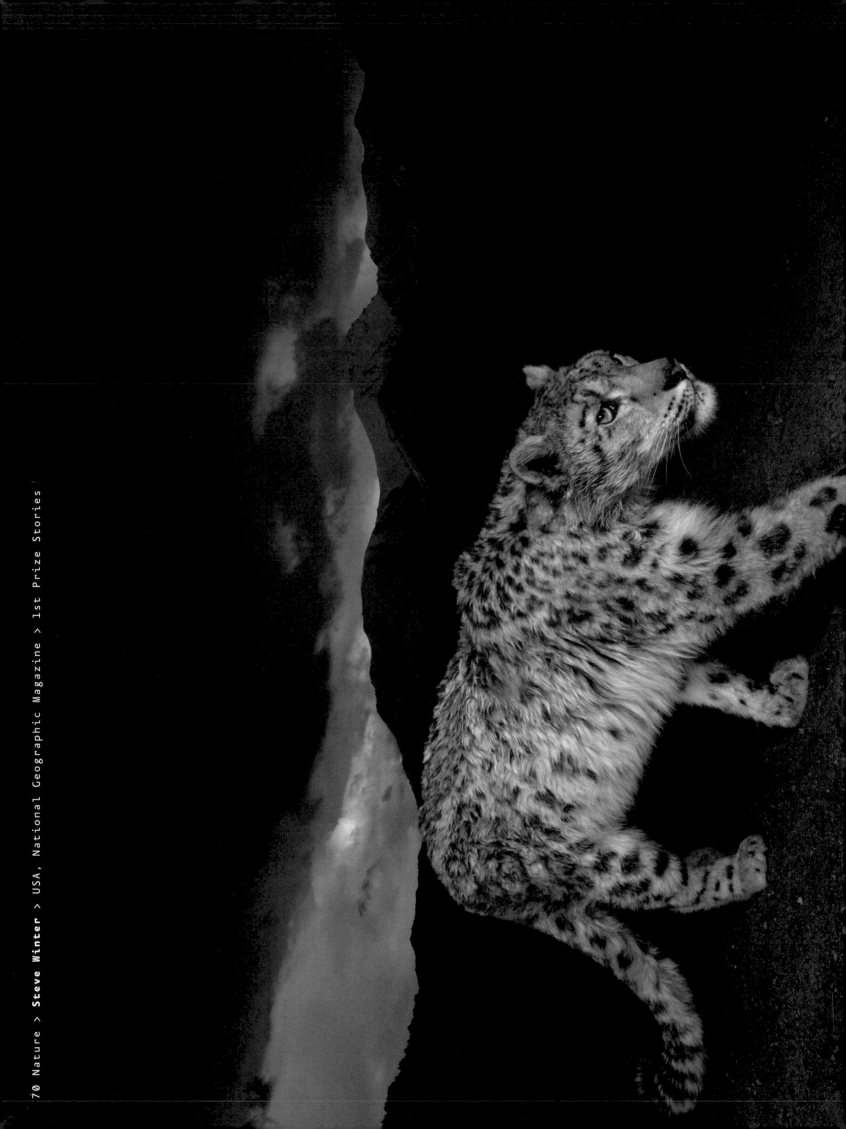

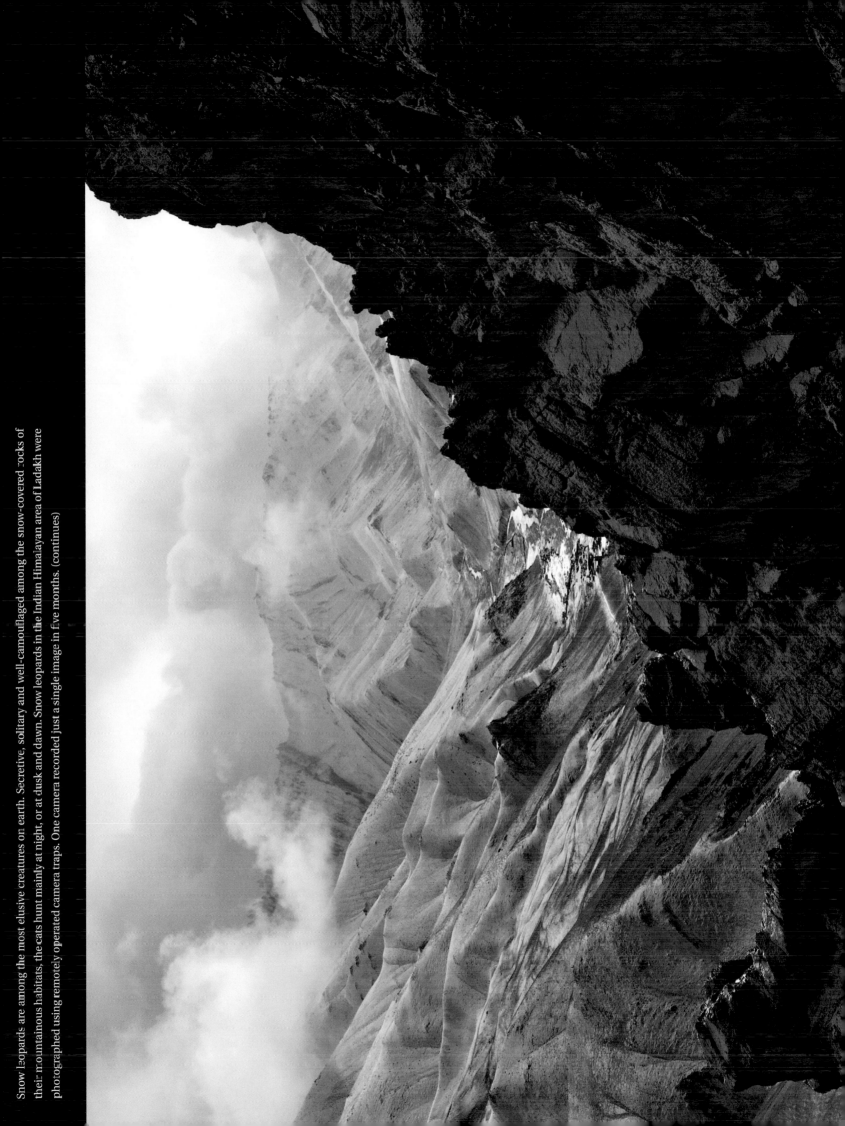

Snow leopards are among the most elusive creatures on earth. Secretive, solitary and well-camouflaged among the snow-covered rocks of their mountainous habitats, the cats hunt mainly at night, or at dusk and dawn. Snow leopards in the Indian Himalayan area of Ladakh were photographed using remotely operated camera traps. One camera recorded just a single image in five months. (continues)

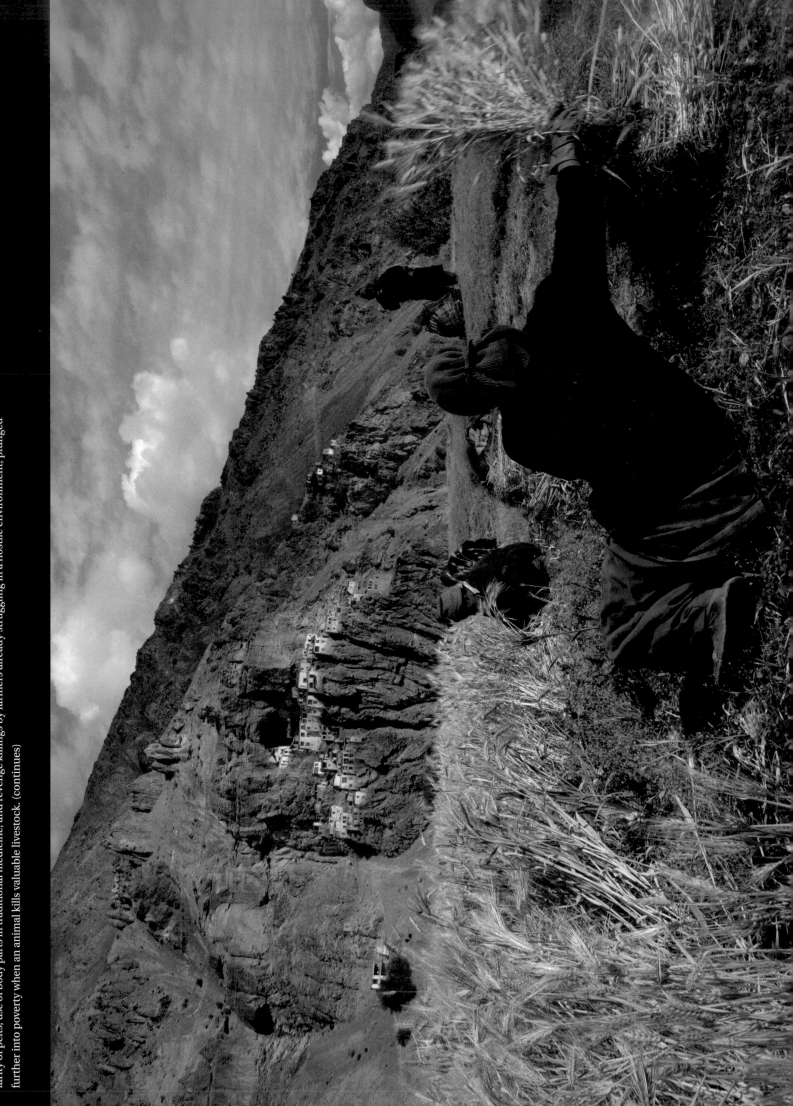

(continues) A scheme whereby trekkers stay with villagers who have agreed to protect local wildlife, and pay around €10 a night for food and board, offers a financial incentive to conservation. The income generated is more than enough to replace lost stock. Above: Villagers in the Ladakh region harvest barley. Many of their yaks, sheep and goats have been killed by wolves and snow leopards.

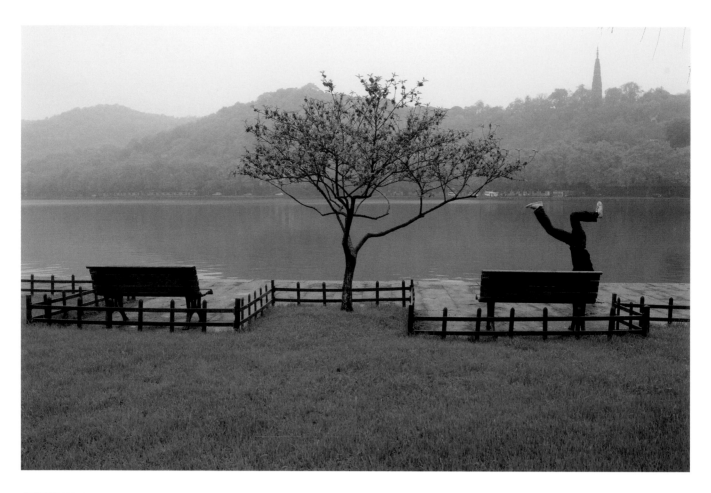

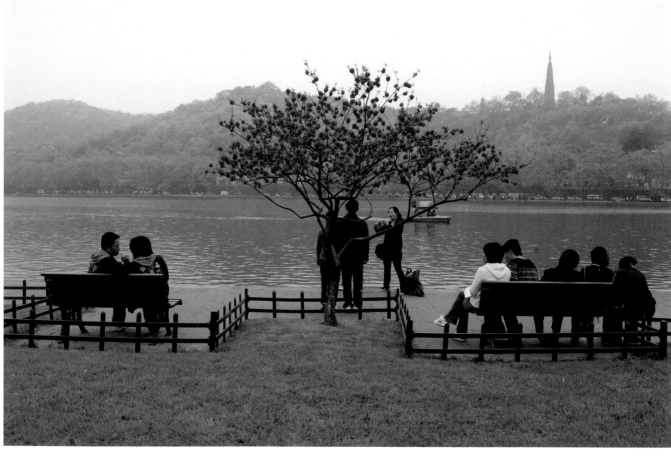

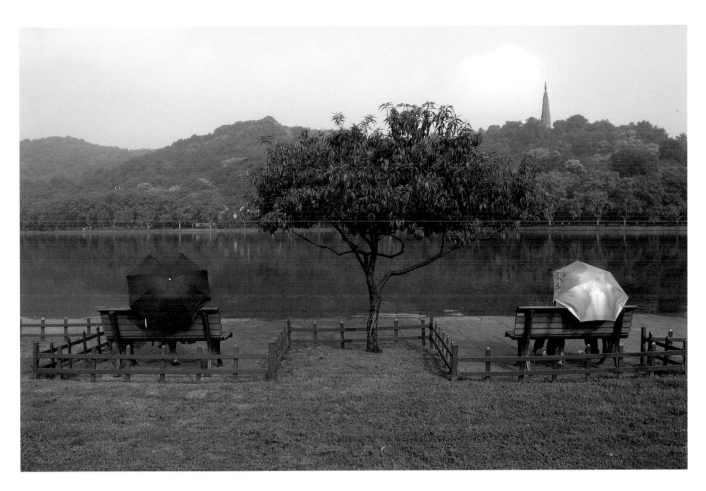

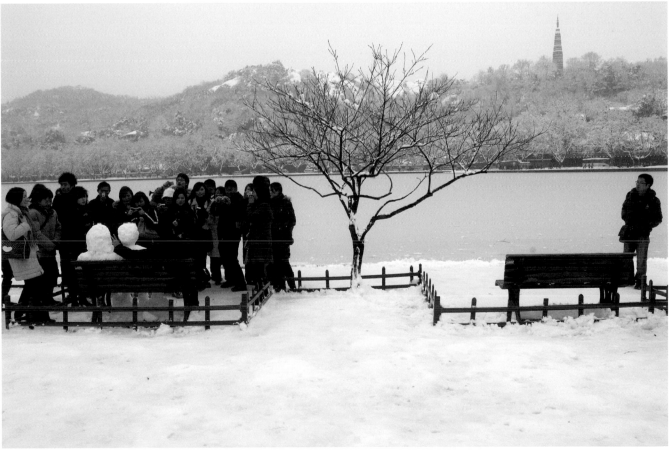

A peach tree beside West Lake in Hangzhou City, Zhejiang province, eastern China. The lake is one of China's most noted natural resorts and features on the back of the 1 Yuan bill.

As different species have adapted to meet specific needs and inhabit varied environments, the eye has evolved with an extraordinary diversity of specialization. Left to right, from top left: Nautilus mollusk. The lensless pupil works rather like the aperture of a pinhole camera. Dragonfly. Made up of some 28,000 units, the dragonfly's compound eye allows simultaneous vision through 360°. Southern ground-hornbill. The bird has remarkably long, wiry eyelashes. Spiny starfish. A red fleck at the tip of each of the starfish's arms is a concentration of sensory cells that allows light-dark perception. Burgundy snail. The snail's eye is a more developed form of the pinhole-pupil, such as that found in the nautilus mollusk. Red-eyed tree frog. The frog is active at night, and during the day covers its bright red eyes with a golden membrane that allows in just enough light for the animal to detect the movement of any possible predator. Nile crocodile. The eye is highly efficient at night; by day the pupil narrows to a slit. Jumping spider. The spider's eight eyes facilitate exceptional spatial and focusing abilities as it hunts its prey.

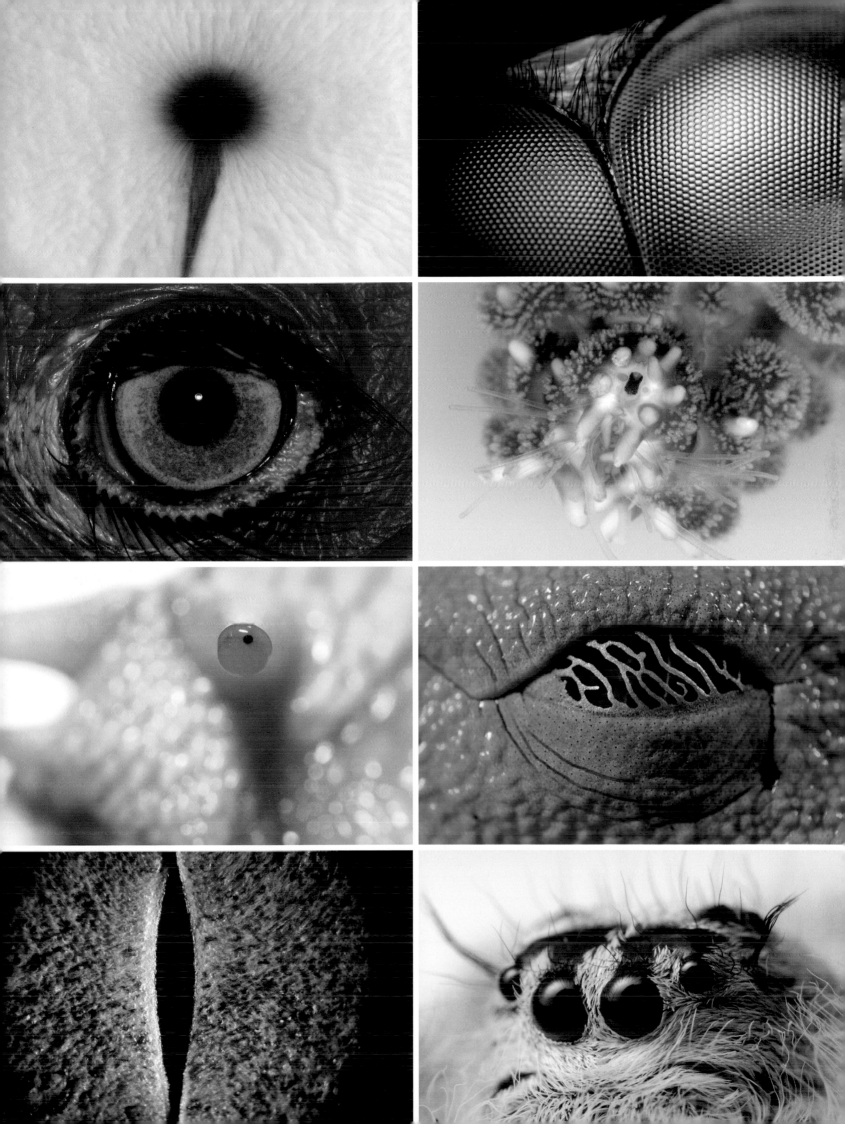

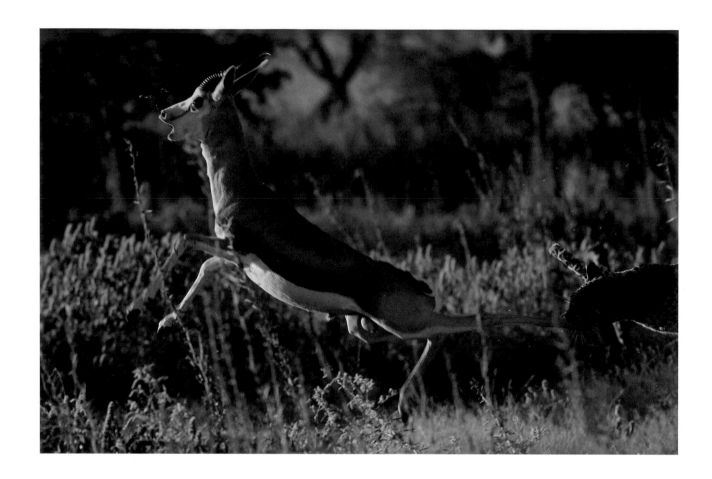

A leopard attacks a springbok in the Etosha National Park in Namibia. Springbok are among the most prolific antelopes in southern Africa, but it is rare to see leopards hunting during the day. The Etosha National Park, established in 1907, is one of Africa's oldest game reserves.

Contemporary Issues

SINGLES
1st Prize
Mashid Mohadjerin
2nd Prize
Guillaume Herbaut
3rd Prize
Véronique de Viguerie
Honorable Mention
Henry Agudelo
STORIES
1st Prize
Carlos Cazalis
2nd Prize
Johan Bävman
3rd Prize
Massimo Siragusa

Coastguards spot a boat carrying migrants on their way to the Italian island of Lampedusa. Just off the coast of Tunisia, Lampedusa forms part of a much-used route for illegal immigration from Africa into Europe. Smugglers charge people high sums of money to make the crossing, often crowded onto barely seaworthy craft. The Italian interior ministry said about 31,700 immigrants landed on Lampedusa during 2008, an increase of 75 percent on the year before. Local authorities are struggling to cope with the influx. Detention centers built to house would-be immigrants are filled beyond capacity, forcing hundreds to sleep outdoors.

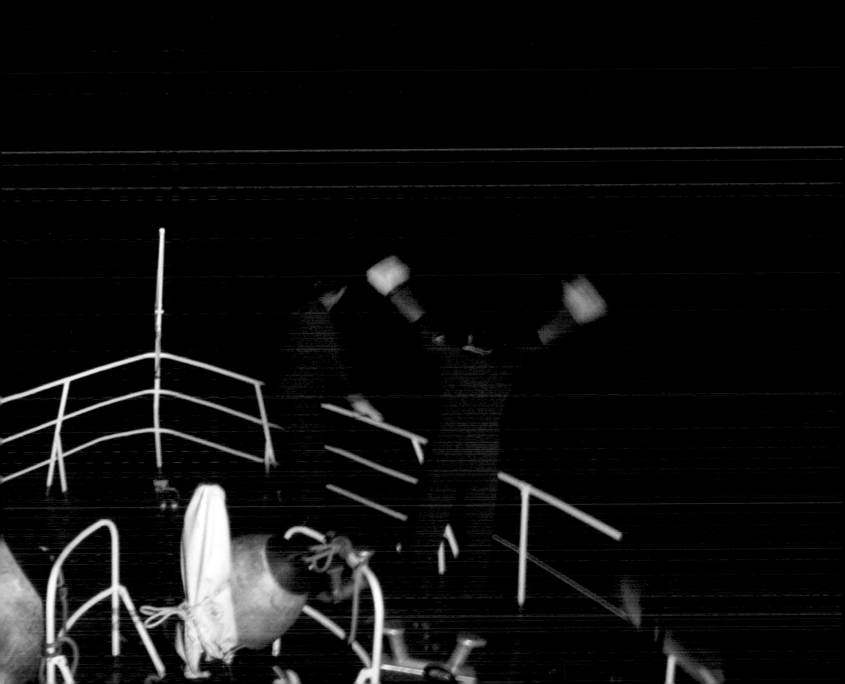

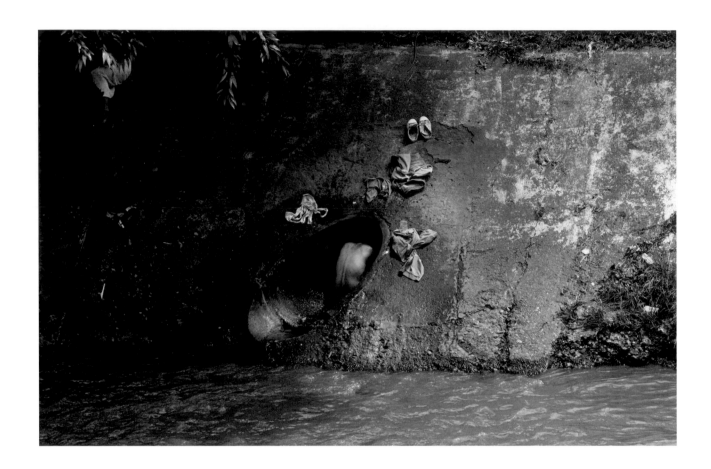

A homeless woman washes beside a river in Medellín, Colombia's second largest city. Once dubbed the 'murder capital of the world' as a result of mainly gang-related violence, Medellín has undergone a dramatic transformation in recent years. The homicide rate has plummeted, unemployment fallen and per capita income substantially increased. Nevertheless, people who sleep rough remain particularly vulnerable to street violence. In the weeks prior to this photograph being taken, four homeless people were killed in the vicinity.

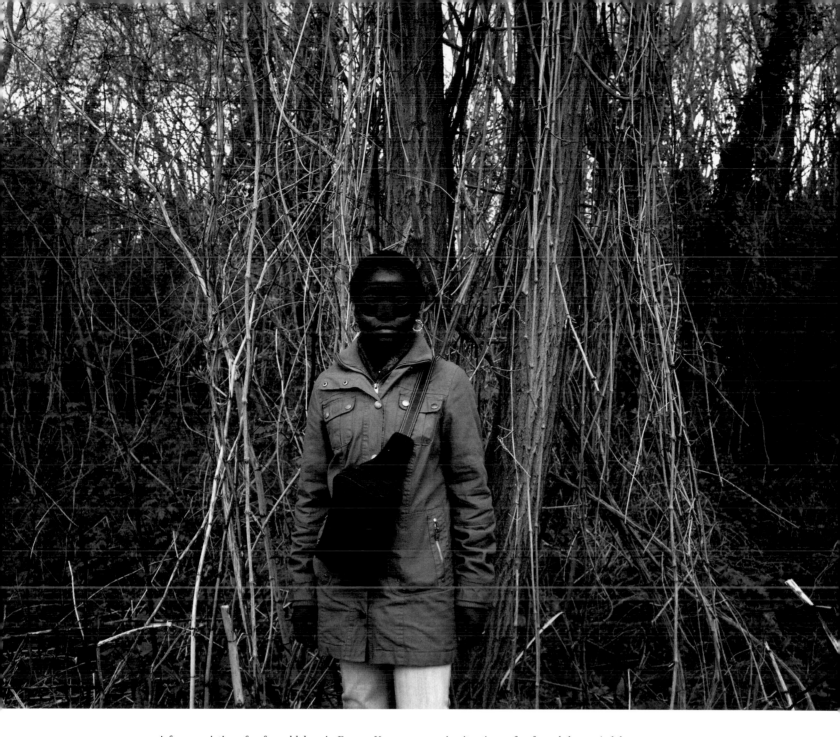

A former victim of enforced labor, in France. Young women in situations of enforced domestic labor are a cause for concern in a number of European countries. The Committee Against Modern Slavery in France says it deals with around 400 cases a year. Young women leave their home countries, primarily in Africa, on the advice of a relative or friend already established abroad. They are promised work or study possibilities, but when they arrive have their identity papers taken away from them and are forced into unpaid labor, usually as maids. Accusations of sexual and physical abuse are rife. Far from home and often unable to speak the language, the women are too scared to flee and become virtual prisoners in the apartments where they work.

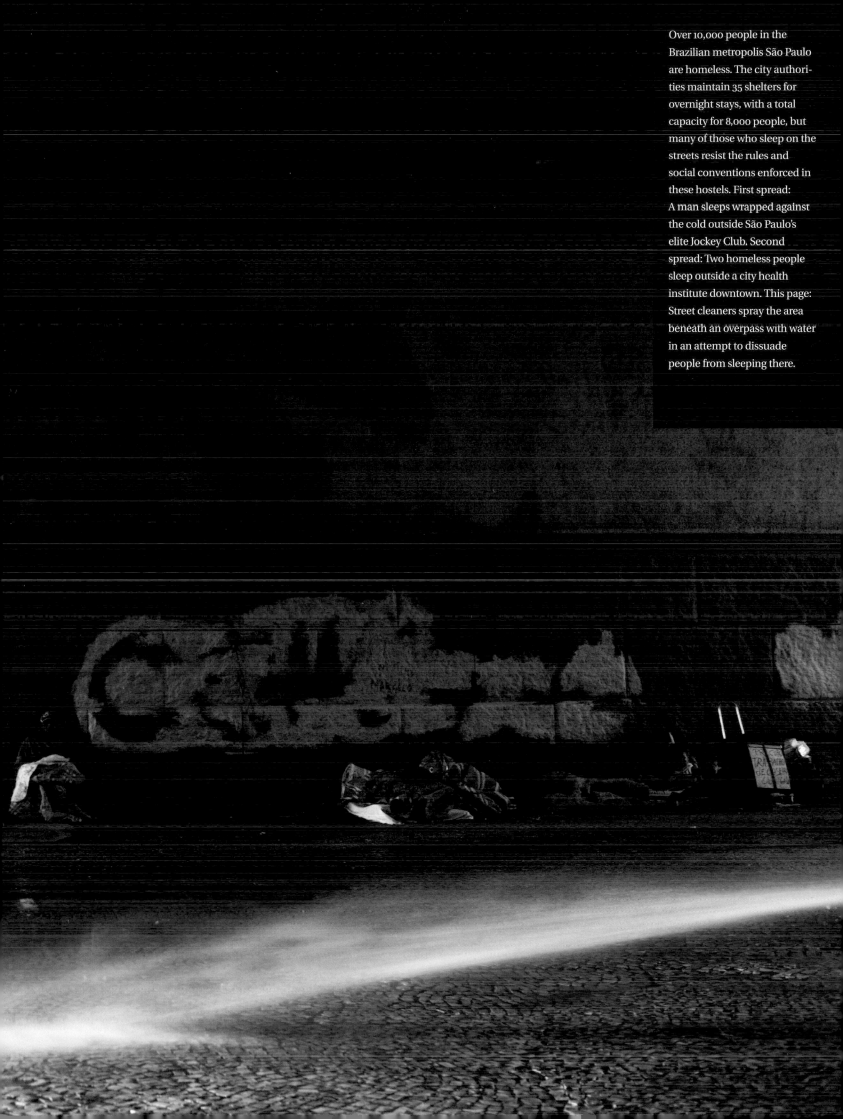

Over 10,000 people in the Brazilian metropolis São Paulo are homeless. The city authorities maintain 35 shelters for overnight stays, with a total capacity for 8,000 people, but many of those who sleep on the streets resist the rules and social conventions enforced in these hostels. First spread: A man sleeps wrapped against the cold outside São Paulo's elite Jockey Club. Second spread: Two homeless people sleep outside a city health institute downtown. This page: Street cleaners spray the area beneath an overpass with water in an attempt to dissuade people from sleeping there.

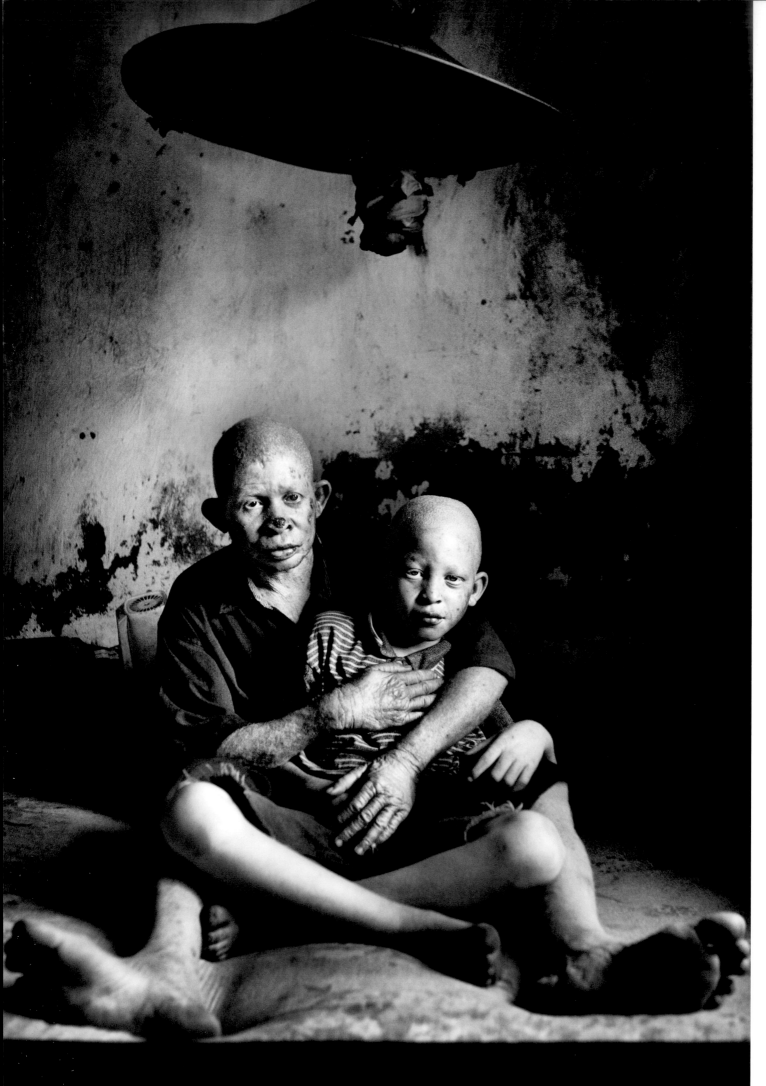

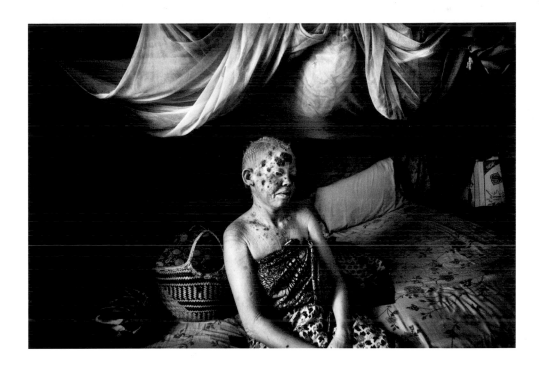

Tanzanian albinos have to struggle with life as outcasts in a climate they are ill adapted to. Those with the hereditary condition are particularly susceptible to skin cancer, and have to avoid exposure to strong sunlight. Albinos are also the targets of witchcraft murders, as it is believed potions made from their body parts bring luck and prosperity. Over 25 albinos were killed in Tanzania in the first 10 months of 2008. Facing page: Saidi Tamin and his son Ally live on handouts. His coal-delivery business went bankrupt because after developing skin cancer, he could no longer work outdoors. This page, top: Hawa Ali lives in one of the poorest regions of Dar es Salaam, and cannot afford treatment for her tumors. Middle: Mwanaidi Mwinyiarida and her friend Selina Robort in a classroom at Mitindo Primary School in northern Tanzania. Below: Mitindo Primary School offers some protection and sanctuary for albino children.

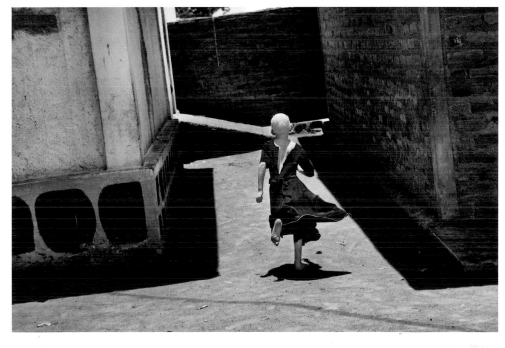

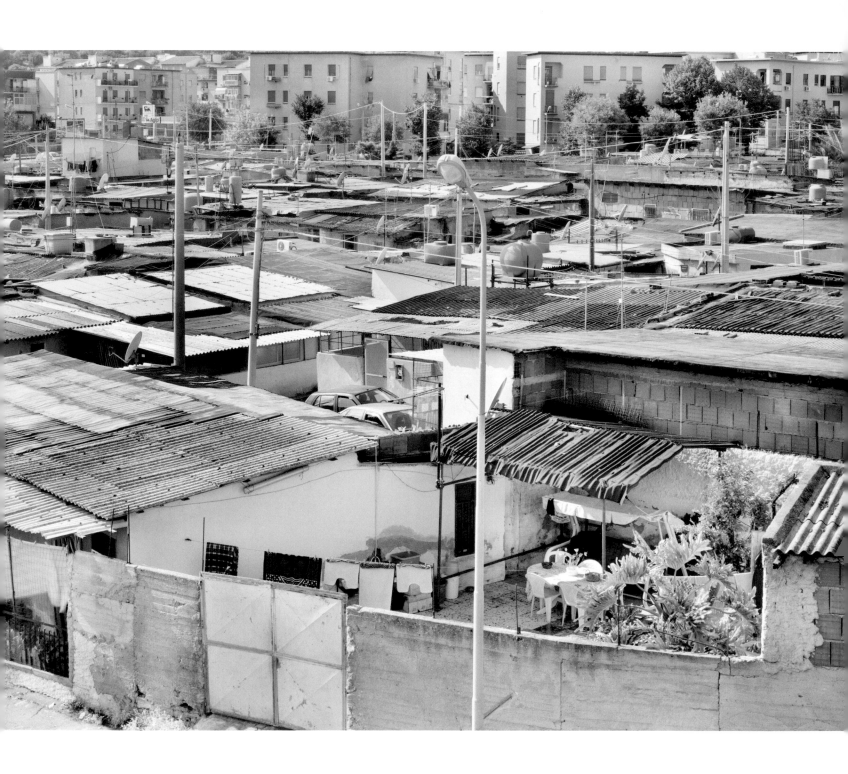

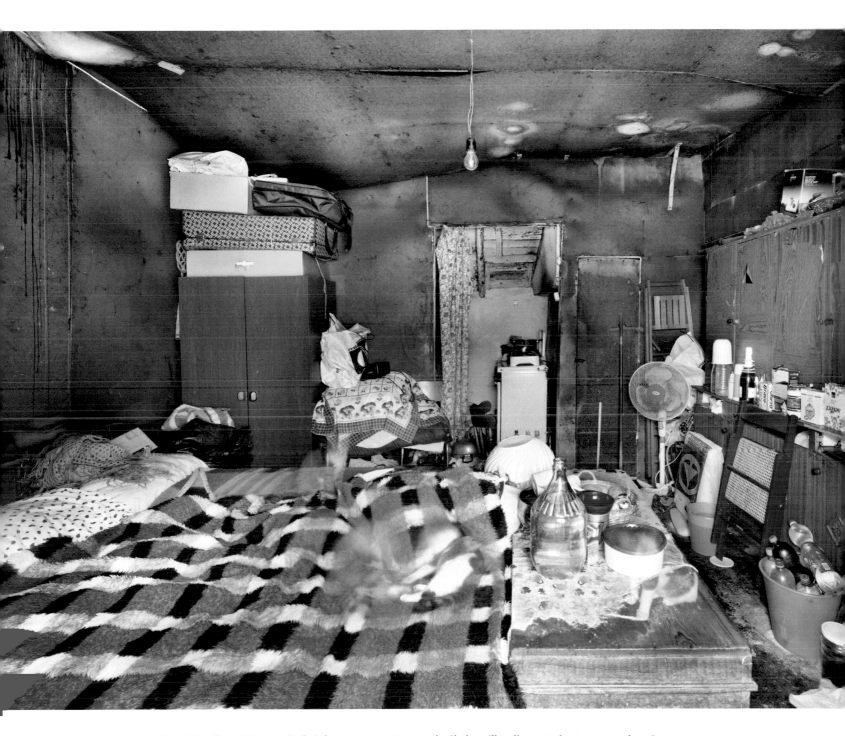

Fondo Fucile, in Messina, Sicily, is home to some 650 people. Shelters illegally erected as temporary housing after the Second World War still serve as family homes, yet there is no drinking-water or drainage system, and many roofs are made of asbestos. The quarter lies adjacent to the even older slum area of Villaggio Annunziata, built after the earthquake that destroyed Messina in December 1908. Successive city administrations have failed to bring any notable improvement to the slums.

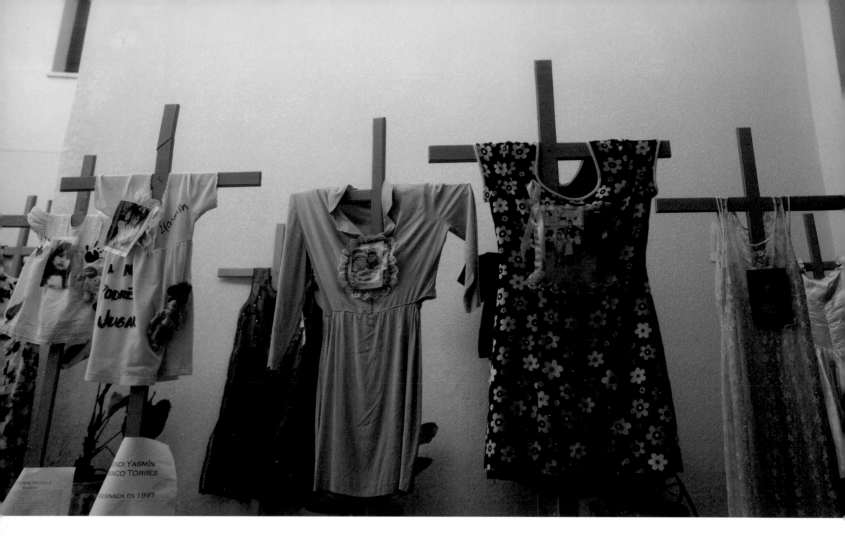

Garden of Angels is a memorial erected by the Sobrevivientes foundation, an organization for survivors of violence against women in Guatemala. Victims of crimes committed against women are represented by the clothes they were wearing at the time hanging on a wooden cross. Guatemala has one of the world's highest rates of violence against wom-

en, reporting 4,000 cases of rape, murder and domestic attack since 2000. In April 2008, the Congress of Guatemala approved a law specifically defining femicide as a crime, establishing punishments of 25 to 50 years imprisonment, as well as jail sentences of five to twelve years for sexual, physical or psychological violence against women.

Arts and Entertainment

SINGLES

1st Prize
Giulio Di Sturco

2nd Prize
Jérôme Bonnet

3rd Prize
André Vieira

STORIES

1st Prize
Roger Cremers

2nd Prize
Kacper Kowalski

3rd Prize
Jonathan Torgovnik

Angolan fashion designer Shunnoz Fiel is one of a new generation of designers and stylists in the country. A period of peace after many years of civil war, together with money generated by an oil boom, is helping to create a class of young professionals in Angola with a growing interest in fashion.

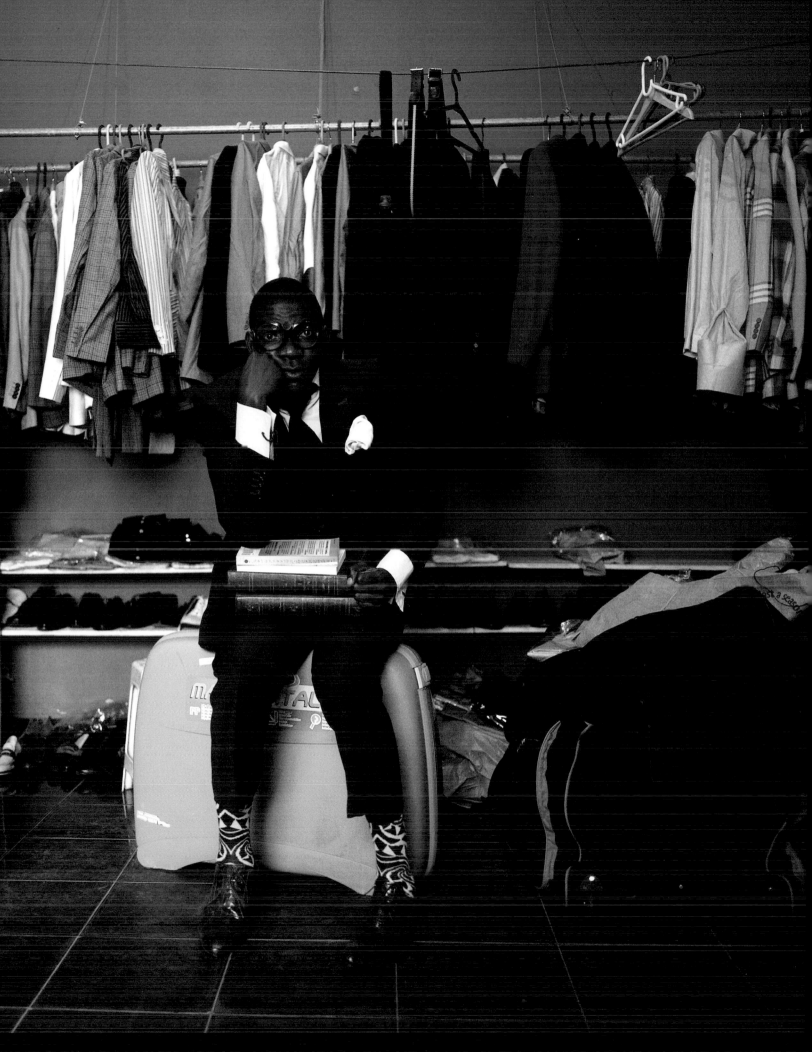

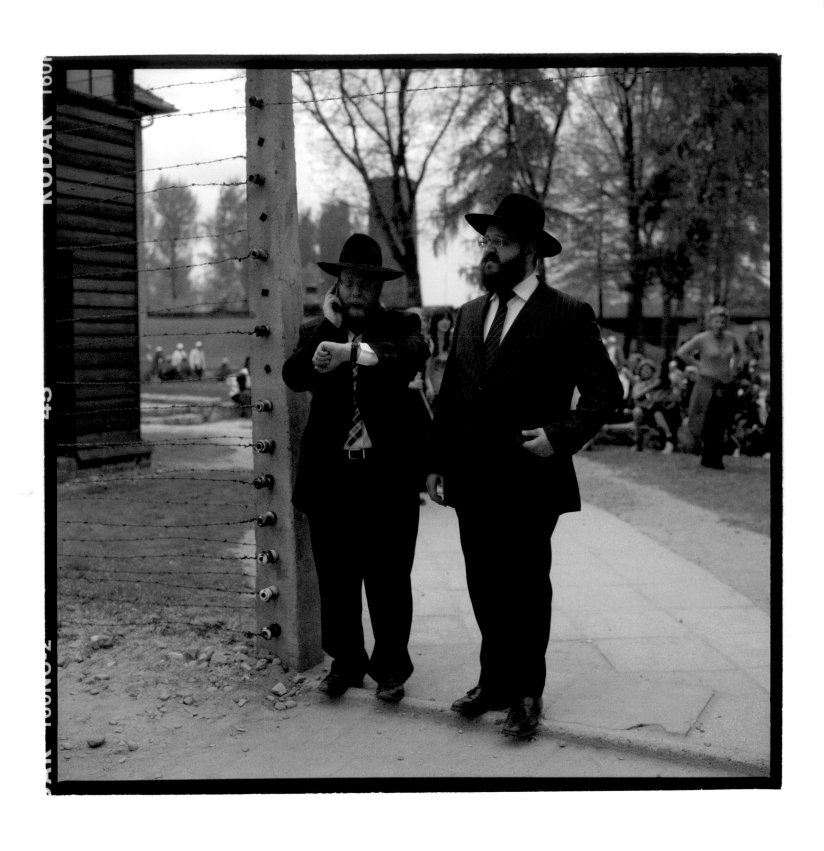

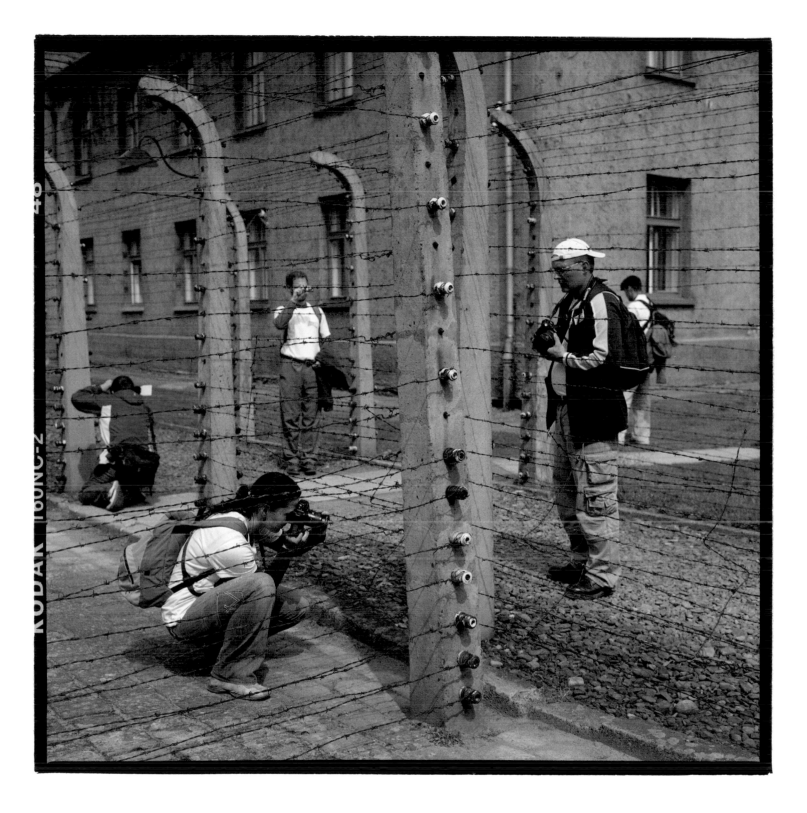

Visitors walk through the grounds of the Auschwitz-Birkenau Memorial and Museum in Poland. The terrain and buildings of the former concentration camps are open to visitors, not only as an historical representation of how they functioned, but as testimony to the atrocities that took place there. (continues)

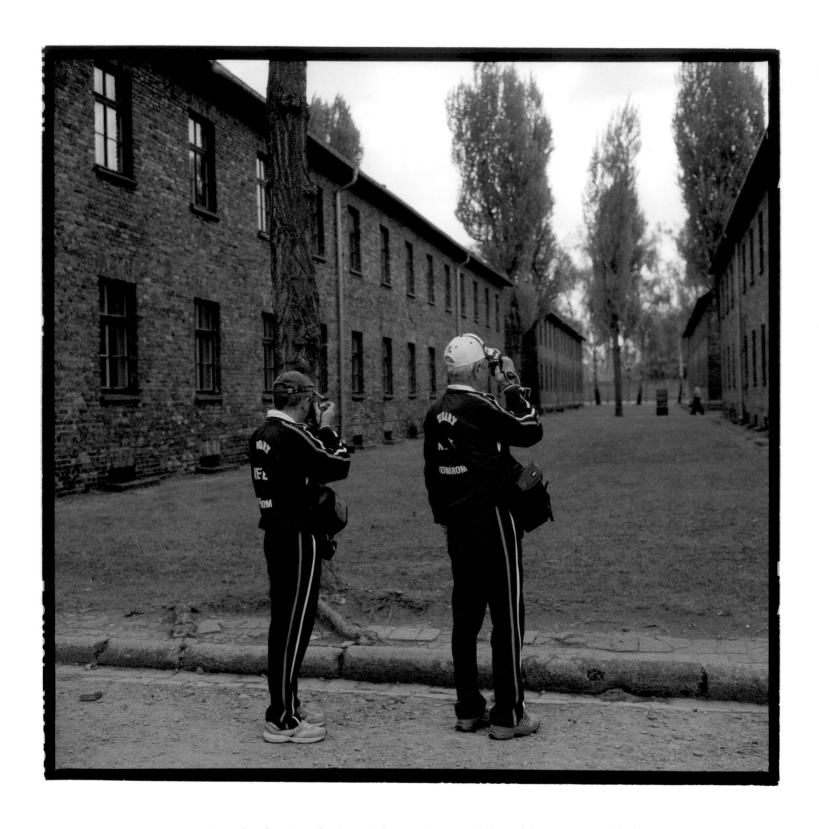

(continued) The Auschwitz-Birkenau Memorial and Museum, with its archive and international education center, has seen a steady increase in visitors in past years. Part of its mission is not only to increase awareness, but to awaken responsibility, so that learning about history has an impact on current thought and behavior.

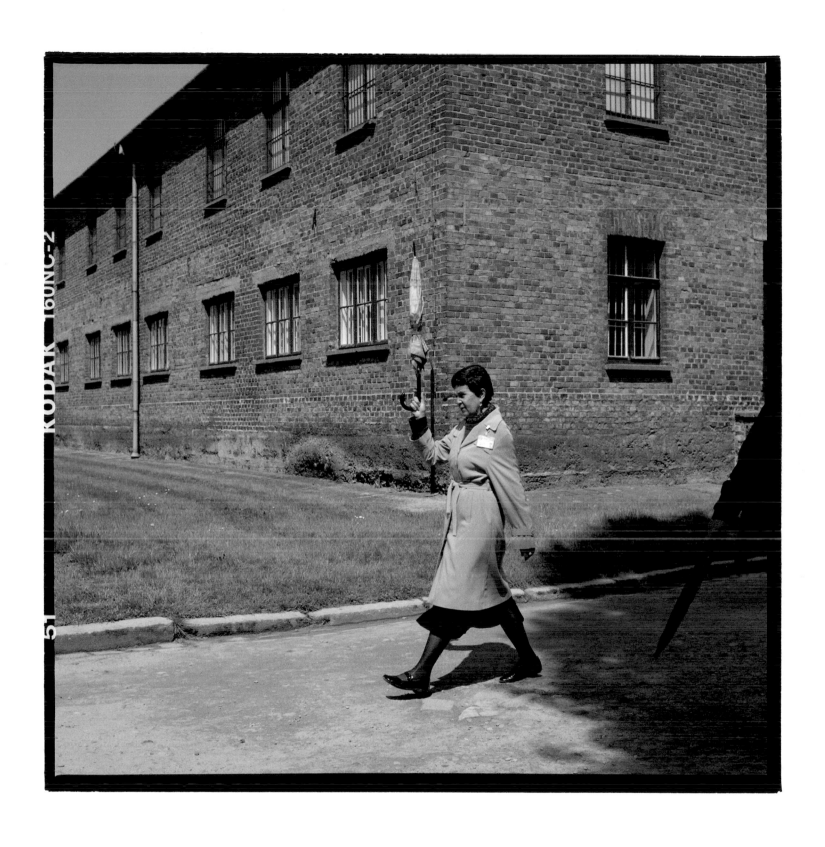

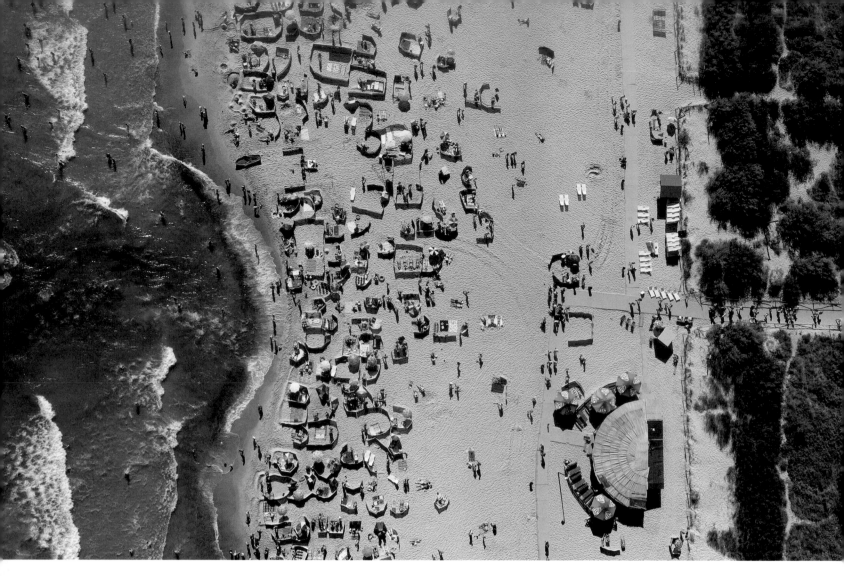

A beach near Wladyslawowo, a small resort on the Baltic Sea coast in Poland, over the course of a July day.

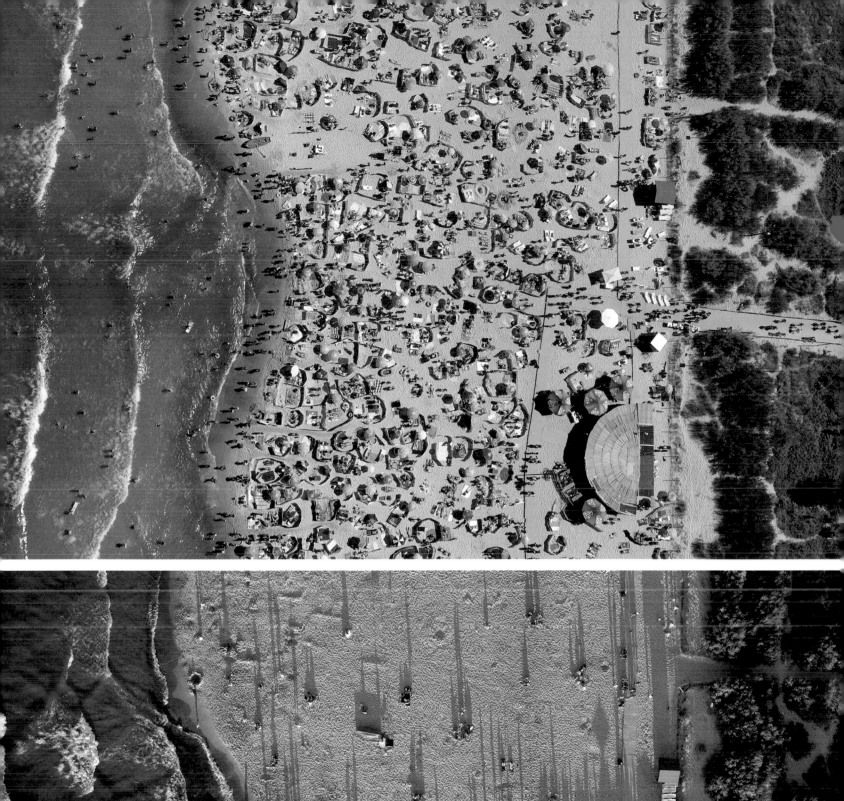
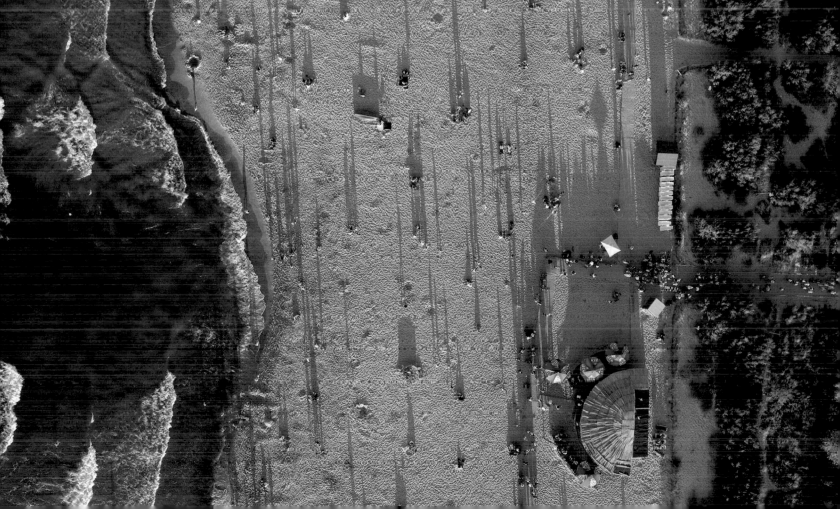

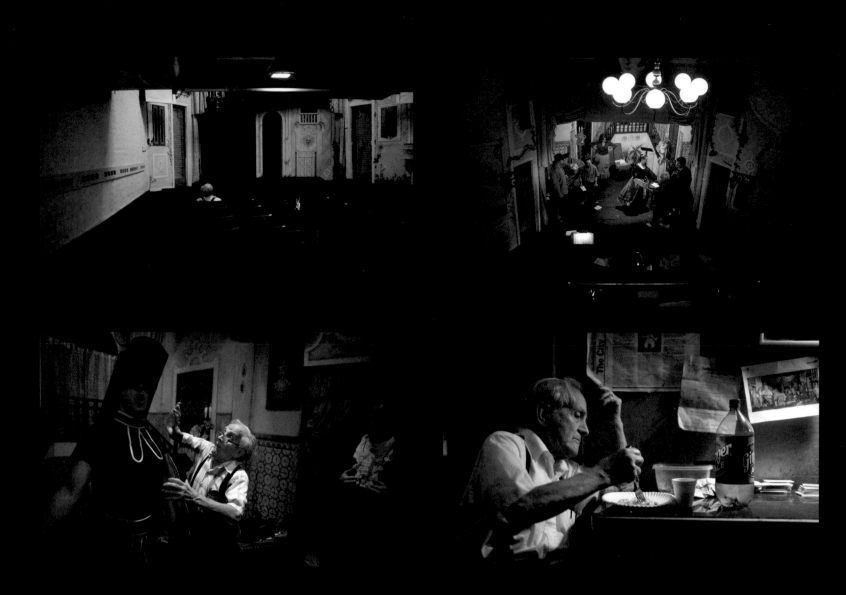

The Amato Opera Theater in New York has survived since 1948 under the care and direction of its founder Anthony Amato. Aimed at presenting grand opera that is also good theater, the basement venue has long provided a platform for aspiring artists. Amato finally closed his theater after its 2008/9 season. This page, top: Anthony Amato (88) sits alone in the front row before a rehearsal. Singers rehearse *The Barber of Seville*. Below: Amato directs a singer on stage. Amato prepares his own lunch daily at the theater. Facing page, top: The cast are costumed for the opera. Amato watches a baseball game under the stage, minutes before the opening-night performance. Below: Amato conducts the tiny orchestra. A singer rehearses for *The Barber of Seville*.

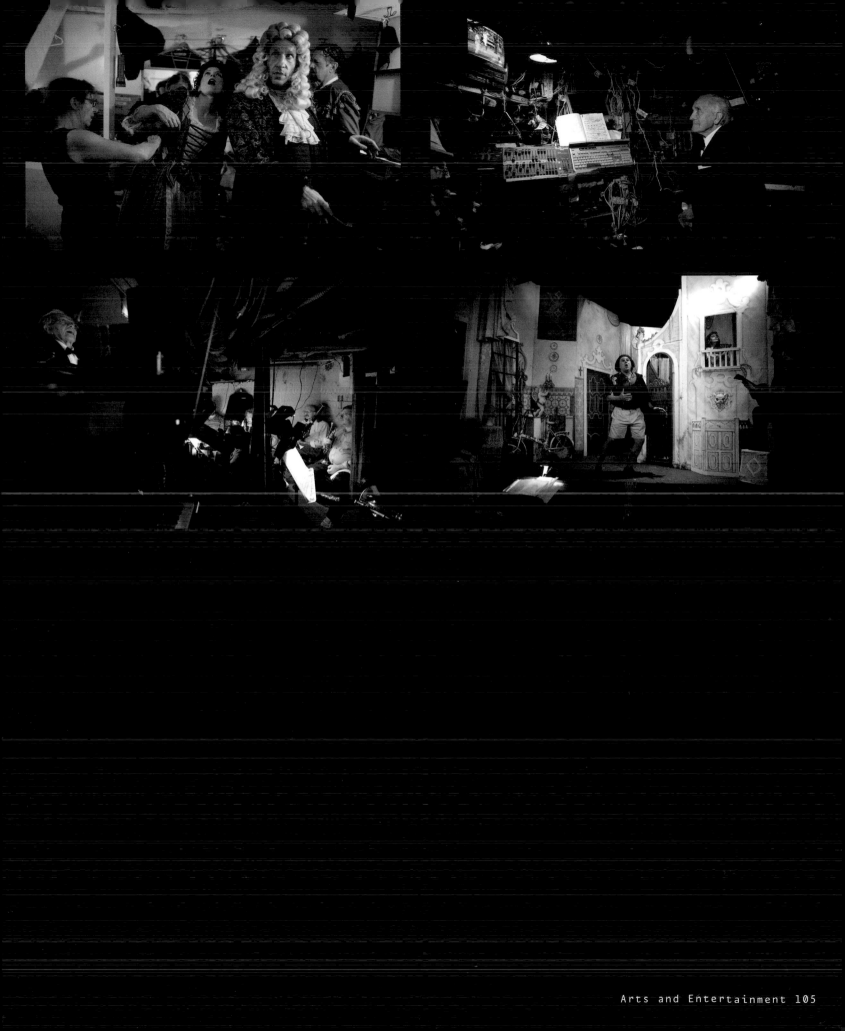

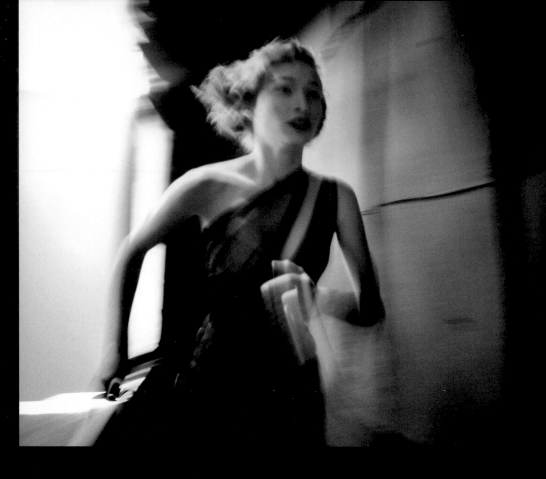

A model hurries backstage during the show of New Delhi design house Gauri & Nainika, at the India Fashion Week, in Delhi, in October.

Anaïs (12) is a young dancer at the Paris Opera Ballet School. Founded during the reign of Louis XIV, the *École de danse* of the Paris Opera is the oldest ballet school in the Western world.

Portraits

SINGLES
1st Prize
Yuri Kozyrev
2nd Prize
Jérôme Bonnet
3rd Prize
Sung Nam-Hun
STORIES
1st Prize
Carlo Gianferro
2nd Prize
Pep Bonet
3rd Prize
Li Jiejun

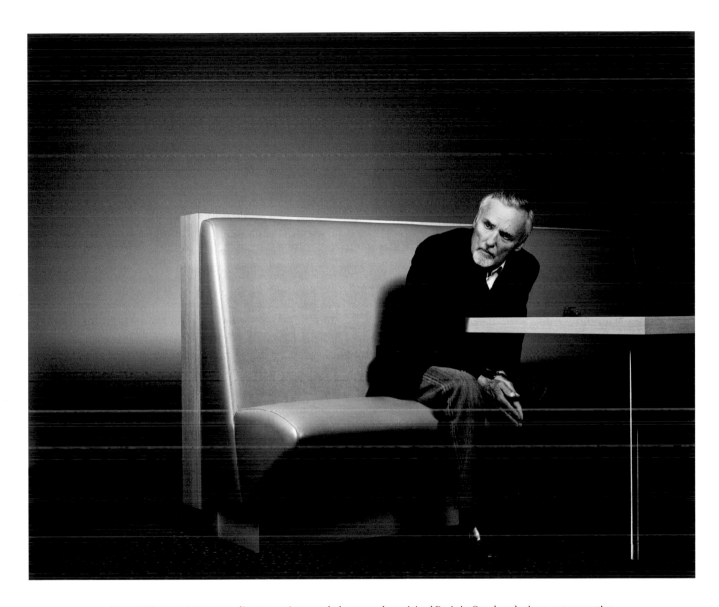

Dennis Hopper (72), actor, director, painter and photographer, visited Paris in October during a retrospective of his work held at the *Cinémathèque française*. The retrospective included not only films he had directed and acted in, but also an exhibition of his paintings and photographs. During the visit Hopper was made a commander in France's National Order of Arts and Letters.

The homes of affluent Roma in Romania and Moldova are a visible demonstration of material wealth as well as family prestige and power. Above: Porcelain is on display in the kitchen, as women prefer to cook outdoors in communal cauldrons alongside friends and neighbors. Facing page: Real dogs are kept outside. Only a stuffed imitation is allowed in the pristine salon. (continues)

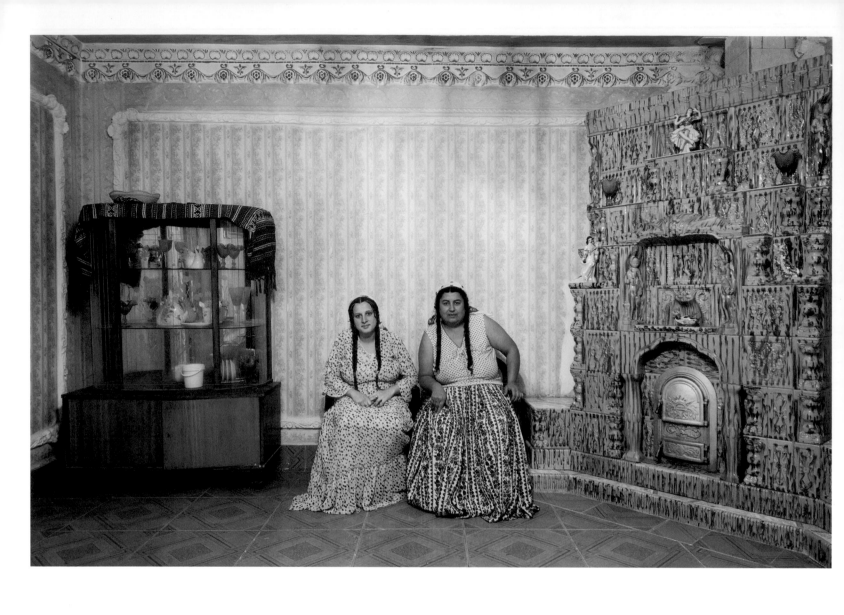

(continued) Well-to-do Roma parents start to build and decorate homes and apartments for their offspring long in advance of anticipated marriages. Facing page: A mother and daughter sit beside a massive tiled heating stove.

Rajiha Jihad Jassim (37) stands with her son Sarhan, in Baghdad, Iraq. Her husband, Gazie Swadi Tofan, was kidnapped in November 2006 and is still missing. For months she visited the city morgue to join the crowd that daily watches the images of unidentified corpses screened on five video monitors, in case she could recognize her husband among the dead. With five children and no family income, she can no longer pay the bus fare so does not visit the morgue any more, but still hopes for Tofan's return.

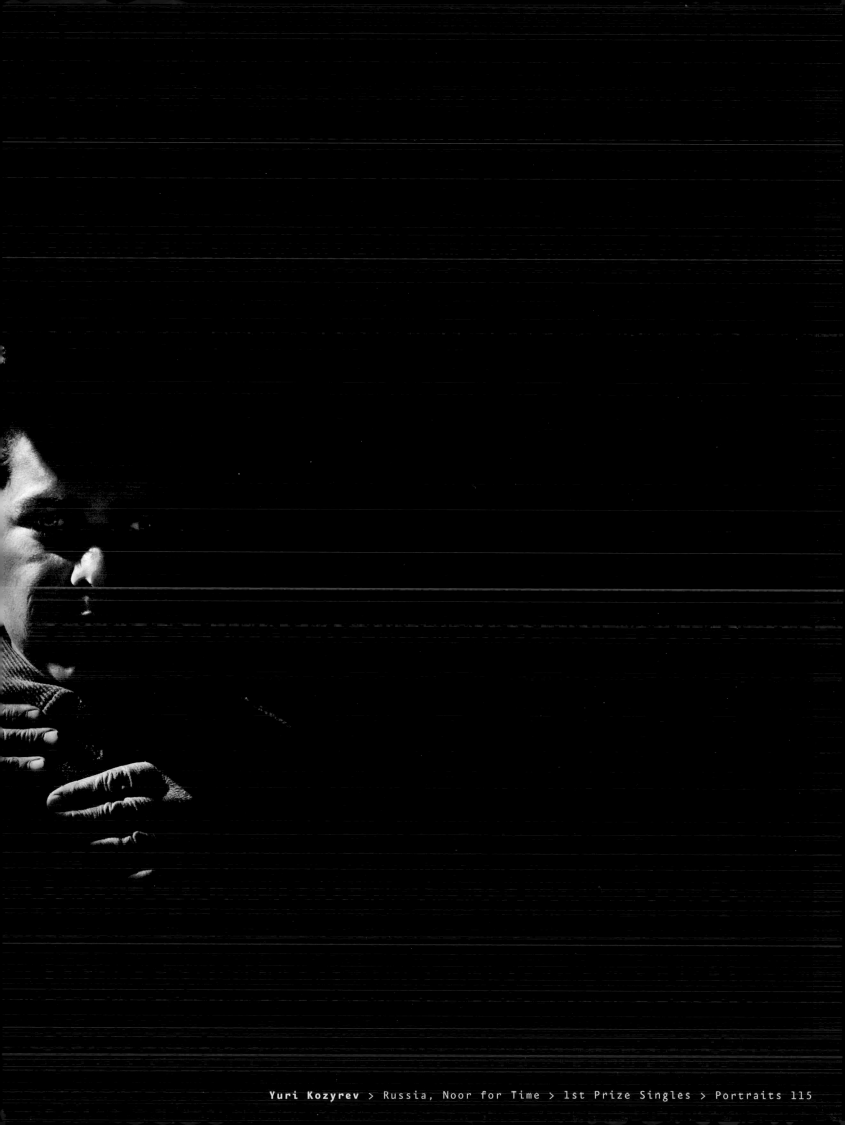

Transsexual sex workers in San Pedro Sula, Honduras. San Pedro Sula is the second largest city in Honduras and has one of the highest prevalences of HIV in the country. Sex workers are particularly vulnerable to infection. Conservative family and religious values mean that gays and transsexuals are often victims of rejection and violence. This page, top and bottom: 'Escarlet Rubi' is twelve years old and was raped at the age of five. He has been working the streets since he was nine, after he was kicked out of the family home for being gay. This page center and facing page: Raul Coto is an occasional sex worker, using the name Gladis, and knows he is HIV positive.

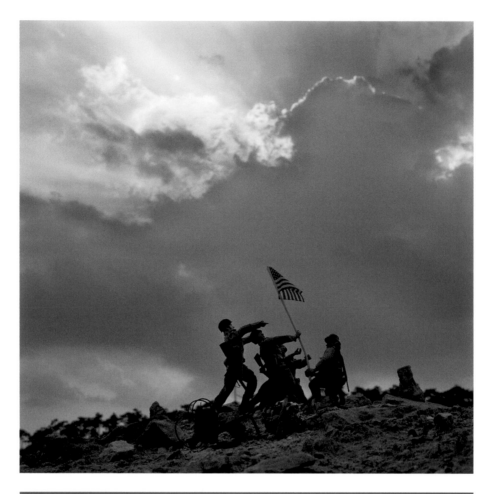

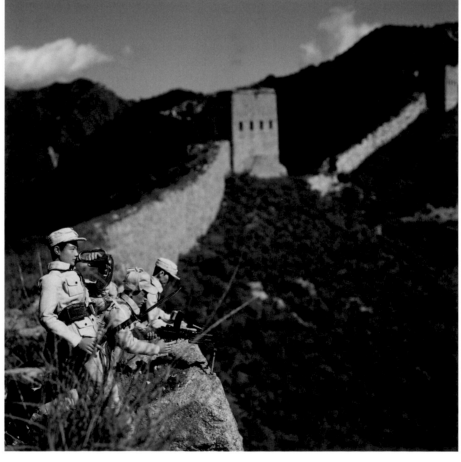

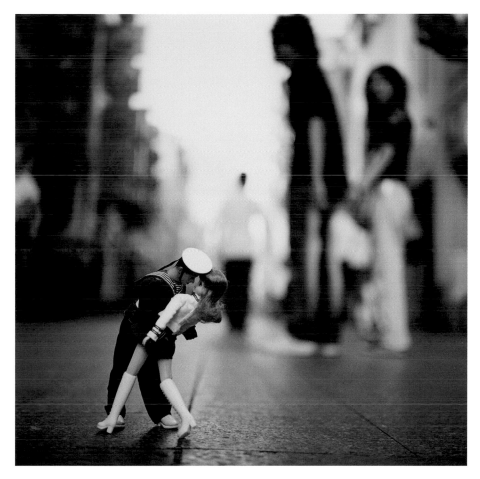

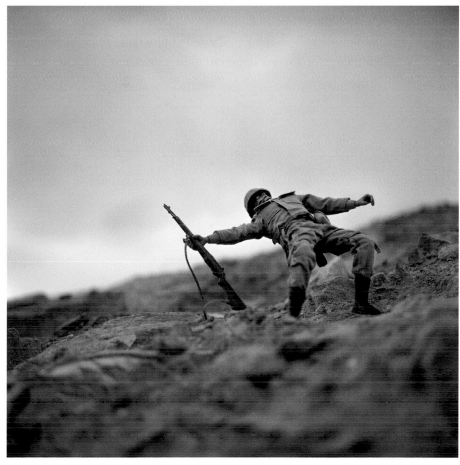

Well-known war photos revisited, staged with action figures. Facing page, top: Joe Rosenthal's 'Raising the Flag on Iwo Jima', originally taken in 1945. Below: Sha Fei's 'The Eighth Route Army Fighting at Futuyu, the Great Wall in Hebei (spring)', originally photographed in 1938. This page, top: Alfred Eisenstaedt's 'V-J day in Times Square', historically shot on August 14, 1945. Below: 'The Falling Soldier', based on a Robert Capa original taken in 1936 during the Spanish Civil War.

A novice nun of an esoteric sect of Tibetan Buddhism, in an isolated monastery high in the Himalayas.

Sports Features

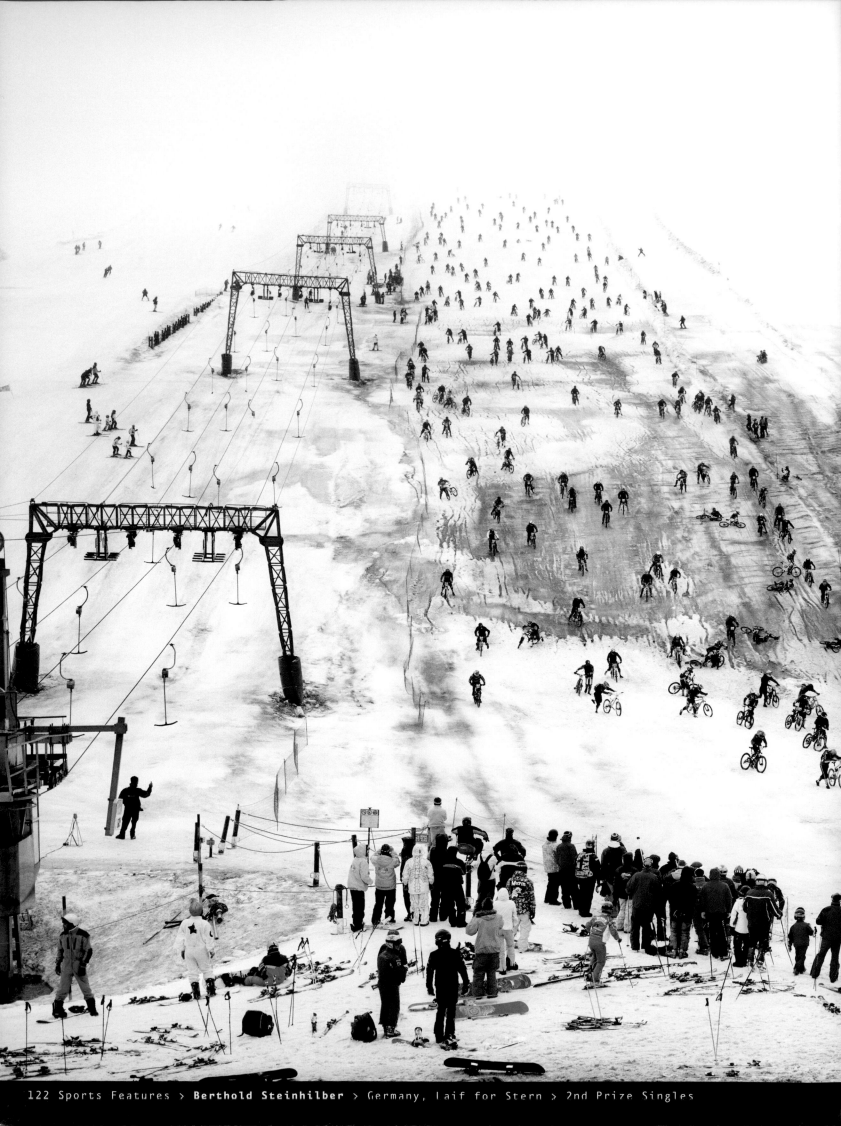

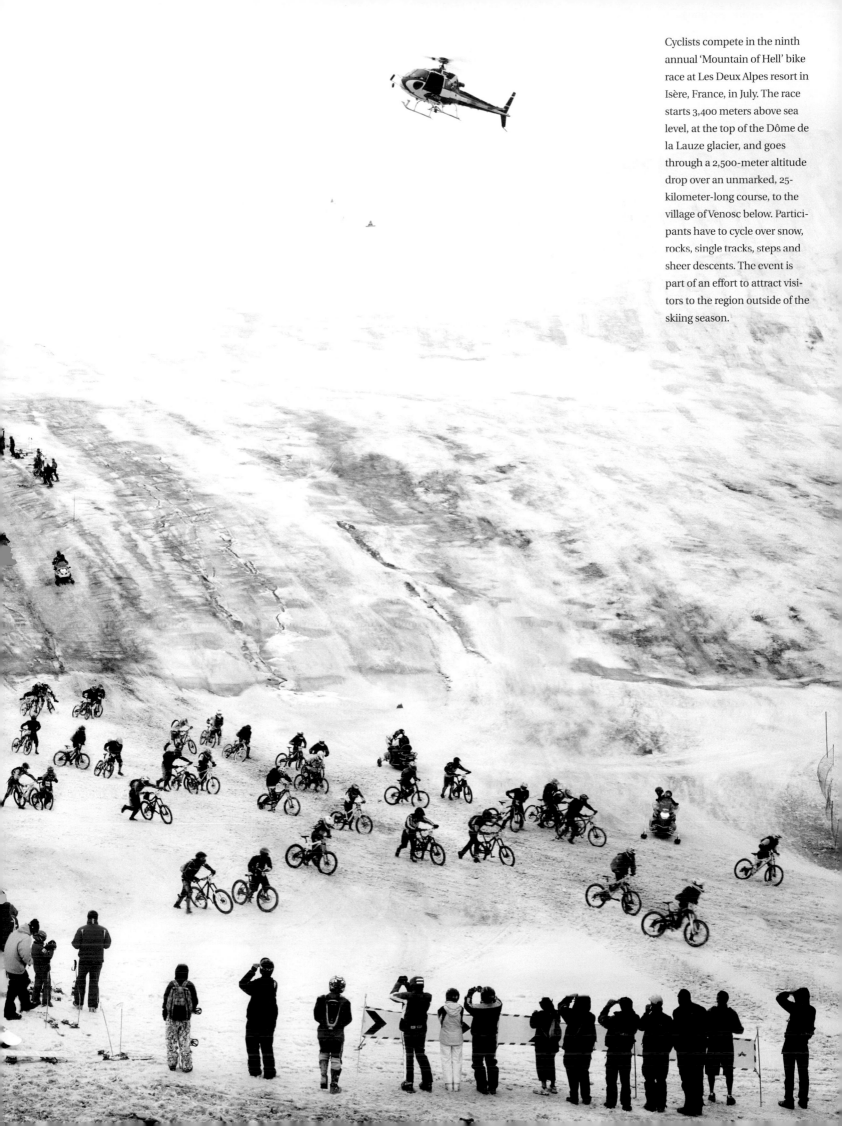

Cyclists compete in the ninth annual 'Mountain of Hell' bike race at Les Deux Alpes resort in Isère, France, in July. The race starts 3,400 meters above sea level, at the top of the Dôme de la Lauze glacier, and goes through a 2,500-meter altitude drop over an unmarked, 25-kilometer-long course, to the village of Venosc below. Participants have to cycle over snow, rocks, single tracks, steps and sheer descents. The event is part of an effort to attract visitors to the region outside of the skiing season.

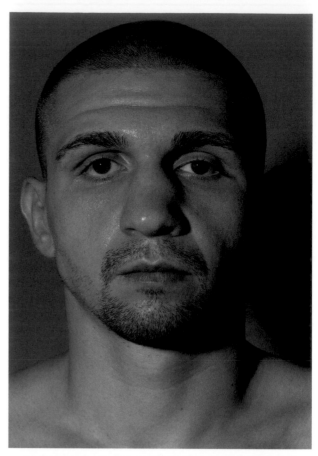

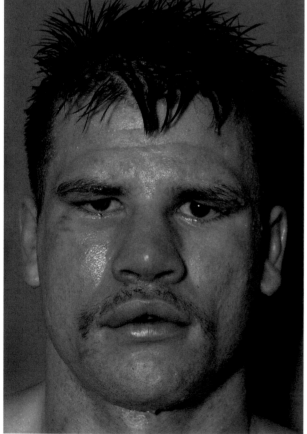

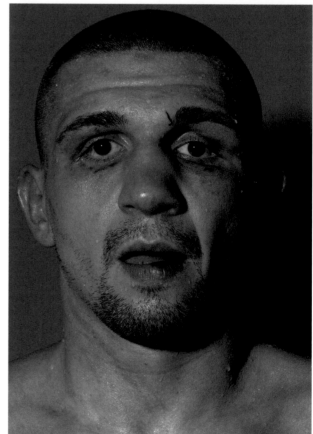

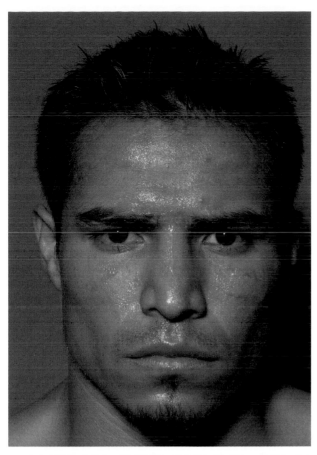
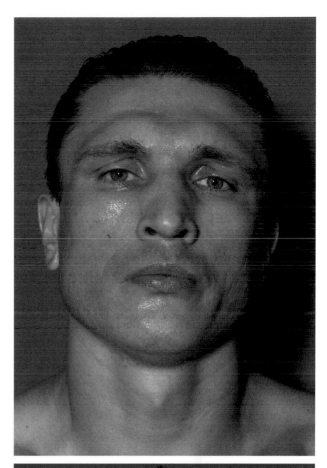
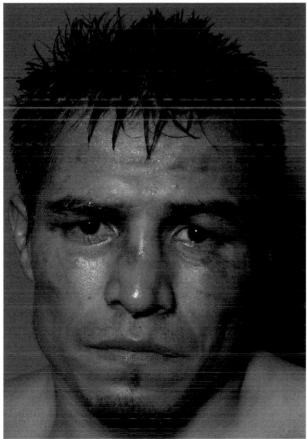
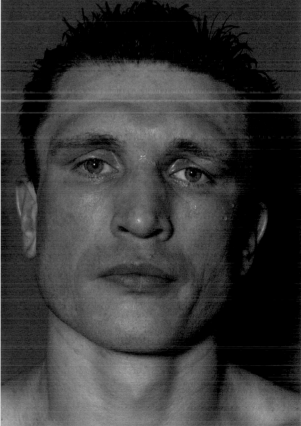

Boxers pictured before and after their fights at venues around New York, USA. From left to right: Jesse Feliciano, welterweight. Pawel Wolak, middleweight. Cecilio Santos, bantam weight. Andrey Tsurkan, light middleweight.

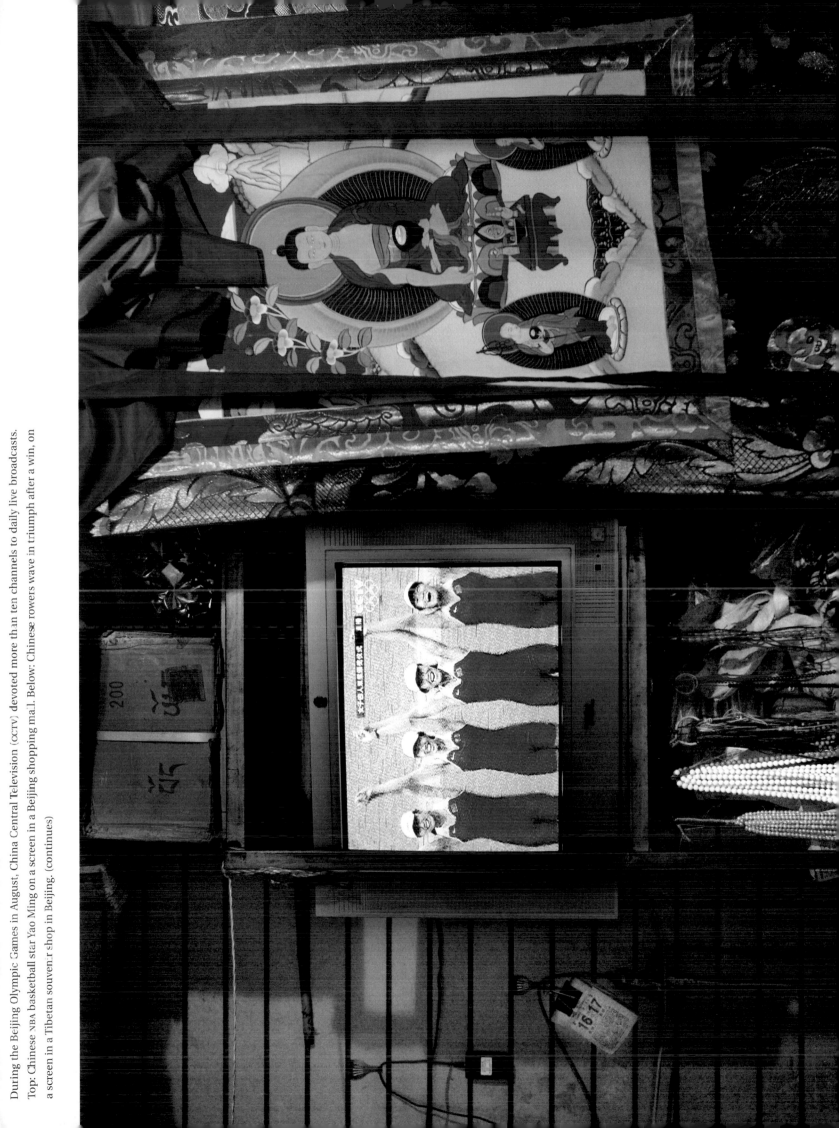

During the Beijing Olympic Games in August, China Central Television (CCTV) devoted more than ten channels to daily live broadcasts. Top: Chinese NBA basketball star Yao Ming on a screen in a Beijing shopping mall. Below: Chinese rowers wave in triumph after a win, on a screen in a Tibetan souvenir shop in Beijing. (continues)

(continued) More than 1.1 billion viewers in China watched television broadcasts of the games. Top: A gymnastics event, on view in a small Beijing barber's shop. (continues)

(continues) Transmission of the Chinese flag during an award ceremony, in an alleyway grocery store.

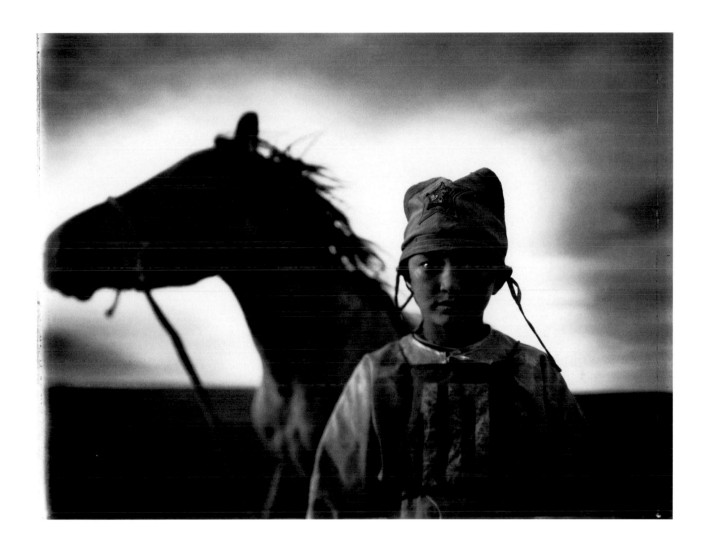

A young jockey stands beside a horse during the Naadam festival in Mongolia, in July. The festival, which traces its roots back to the days of Genghis Khan in the 12th century, involves the country's most popular sports: horse racing, archery and wrestling. Up to 1,000 horses are chosen to compete in various races over open grasslands. Children are preferred as jockeys because of their light weight. It is also believed that child jockeys guarantee that a race tests the horse's skill and not the rider's. The five winning horses are revered in poetry and music. The top jockey is honored with the title *tumny ekh* or leader of ten thousand.

Tomasz Gudzowaty > Poland, Yours Gallery/Focus Photo und Presse Agentur
> 3rd Prize Singles > Sports Features 131

Michel Platini, the president of UEFA, European football's governing body, pays an official visit to Russia and the European Council in Strasbourg. The former French player oversees an annual budget of over € 820 million. Left to right, from top left: Platini leaves the Piskarevskoe Cemetery in St Petersburg after a ceremony commemorating the city's liberation during the Second World War. The UEFA president stands alongside Vitaly Mutko, president of the Russian football association, at the Piskarevskoe war memorial. Officials enjoy a dinner during half-time at the final of the Commonwealth of Independent States and Baltic States Cup. Platini listens to a speaker at the European Council in Strasbourg. The UEFA president signs a visitors' book at the Piskarevskoe war memorial. Platini watches the CIS and Baltic States Cup final. An official dinner in St Petersburg. The visiting delegation walks through the Piskarevskoe Cemetery in St Petersburg.

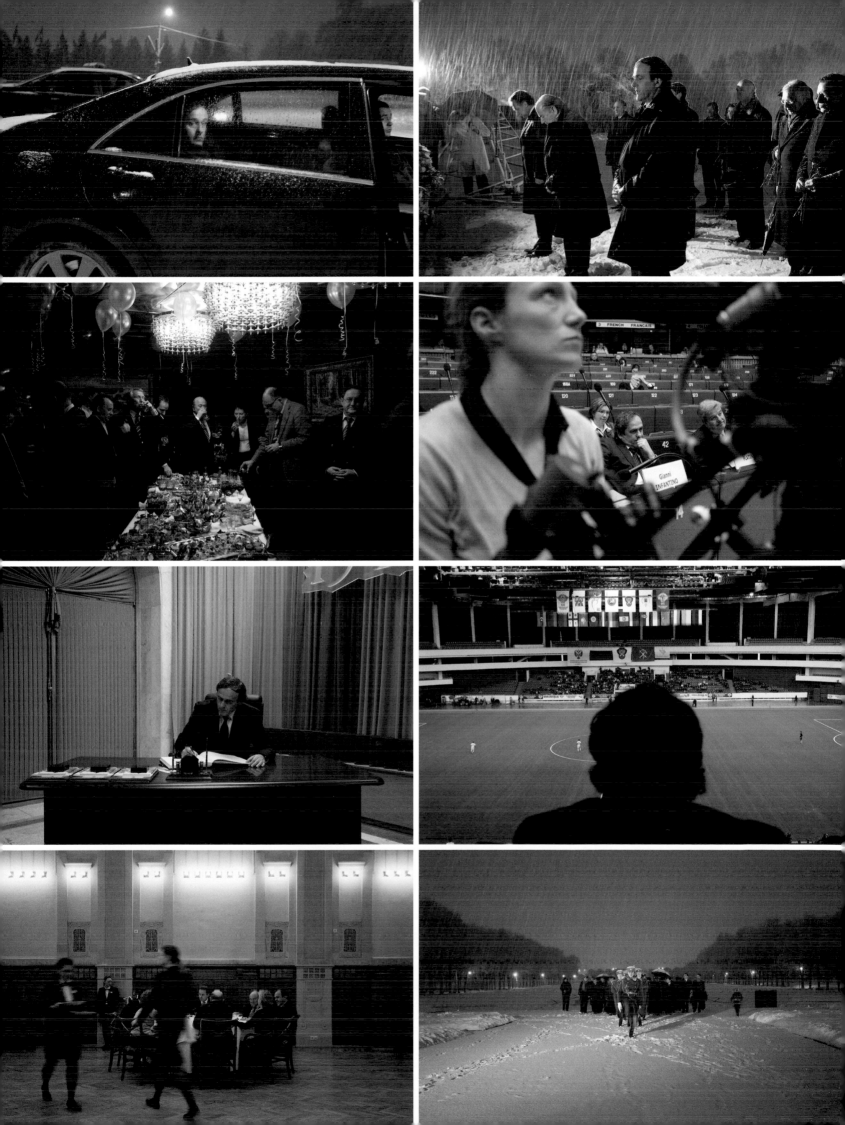

Sports Action

SINGLES
1st Prize
Paul Mohan
2nd Prize
Mark Dadswell
3rd Prize
Franck Robichon
STORIES
1st Prize
Vincent Laforet
2nd Prize
Alexander Taran
3rd Prize
Julian Abram Wainwright

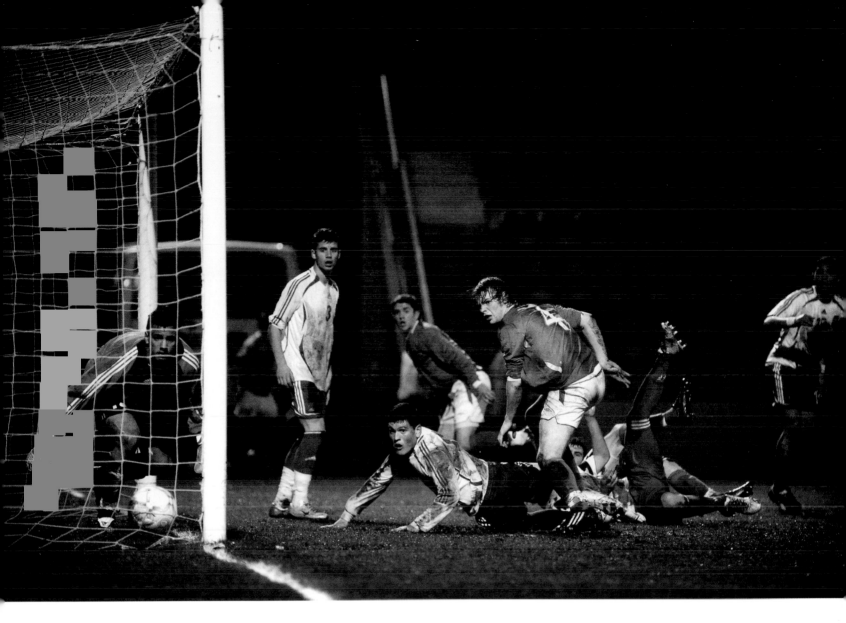

Greek goalkeeper Spyridon Papathanasiou makes a dive for the ball as Gavin Gunning scores Ireland's first goal in a qualifier for finals of the UEFA men's under-17 football championship, at the Lissywollen Stadium in Athlone, County Westmeath, Ireland. Greece eventually won the match 2-1.

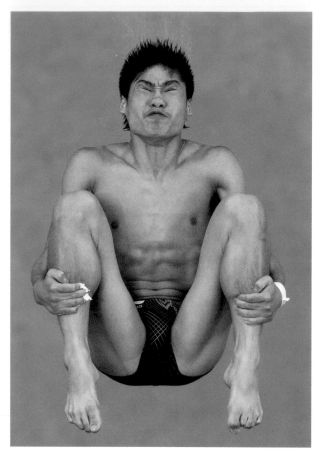

Huo Liang (China)

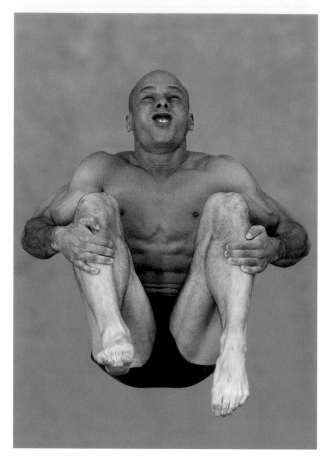

Peter Waterfield (UK)

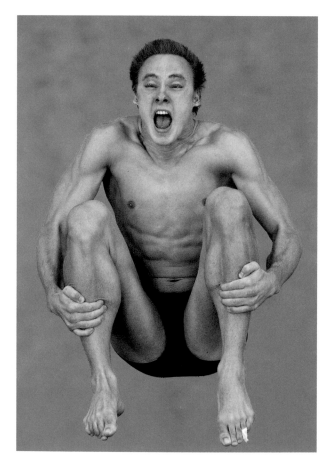

Ross Reuben (Canada)

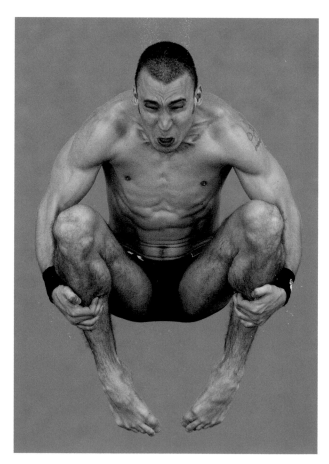

Gleb Galperin (Russia)

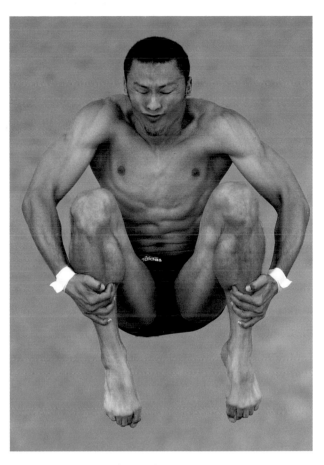

Jose Antonio Guerra Oliva (Cuba)

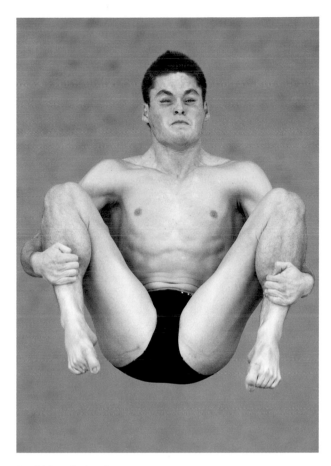

David Boudia (USA)

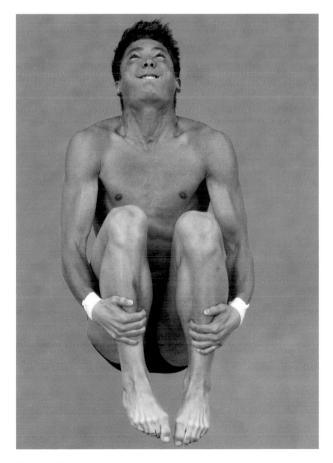

Thomas Finchum (USA)

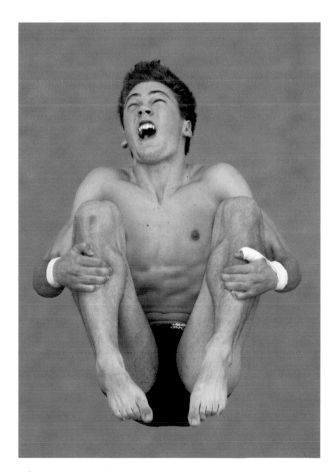

Riley McCormick (Canada)

Competitors in the men's semifinal of the 10-meter platform diving competition, at the Beijing Olympic Games in August.

Alex Copello of Cuba competes during a qualification round for the men's triple jump, at the Beijing Olympics on August 18. Copello missed qualifying for the final by just two centimeters.

Sambo, a Russian acronym that stands for self-defense without weapons, is a martial art that combines striking, throws and submissions, using both hands and feet. It has a reputation for its crushing leg submissions. Sambo was developed in the Soviet Union in the 1920s and 1930s as a combination of judo and regional ethnic wrestling styles, but in the past few years has gained an international following, particularly in the United States. Above: Katsiaryna Prakapenka (Bulgaria) pins down an opponent using a leg submission. Facing page: Sébastien Libebe (France) participates in the St Petersburg world championship.

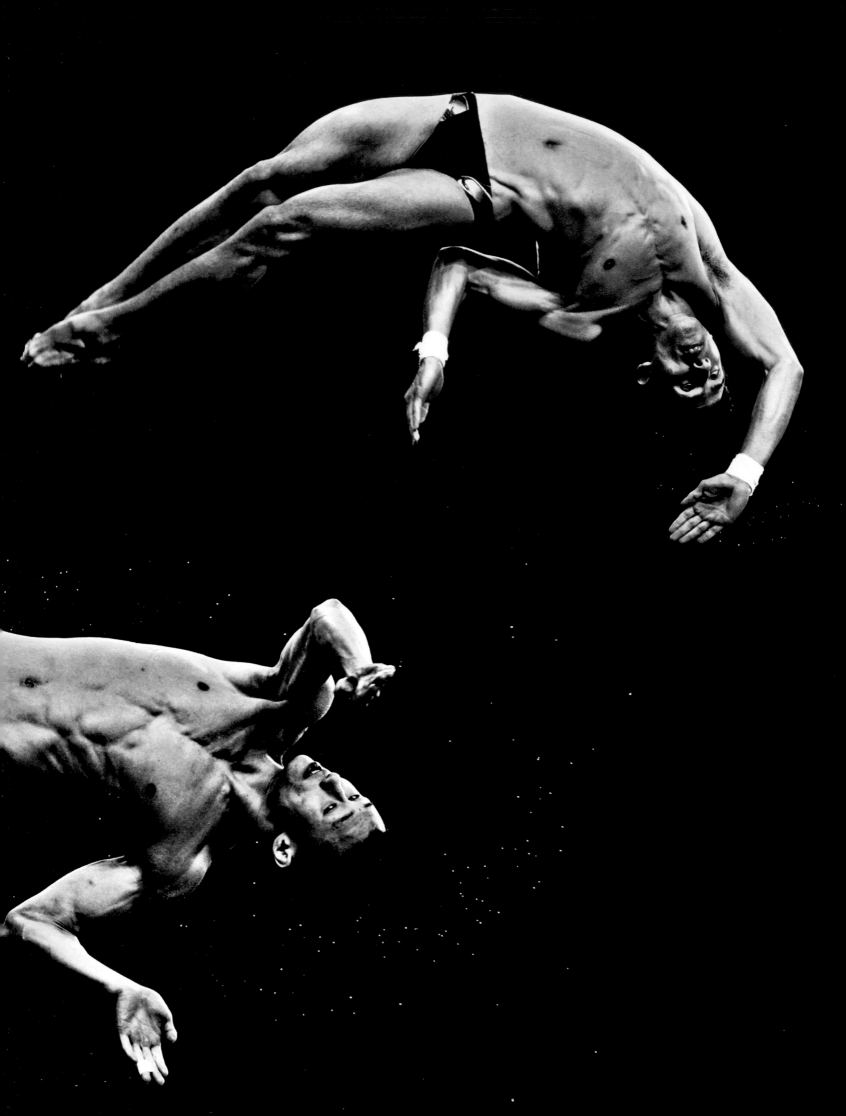

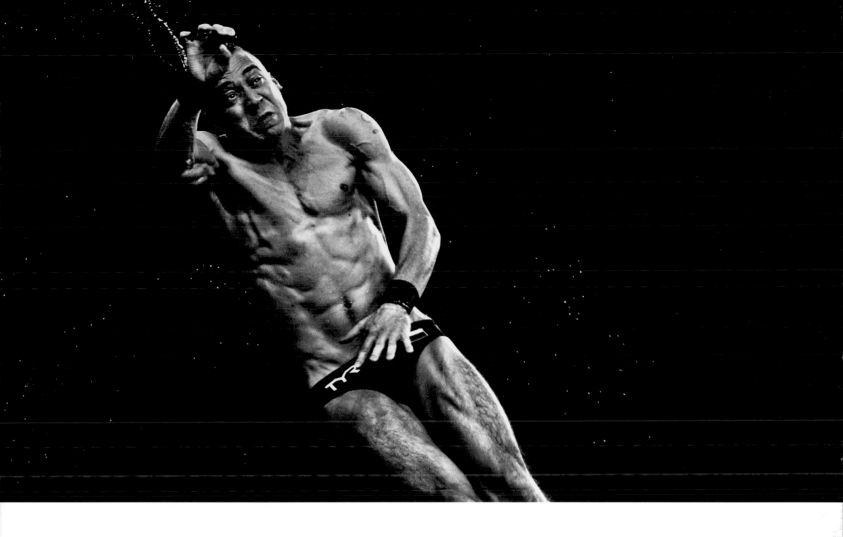

Participants in the men's 10-meter platform diving competition, at the Beijing Olympic Games in August. The event was won by Australian Matthew Mitcham, giving Australia its first diving gold medal since 1924 and preventing China from sweeping all eight diving golds. Facing page, top: Rommel Pacheco (Mexico), in the semifinal. Below: Zhou Luxin (China), in the final. This page: Gleb Galperin (Russia), in the final.

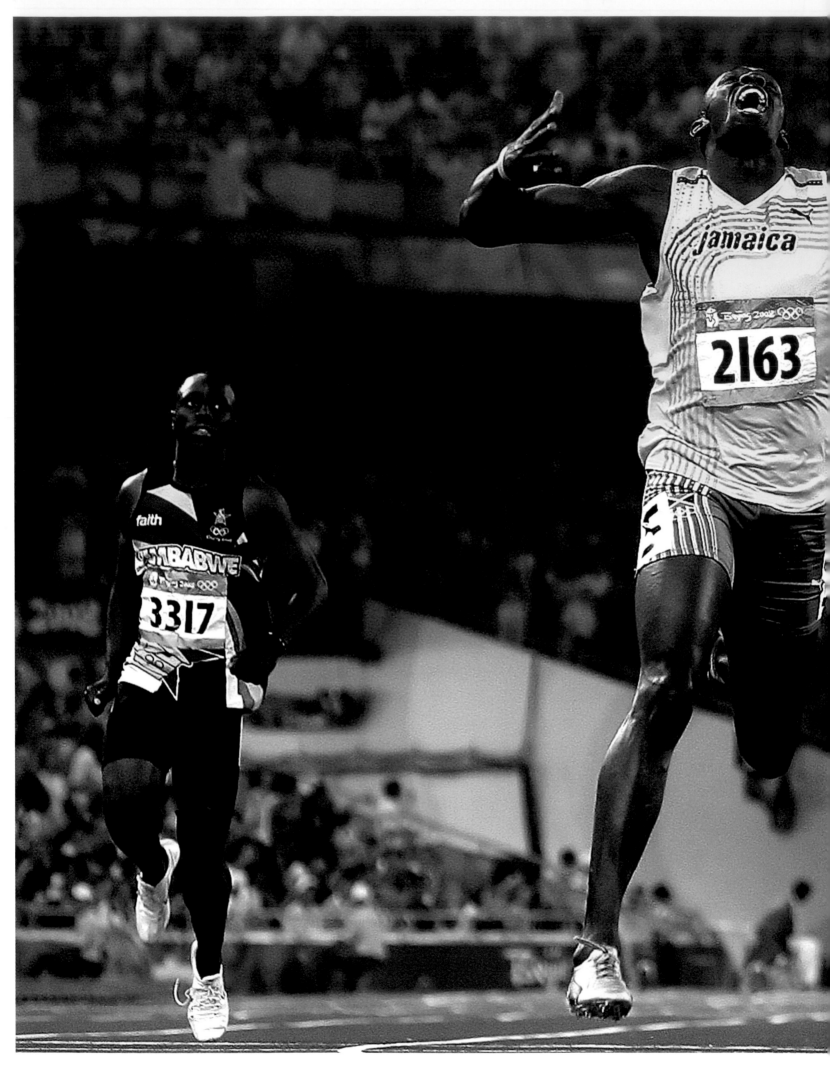

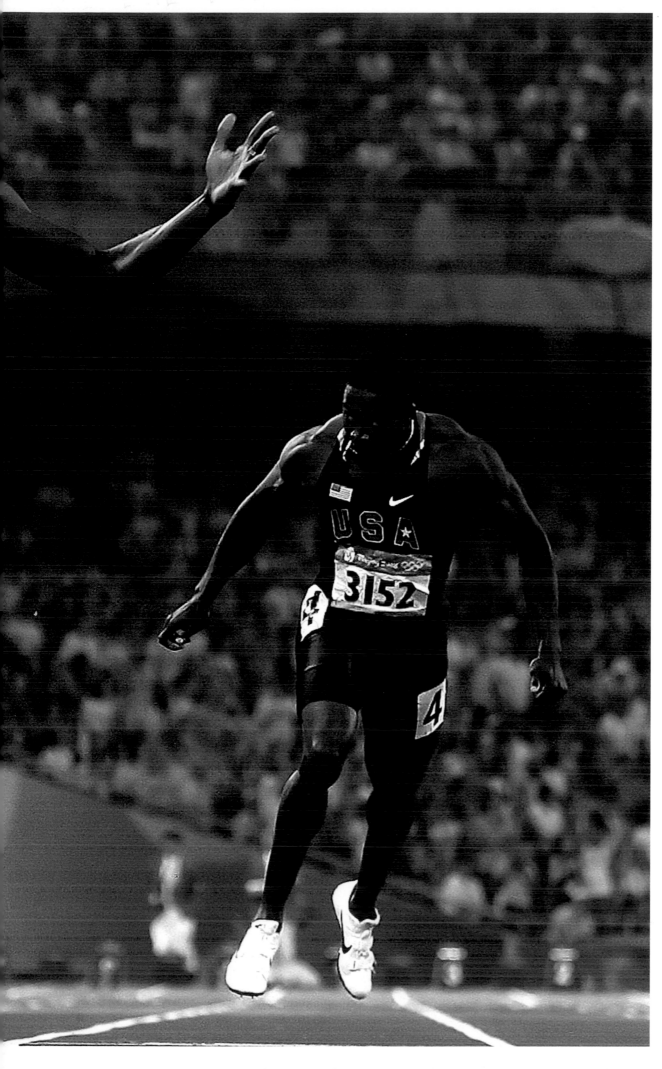

Usain Bolt of Jamaica wins the men's 200 meters sprint at the Beijing Olympic Games on August 20, with a world-record time of 19.3 seconds. Bolt also broke world records in the 100 meters and, along with his teammates, in the 4 x 100 meters relay, becoming the first man in history to set all three records at a single Olympics.

Participants 2009 Contest

In 2009, 5,508 photographers from 124 countries submitted 96,268 entries. The participants are listed here according to nationality as stated on the contest entry form. In unclear cases the photographers are listed under the country of postal address.

Afghanistan
Barat Ali Batoor
Imal Hashimi
Riza Yemak
Marai Shah
Hosseini Massoud
Musadeq Sadeq
Basir Seerat
Fardin Waezi

Albania
Arben Bici
Edvin Celo
Nuri Cumani
Bevis Fusha
Petrit Kotepano
Keti
Elidon Veshaj
Niko Xhufka

Angola
Lino Guimaraes

Argentina
Marcelo F. Aballay
Enrique Manuel Abbate
Rodrigo Abd
Martin Acosta
Humberto Lucas Alascio
Manuel Arce
Walter Astrada
Leo Aversa
Diego Azubel
Yonah Baby
Carlos Barria
Verónica Bellomo
Mauricio Bustamante
Pablo Cabado
Daniel Caceres
Marcelo Caceres
Carolina Camps
Marcos Carrizo
Daniel Cima
Viviana Coman
Pablo Cuarterolo
Daniel Dapari
David Fernandez
Nestor García
Marcelo Genlote
Marcos Guillermo Gómez
Pablo Gómez
Ileana AG Gavinoser
Jeremias Gonzalez
Renzo Gostoli
Néstor Grassi
Leonardo Di Gregorio
Juan Hein
Axel Indik
Gustavo Jononovich
Silvina von Lapcevic
Emiliano Lasalvia
Diego Levy
Romina Llomovatte
Eduardo Víctor Longoni
Maximiliano Luna
Alfredo Martinez
Blas Martinez
Ali Burafi
Lucia Merle
Luis Micou
Emiliana Miguelez
Leo Mirvois
Celina Mutti Lovera
Emilse Neme
Nadia Noguera
Juan Obregon
Ernesto Oehler
Fernando de la Orden
Atilio Orellana
Hernan Gustavo Ortiz
Ariel Pacheco

Gabriel Pecot
Javier Orlando Pelichotti
Rodolfo Pezzoni Carbo
Natacha Pisarenko
Mario Quiroga
Angel Ricardo Ramírez
Paula Ribas
Héctor Rio
Patricio Ivan Rivera
José Romero
Miru Trigo
Jorge Saenz
Sebastián Salguero
Silvina Salinas
Mariela Sancari Lepka
Juan Sandoval
Ricardo J Santellan de Leon
Daniel Sempé
Jose Enrique Sternberg
Nicolás Stulberg
Leon Szajman
Juano Tesone
Feliciano Tisera
Mario Travaini
Juan José Traverso
Tony Valdez
Maximiliano Vernazza
Horacio Villalobos
Hernan Zenteno

Armenia
Nazik Armenakyan
German Avagyan
Eric Grigorian
Anahit Hayrapetyan
Ruben Mangasaryan
Karen "Emka" Mirzoyan
Hasmik Smbatyan
Stepanyan

Australia
Nicolas Axelrod
Ben Baker
Kelly Barnes
Janie Barrett
Daniel Berehulak
Rowan Bestmann
Pip Blackwood
Philip Blenkinsop
Marty Blumen
Penny Bradfield
James Brickwood
Philip Brown
Mark Calleja
Glenn Campbell
David Cartier
Brian Cassey
Steve Christo
Robert Cianflone
Warren Clarke
Lisa Clarke
Tim Clayton
Brett Costello
Murray Cox
Nick Cubbin
Megan Cullen
Marisol Da Silva
Mark Dadswell
David Darcy
Sean Davey
Howard Davies
John Donegan
Kristian J. Dowling
Andy Drewitt
Stephen Dupont
Brenton Edwards
Mark Evans
Jenny Evans
Adam Ferguson
Andrea Francolini
Alex Frayne
Tim Georgeson
Kate Geraghty
Ashley Gilbertson
Kirk Gilmour
Craig Golding
David Gray
Robert Gray
Toni Greaves
Craig Greenhill
Natalie Grono
Sahlan Hayes
Phil Hillyard

Ian Hitchcock
Lisa Hogben
Adam Hourigan
Bradley Hunter
Anthony Johnson
Quentin Jones
David L. Kelly
Ken Ming Ng
Adam Knott
Nick Laham
Sylvia Liber
Bruce Long
Brendan McCarthy
Chris McGrath
Justin McManus
Paul Miller
Frances Mocnik
Palani Mohan
Nick Moir
Sam Mooy
Michele Mossop
Renee Nowytarger
Jason O'Brien
Warrick Page
Trent Parke
Martine Perret
Sam Phelps
Ryan Pierse
Adam Pretty
Andrew Quilty
Mark Ralston
Jason Reed
Quinn Rooney
Moshe Rosenzveig
Sam Ruttyn
Dean Saffron
Dean Sewell
Russell Shakespeare
Ezra Shaw
Doug Sherring
Steven William Siewert
Ellen Smith
Troy Snook
Marko Sommer
Cameron J Spencer
Hank van Stuivenberg
Dave Tacon
Tasso Taraboulsi
Adam Taylor
Hadley Toweel
Mick Tsikas
Astrid Volzke
Tamara Voninski
Bohdan Warchomij
Nicholas Welsh
Clifford White
Lisa Maree Williams
Annette Willis
Craig Wilson
Gregory Wood
Sasha Woolley
Krystle Wright
Megan Young
Andy Zakeli

Austria
Heimo Aga
Michael Appelt
Matthias Hauer
Philipp Horak
Kurt Hoerbst
René Huemer
Karl Joch
Christopher Klettermayer
Lois Lammerhuber
Udo Mittelberger
Joerg Mitter
Arnold Morascher
Josef Polleross
Werner Puntigam
J. Schedler
Eva Schimmer
Bernhard Stadlbauer
Rene M. Stocker
Aram Voves
Holger R. Weimann

Azerbaijan
Majid Aliyev
Agdes Baghirzade
Rena Effendi
Rafiq Gambarov
Irada Humbatova

Ilgar Jafarov
Ismayil Kerim
Emil Khalilov

Bahrain
Hamad Mohammed

Bangladesh
Abir Abdullah
Maruf Hasan
Tanvir Ahmed
G.M.B. Akash
J.A. Akash
Md. Akhlas Uddin
Monirul Alam
M. Yousuf Tushar
Amin
Syed Ariful Islam
K. M. Asad
Abdul Malek Babul
Wahid Adnan
Saikat Ranjan
Andrew Biraj
Rabi Sankar
M.N.I. Chowdhury
Emdadul Islam Bitu
Shoeb Faruquee
Saydul Fateheen
Al Emrun Garjon
Khaled Hasan
Mohammad Rakibul Hasan
Abu Ala Russel
Farzana Hossen
Amdadul Huq
M.K. Islam
Nazrul Islam
Momena Jalil
Enayet
Khamin
Dilruba Khanam
Tanvir Murad Topu
Abu Taher Khokon
Saiful Huq Omi
Masud Alam Liton
Kazi Azad Mohammad
Munem Wasif
Noor Alam
Md. Rashed Kibria Palash
Sultana Parvin
Kakoli Prodhan
Md. Zillur Rahman Khan
Masud Rana
Probal Rashid Sabuj
Srabon Reza
Bapy Roy
Jashim Salam
Jewel Samad
Khaled Sattar
Taufique Sayeed
Shaikh Mohir Uddin
Din M. Shibly
Debasish Shom
Partha Talukdar
A.K.M. Shehab Uddin
Munir uz Zaman
Zobaer Hossain Sikder

Belarus
Vasily Fedosenko
Uladz Hrydzin
Mikhail Leshchanka
Andrei Liankevich
Eugene Reshetov
Alexander Sayenko
Alexander Vasukovich
Tanja Zenkovich

Belgium
Malek Azoug
Nicolas Bouvy
Kaat Celis
Michael Chia
Jean-Michel Clajot
Gert Cools
Frederic Courbet
Guido Van Damme
Marleen Daniels
Stijn Decorte
Frank Dejongh
Delfosse
Fabrice Demoulin
Tim Dirven
Karl Donvil

Sarah van den Elsken
Thierry Falise
Thomas Freteur
Cédric Gerbehaye
Brigitte Grignet
Gregory Heirman
Tomas van Houtryve
Nicol' Andrea
Roger Job
Gert Jochems
Eddy Kellens
Wim Kempenaers
Jimmy Kets
Frédéric Lecloux
Jan Locus
De Maitre
Wendy Marijnissen
Olivier Matthys
Virginia Mayo
Bart van der Moeren
Mashid Mohadjerin
Didier Mossiat
Christian Overdeput
Isabelle Pateer
Dario Pignatelli
Evy Raes
Joost De Raeymaeker
RRonny Smedts
Alice Smeets
Sébastien Smets
Sigrid Spinnox
Bruno Stevens
Marc de Tollenaere
Gaël Turine
Wouter van Vaerenbergh
Bruno Vandermeulen
Davy Vanham
Alex Vanhee
Philip Vanoutrive
Danny Veys
John Vink
Peter de Voecht
Warnand Julien

Bolivia
Miguel Carrasco
Gonzalo Contreras
Patricio Crooker
Mónica Oblitas

Bosnia-Herzegovina
Jasmin Brutus
Hare
Ziyah Gafic
Amer Kuhinja
Damir Sagolj

Brazil
Raphael Alves
Patrícia Santos
Paulo Amorim
Áthila Bertoncini
Rafael Andrade
Juliana Leitão
Keiny Andrade
Andre Arruda
Eduardo Anizelli
Filipe Araujo
Alberto César Araújo
Arnaldo Carvalho
Guilherme Baffi
Juan Barbosa
Nário Barbosa
Paulo Batalha
Alexandre Belém
Mônica Bento
Marlene Bergamo
Jamil Bittar
Gabriel Boieras
Mario Bourges
Marina Brandão
Ivana Cabral
Alexandre Cappi
Claudio Capucho
Rubens Cardia
Marcelo Carnaval
Weimer Carvalho
Fernando Rafael Cavalcanti
Rubens Cavallari
Antonio Cazzali
Célio Messias
Tina Coêlho
André Coelho

Sergio Quissak
Coimbra Custódio
Luiz Santos
Jose Luis da Conceição
João Correia Filho
Beto Barata
Antonio Costa
Marcos Michael
Fábio D'Castro
Cristiano Borges
Orlando Filho
Luiz Maximiano
Fernando Dantas
Rodrigo Capote
José Francisco Diorio
Edvaldo Santos
Fernando Donasci
Rafael Guadeluppe
Choque
Marcos Fernandez
Gleilson Miranda
Alcione Ferreira
Pio Figueiroa
André François
Ricardo Teles
Nilton Fukuda
Christina Rufatto
Pisco del Gaiso
Dado Galdieri
João Mário Goes
Apu Gomes
Cristiano Estrela
Jonne Roriz
Valéria Gonçalvez
Luiz Vasconcelos
Jair Grandin
Érico Hiller
Iano Andrade
Rafael Jacinto
Joyce Cury
João Kehl
Daniel Kfouri
Antonio Lacerda
Antonio Ledes
Claus Lehmann
Marcelo Leite de Oliveira
Paulo Liebert
Mauricio Lima
Rodrigo Lôbo
Moacyr Lopes Junior
Davi Ribeiro
Cezar Magalhaes
Gustavo Magnusson
Bruno Magalhaes
Kardec Epifânio
Lula Marques
Guga Matos
Leonardo Melgarejo
Ney Mendes
Antonio Menezes
Márcio Mercante
E. Monteiro de Carvalho
Nana Moraes
Sebastião Moreira
Letícia Moreira
Fabio Motta Lins
Marcelo Ferrelli
Marta Nascimento
Malabi
Michael Patrick O'Neill
Sergio Ricardo de Oliveira
Carlos Oliveira
Isabela Pacini
Diego Padgurschi
Joao Padua
Paulo Pampolin
Marcos D'Paula
Hamilton Pavam
Andre Penner
Clóvis Pereira
Eraldo Peres
Marcos Piffer
Fernando Pilatos
Paulo Pinto
Claudinei Plaza
André Porto
Chico Porto
Eduardo Queiroga
Tiago Queiroz Luciano
Thiago Leon
Marcos Ramos
Sergio Ranalli
Marcelo Regua

Mastrangelo Reino
Claudio Reis
Marilene Ribeiro
Brigida Rodrigues
Ernesto Rodrigues
Evelson de Freitas
Célio Jr.
Ricardo Saibun
Juliano Gouveia
Rodrigo Albert
Anderson Schneider
Jean Schwarz
Marcos Semola
José Patricio da Silva
Olga Leiria
Ricardo Rafael
Ferdinando Ramos
Andre Silva
Jean Lopes
Patricia Stavis
Rogério Stella
Leandro Taques
Andrea Testoni
Thiago Piccoli
Felipe Vaiano
Cynthia Vanzella
José Varella
Djalma Vassao
Robson Ventura
Joao Vergueiro
Danilo Verpa
F. Vicentini Lanes de Souza
Luciano Vicioni
Cláudio Vieira
Tuca Vieira
André Vieira
Tadeu Vilani
Talita Virgínia
Ricardo Yamamoto
Marcos Zanutto
Mônica Zarattini
Adriana Zehbrauskas

Bulgaria
Iosif Astrukov
Mehmed Aziz
Svetlana Bahchevanova
Ladislav Cvetkov
Dimitar Dilkoff
Dimitar Dobrev
Nellie Doneva
Vassil Donnev
Nikolay Doychinov
Hristo Dimitrov Hristov
Slavtcho Kalinov
Dimitar Kyosemarliev
Julia Lazarova
Philip Idan
Stoyan Nenov
Valéry Poshtarov
Krasimir
Ivaylo Velev
Yellowman
Boris Voynarovitch

Cameroon
Okumo Angwa
Happi Raphaël Mbiele

Canada
Carlo Allegri
Kiran Ambwani
Christopher Anderson
Tyler Anderson
Benoit Aquin
Berge Arabian
Terry Asma
Olivier Asselin
Anthony Shiu Hung Au
Charles Mathieu Audet
Cheol Joon Baek
Deborah Baic
Jan Becker
Mathieu Belanger
Mike Berube
Norm Betts
Mike Blake
Normand Blouin
Susan Bradnam
Bernard Brault
Joe Bryksa
Kitra Cahana
Marco Campanozzi

Ryan Carter
Sheldon Chad
Noel Chenier
Philip Cheung
Andy Clark
Mark Coatsworth
Nathalie Daoust
Barbara Davidson
Ivanoh Demers
Don Denton
Yannis Dessureault
Mike Drew
Mauve Drouin
Bruce Edwards
Elliot Ferguson
Brent Foster
Kevin Frayer
Ricky Friedlander
Renato Gandia
Benoit Gariépy
Ryan Gauvin
Brian J Gavriloff
Rafal Gerszak
Greg Girard
Wayne Glowacki
Jacques Grenier
Guang Niu
Brett Gundlock
Robert vanWaarden
Olivier Hanigan
John Hasyn
Caroline Hayeur
Simon Hayter
James Helmer
Leah Hennel
Gary Hershorn
Megan Hirons
Ryan Enn Hughes
Michel Huneault
Anne-Marie Jackson
Chul-Ahn Jimmy Jeong
Emiliano Joanes
Guy Labissonnière
Esmond Lee
Rita Leistner
Jean-Francois Lemire
Jean Levac
Nicolas Lévesque
Brent Lewin
Allan Cedillo Lissner
Larry Louie
John Lucas
Fred Lum
Doug MacLellan
Rick Madonik
Jude Mak
Marie-Reine Mattera
Jeff McIntosh
Kari Medig
Kamal
Stephen Morrison
Samer Muscati
Paul Nicklen
Farah Nosh
Gary Nylander
Brennan O'Connor
Finbarr O'Reilly
Lucas Oleniuk
George Omorean
Ed Ou
Charles-F. Ouellet
Kevin van Paassen
Louie Palu
Carl Patzel
Jason Payne
Paul van Peenen
François Pesant
Wendell Phillips
André Pichette
Vincenzo Pietropaolo
Peter Power
Duane Prentice
Patrick Price
Ryan Pyle
Rich Riordan
Alain Roberge
Marc Rochette
Lara Rosenoff
Jim Ross
Derek Ruttan
Dan Shugar
Dave Sidaway
Steve Simon
Guillaume Simoneau
Jack Simpson
Sami Siva

Timothy Smith
Lyle Stafford
Maciej Tomczak
Stephen Uhraney
Andrew Vaughan
Aaron Vincent Elkaim
Christopher Wahl
Julian Abram Wainwright
Andrew Wallace
George Webber
Donald Weber
Ian Willms
Adrian Wyld
Jim Young
Iva Zimova

Chile
Ivan Alvarado
Rodrigo Arangua
Orlando Barría
Marco Fredes
Rodrigo E. Garrido
Rodrigo Gomez Rovira
Carlos F. Gutiérrez
Marcelo Hernandez
Andres Leighton
Ferran Majol
Fernando Morales
Tomás Munita
Waldo Nilo
Jaime Puebla
Hector Retamal Correa
Ian Salas
Claudio Santana
Pedro Ugarte
Jorge Uzon
Carlos Villalon
Nicolas Wormull
Ernesto Zelada

Colombia
Filiberto Pinzon
Luis Acosta
Henry Agudelo
Gabriel Aponte Salcedo
Raul Arboleda
Fernando Ariza Romero
Juan D Arredondo
Kena Betancur
Carlos A Bravo A.
Juan Manuel Barrero Bueno
Felipe Caicedo Chacón
David Campuzano
Juan Fernando Cano
Nelson Cárdenas
Abel E. Cardenas O.
Javier Casella
Felipe Castaño
Edgar Domínguez Cataño
Carlos Duran Araujo Escobart
Christian Escobar Mora
César Flórez
Javier A. Galeano Naranjo
Jose Miguel Gomez
Juan Pablo Gomez
Milton Diaz
Camilo Henao
Andres Hernandez Godoy
Mario Hernandez Jr
Iván Darío Herrera
Julian Lineros
Albeiro Lopera Hoyos
William Fernando Martinez
Andrea Moreno
Mauricio Moreno
Daniel Munoz
Eduardo Munoz
Jaiver Nieto
Jorge E. Orozco Galvis
Federico Orozco
Carlos Ortega
Jaime Pérez
Luis Ramirez
Pedro Alfonso Reina Leon
Federico Rios Escobar
Luis Robayo
Henry Romero
Camilo Rozo
Manuel Saldarriaga
Jaime Saldarriaga
Diana Sanchez
Juan A. Sanchez Ocampo Hansel
Juan Carlos Sierra
Gabriela Sierra

Joana Toro
Guillermo Torres
Hernan Vanegas
Ricardo Vejarano
John W. Vizcaino
Zamora

Costa Rica
Jeffrey Arguedas Benavides
Adrian Arias
Jose Diaz
Marco Monge Rodriguez
Priscilla Mora Flores
Alexander Otarola
Rafael Pacheco Granados
Mónica Quesada C.
Alexander Arias Valverde
Kattia Vargas Araya

Croatia
Tino Juric
Miroslav Kis
Vlado Kos
Igor Kralj
Sandra Krunic
Zeljko Lukunic
Dragan Matic
Igor Sambolec
Sanjin Strukic
Mario Topic

Cuba
Daniel Anaya
Jose Goitia
Cristóbal Herrera
Ulashkevich
Noel Miranda
Randy Rodriguez Pagés
Idael

Cyprus
Nicolas Iordanou
Sarah Malian

Czech Republic
Peter Zurek
Tomas Bican
Michal Bílek
Jaroslav Bocek
Radek Burda
Jan Cága
Michal Cizek
Vladimir David
Jiri Dolezel
Lukas Houdek
Salim Issa
Petr David Josek
Tom Junek
Alzbeta Jungrova
Kaman Juraj
Kaifer Daniel
Lenka Klicperová
Dalibor Konopác
Antonin Kratochvil
Standa Krupar
Vlastimil Kula
Veronika Lukasova
Martin Mraz
Michal Novotny
Jan H. Ponert
Ivan Prokop
Jan Rasch
Jiri Rezac
Slavek Ruta
Robert Sedmik
Filip Singer
Josef Sloup
Jan Sochor
Stepanka Stein
Jirí Urban
Ivan Vetvicka
Jan Zatorsky
Barbora Zurek
Radim Zurek

Denmark
Steven Achiam
Niels Ahlmann
Christian Als
Nicolas Asfouri
Rune Backs
Soren Bidstrup
Jonathan Bjerg Møller
Michael Barrett Boesen
Sisse Brimberg
Jakob Carlsen

Jeppe Carlsen
Klavs Bo Christensen
Emil Ryge Christoffersen
Fredrik Clement
Cotton Coulson
Jan Dago
Casper Dalhoff
Jakob Dall
Miriam K. S. Dalsgaard
Jacob Ehrbahn
Peter Helles Eriksen
Lene Esthave
Jørgen Flemming
Mette Frandsen
Thomas Fredberg
Jan Grarup
Mads Greve
Martin Stampe
Tine Harden
Peter Hauerbach
Maria Tuxen Hedegaard
Lars Helsinghof Bæk
Christian Holst
Simon Birk
Simon Jeppesen
Martin N. Johansen
Jesper Westley
Anna Kari
Henrik Kastenskov
Lars Krabbe
Joachim Ladefoged
Claus Bjørn Larsen
Thomas Lekfeldt
Nikolai Linares Larsen
Bax Lindhardt
Erik Luntang
Poul Madsen
Thomas Madsen
Nils Meilvang
Joachim Adrian
Rikke Milling
Lars Moeller
Morsi
Mads Nissen
Peter Hove Olesen
Thorsten Overgaard
Soren Pagter
Jeannette Pardorf
Ulrik Pedersen
Kim R
Karl Ravn
Erik Refner
Anders Birger Schjoning
Thomas Sjoerup
Betina Skovbro
Carsten Snejbjerg
Jacob Aue Sobol
Johan Spanner
Jorn Stjerneklar
Morten Stricker
Sisse Stroyer
Michael Svenningsen
Klaus Thymann
Jan Unger
Christian Vium
Jakob Vølver
Robert Wengler
Kaspar Wenstrup
Thomas Wilmann

Dominican Republic
Jorge Cruz
Pedro Farias-Nardi
Pedro Jaime Fernandez
Miguel Gomez
Adriano Rosario

Ecuador
Richard Castro Rodriguez
Julio Estrella
Karla Gachet
Vicente Galbor
Carlos Granja Medranda
José Jácome
César Morejón
Paul Navarette
Edison Serrano
Diego Pallero
Carlos Pozo Alban
Alejandro Reinoso
Fernando Sandoval Jr
Santiago Serrano
Eduardo Valenzuela

Egypt
Farid Abdulwahab

Mohamed Abdou
Nour El Refai
Bassam El-Zoghby
Ahmed Tamboly

El Salvador
Mauro Arias
José Cabezas
Ericka Chávez
Lissette Lemus
Luis Alonso López
Frederick Meza
Ulises Rodriguez
Luis Romero
Luis Angel Umaña
Salomón Vásquez
Claudia Zaldaña de Mármol

Estonia
Tiit Blaat
Andres Haabu
Annika Haas
Tairo Lutter
Erik Prozes
Tiit Räis
Henn Soodla

Ethiopia
Olivier Boëls
Aida Muluneh

Finland
Joonas Brandt
Markus Jokela
Martti Kainulainen
Sami Kero
Petteri Kokkonen
Tatu Lertola
Katja Lösönen
Henrik Malmström
Timo Marttila
Vesa Moilanen
Elina Moriya
Juhani Niiranen
Jussi Nukari
Hans Paul
Tatu Paulaharju
Heidi Piiroinen
Timo Pyykkö
Kaisa Rautaheimo
Jukka Ritola
Johan Sandberg
Heikki Saukkomaa
Eetu Sillanpää
Mikko Takkunen
Petri Mikael Uutela
Mikko Vähäniitty

France
Ammar Abd Rabbo
Pascal Aimar
Denis Allard
Christian Alminana
Christophe Archambault
Bruno Bade
Capucine Bailly
Bernard Bakalian
Jerome Barbosa
Martin Barzilai
Benjamin Béchet
Salah Benacer
Yacine Benseddik
Cyril Bitton
Alain Bizos
Samuel Bollendorff
Guillaume Bonn
Régis Bonnerot
Jerome Bonnet
Yohan Bonnet
Marc Bonneville
Laura Boushnak
Jean-Christian Bourcart
Denis Bourges
Pierre Boutier
Franck Boutonnet
Philippe Brault
Fabien Breuil
Arnaud Brunet
Franck Bugnet
Martin Bureau
Alain Buu
Christophe Calais
Anne-Laure Camilleri
Serge Cantó
Alain Carayol
François Carlet-Soulages

Edouard Caupeil
Tiane Doan Champassak
Philippe Chancel
Patrick Chapuis
Baudouin
Aurelien Chauvaud
Eric Chauvet
Mehdi Chebil
Sylvain Cherkaoui
Olivier Chouchana
Pierre Ciot
Martin Clement
Sébastien Le Clézio
Guillaume Collanges
Nicolas Comment
Philippe Conti
Olivier Coret
Olivier Corsan
Jean-Christophe Couet
Olivier Coulange
Gilles Coulon
Franck Courtes
Jean-Louis Courtinat
Jean-Claude Coutausse
Antoine Couvercelle
Viviane Dalles
Julien Daniel
William Daniels
Jean-Robert Dantou
Denis Darzacq
Beatrice De Gea
Gautier Deblonde
Jerome Delay
Dominique Delpoux
Francis Demange
Michel Denis-Huot
Christine Denis-Huot
Jean-François Deroubaix
Patrick Desgraupes
Philippe Desmazes
Eric Dessons
Jean Jérôme Destouches
Agnes Dherbeys
Claudine Doury
Nicolas Dubreuil
Sébastien Dufour
Richard Dumas
Emmanuel Dunand
Christophe Ena
Isabelle Eshraghi
Cédric Faimali
Hubert Fanthomme
Franck Faugère
Gilles Favier
Jerome Favre
Eric Feferberg
Olivier Fermariello
Bruno Fert
Franck Ferville
Franck Fife
Corentin Fohlen
Jean François Fourmond
Emmanuel Fradin
Raphaël Gaillarde
Nicolas Gallon
Bertrand Gaudillère
Yves Gellie
Christophe Gin
Frédéric Girou
Baptiste Giroudon
Georges Gobet
Julien Goldstein
Nanda Gonzague
Mathieu Grandjean
Diane Grimonet
Marion Gronier
Olivier Grunewald
Damien Guerchois
Jean-Paul Guilloteau
Fabrice Guyot
Antoine Gyori
Valery Huche
Hervé Hamon
Laurent Hazgui
Eleonore Henry de Frahan
Guillaume Herbaut
Anne Holmes
Gerald Holubowicz
Guillaume Horcajuelo
Mat Jacob
Olivier Jobard
Jean-François Joly
Boris Joseph
Guilad Kahn
Christophe Karaba
Daniel Karmann

Alain Keler
Vincent Kessler
France Keyser
A. Kremer-Khomassouridze
Benedicte Kurzen
Olivier Laban-Mattei
Eric Lafforgue
Patrick Landmann
Ian Spencer Langsdon
Sébastien Lapeyrere
Francis Latreille
Laurence Leblanc
Lydie Lecarpentier
Merve Lequeux
Lisandru
Philippe Lissac
Sébastien Loffler
Christian Lombardi
Thierry Lopez
Jean-Luc Luyssen
Lyky
Tariq Mahmood
Pascal Maître
Jean-Luc Manaud
Richard Manin
François Xavier Marit
Benoît Marquet
Jean Dominique Martin
Catalina Martin-Chico
Pierre-Yves Marzin
Pierre Mérimée
Olivier Miguet
Olivier Morin
Vincent Mouchel
Frédéric Mouchet
Raphael Olivier
Freddy Muller
Ikram N'gadi
Frédéric Nebinger
Roberto Neumiller
José Nicolas
Sebastien Nogier
Alain Noguès
Hector Olguin
Olivier Robin
Emmanuel Ortiz
Matthieu Paley
Jean-Erick Pasquier
Celia Pernot
Bruno Perousse
Eric Perriard
Philippe Petit
Joël Peyrou
Théo
Poiron
Florence Poulain
Philip Poupin
Christian Poveda
Noël Quidu
Guillaume Ribot
Franck Robichon
Olivier Roller
Johann Rousselot
Denis Rouvre
Lizzie Sadin
Frédéric Sautereau
Pierrick Sauvage
David Sauveur
Laurent Sazy
Franck Seguin
Jérôme Sessini
Christophe Simon
Sébastien Soriano
Fabrice Soulié
Michel Spingler
Flore-Aël Surun
Boris Svartzman
Fred Tanneau
Benoit Tessier
Eline Edden
Pierre Torset
Patrick Tourneboeuf
Olivier Touron
Eric Travers
Jean-Michel Turpin
Gerard Uferas
Laurent Vautrin
Maya Vidon
Veronique de Viguerie
Seb et Enzo
Franck Vogel
Laurent Weyl
Philippe Wojazer
Lucas Dolega
Laurent Zabulon
Zeng Nian

Xavier Zimbardo
Zuili
Boris Zuliani
Michael Zumstein

Georgia
George Abdaladze
Mariam Amurvelashvili
Khatia Jijeishvili
Levan Kherkheulidze
Michael Korkia
Zurab Kurtsikidze
Yuri Lobodin
David Mdzinarishvili
Ketevan Mgebrishvili
Liza Osepaishvili
Dato Rostomashvili
Mzia Saganelidze
Daro Sulakauri
Niko Tarielashvili
Giorgi Zghuladze

Germany
Valeska Achenbach
Emil Alfter
Hans-H. Alpers
Eva Alpers-Gromoll
Johannes Arlt
Bernd Arnold
Cathrin Bach
Kathryn Baingo
Jens Sundheim
Heilze Baldauf
David Baltzer
Christoph Bangert
Lars Baron
Theodor Barth
Patrick Barth
Rolf Bauerdick
Siegfried Becker
Andreas Beil
Fabrizio Bensch
Anja Beutler
Kim Bierbrauer
Stefan Binnewies
Anja Bohnhof
Sebastian Bolesch
Stefan Boness
Maik Bönisch
Verena Brandt
Wolfgang Brauchitch
Hermann Bredehorst
Gero Breloer
Hansjürgen Britsch
Jörg Brüggemann
Till Budde
D.T. Butzmann
Sven Creutzmann
Michael Dalder
Peter Dammann
Andrea Diefenbach
Steffen Diemer
Frank Dietz
Tinka Dietz
Reinhard Dirscherl
Sven Döring
Thomas Dworzak
Philipp Ebeling
Winfried Eberhardt
Stefan Eigner
Jörg-Florian Eisele
Andreas Ellinger
Stefan Enders
Philipp Engelhorn
Stephan Engler
Frank Eppler
Daniel Etter
Simon Eymann
Stefan Falke
Klaus Fengler
Rüdiger Fessel
Meike Fischer
Uwe Fischer
Walter Fogel
Gerald Forster
Kai Peter Försterling
Peter Franck
Peter Franke
Samantha Franson
Nick Nostitz
Sascha Fromm
Jürgen Fromme
Maurizio Gambarini
Frank Gehrmann
Olli Geibel
Uwe Gerig

Christoph Gerigk
Gaby Gerster
Peter K. Gintert
José Giribás
Jörg Gläscher
Bodo Goeke
Thomas Grabka
Ute Grabowsky
Jens Grossmann
Patrick Haar
Robert Haaß
Michael R. Hagedorn
Karl Haimel
Matthias Hangst
Alfred Harder
Benjamin Haselberger
Alexander Hassenstein
Julie Hau
Harald Hauswald
Marc Heiligenstein
Katja Heinemann
Dirk-Martin Heinzelmann
Sarah Held
Katharina Hesse
Markus C. Hildebrand
Benjamin Hiller
Annegret Hilse
Gregor Hohenberg
Thomas Holtrup
Helge Holz
Eva Horstick-Schmitt
Sandra Hoyn
Wolfgang Huppertz
Florian Jaenicke
Malte Jäger
Britta Jaschinski
Dirk Jeske
Patrick Jöst
Matthias Jung
Michael Jungblut
Kati Jurischka
Rasmus Kaessmann
Enno Kapitza
Christiane Kappes
Dagmar Kielhorn
Lorenz Kienzle
Christian Klein
Simon Klingert
Jens Knappe
Herbert Knosowski
Carsten Koall
Heidi Koch
Hans-Jürgen Koch
Marcus Koppen
Christof Köpsel
Reinhard Krause
Tom Krausz
Gert Krautbauer
Ralf Krein
Harald Kroemer
Andrea Künzig
Peter Lammerer
Martin Langer
Narges Lankarani
Christoph Leib
Dieter Leistner
Evi Lemberger
Oliver Lieber
Ralf Lienert
Christoph Lienert
Markus Lokai
Maximilian Ludwig
Hans Madej
Uwe H. Martin
Noel Tovia Matoff
Fabian Matzerath
Daniel Maurer
Arne Mayntz
Andreas Meichsner
Ursula Meissner
Günther Menn
Dieter Menne
Thomas E.O. Metelmann
Jens Meyer
Denis Meyer
Volker Minkus
Hardy Müller
Daniel Müller
Heiner Müller-Elsner
Oliver Multhaup
Lene Münch
Sinan Muslu
Lydia Mutschmann
Merlin Nadj-Torma
Kay Nietfeld
Christian Nusch

Christoph Otto
Ingo Otto
Jens Palme
Laci Perenyi
Carsten Peter
Kai Pfaffenbach
Thomas Pflaum
Daniel Pilar
Helge Prang
Thomas Rabsch
Wolfgang Rattay
Hannelore Rauchensteiner
Johann Rauchensteiner
Andreas Reeg
Hartmut Reeh
Dirk Reiher
Markus Georg Reintgen
Andreas Rentz
Pascal Amos Rest
Sascha Rheker
Astrid Riecken
Frank Roeth
Daniel Rosenthal
Rothermel
Jo Röttger
Jens Rötzsch
Stephan Sagurna
Martin Sasse
Helena Schaetzle
Peter Schatz
Ralf Schedlbauer
Tomas Schelp
Frank Schirrmeister
Roberto Schmidt
Oliver Schmieg
Harald Schmitt
Walter Schmitz
Michael Schnabel
Harry Schnitger
Uwe Schober
Thomas Schreyer
Annette Schreyer
Frank Schultze
Sascha Schürmann
Stephan Schütze
Oliver Sehorsch
Yvonne Seidel
Frank Siemers
Falko Siewert
Mona Simon
Karsten Socher
René Spalek
Heiko Specht
Martin Specht
Andy Spyra
Günter Standl
Martin Steffen
Berthold Steinhilber
Marc Steinmetz
Björn Steinz
Thomas Stephan
Angelika von Stocki
Carsten Stormer
Cornelia Suhan
Jens Sundheim
Stefan Syrowatka
Andreas Teichmann
Tuna Sandwich
Jürgen Teller
Karsten Thielker
Bernd Thissen
Andreas Toepfer
Olaf Unverzart
Miguel Villagran
Helmuth Vossgraff
Vanja Vukovic
Harry Weber
Oliver Weiken
Udo Weitz
Gordon Welters
Candy Welz
René Werse
Kai Wiedenhöfer
Arnd Wiegmann
Claudia Yvonne Wiens
Michael Wolf
Valdrin Xhemaj
Monique Yazdani
Solvin Zankl
Fabian Zapatka
Frank Zauritz
Christian Ziegler

Ghana
Emmanuel Quaye

Greece
Yannis Behrakis
Alexandros Beltes
Greg Chrisohoidis
Jonnek Jonneksson
Iason Athanasiadis
Ioannis Galanopoulos
Vangelis
Asimina Giagoudaki
Petros Giannakouris
Harris Gikas
Angelos Giotopoulos
Iakovos Hatzistavrou
Nikos Kokkas
Yannis Kolesidis
Yannis Kontos
Dionysis Kouris
Sakis Lalas
Alexandros Lamprovasilis
Georgios Makkas
Michele A. Macrakis
Kostas Mantziaris
Dimitris Michalakis
Stefania Mizara
Giorgos Moutafis
Orestis Panagiotou
Simela Pantzartzi
Olga Stefatou
Nikos Pilos
Lefteris Pitarakis
Vladimir Rys
Fanny Sarri
Thanassis Stavrakis
John Stratoudakis
Elias Staris
Spyros Tsakiris
Sofia Tsampara
Aris Vafiadakis
Yiorgos Zacharopoulos

Guam
Ed Crisostomo

Guatemala
Jesús Alfonso
Enrique Hernandez Avila
Doriam Morales
Andrea Pennington
Danilo Ramírez

Haiti
Carl Juste

Hong Kong, S.A.R. China
Fu Chun Wai
Chung Ming Ko
Thomas Lee
Leung Cho Yi
Lui Siu Wai
Robert Ng
jackypoon83
Simon Song
Huang Songhe
Eric Tsang
Tse Ka Yin
Yiulun Wong
Xu Yuanchang
Paul
Bobby Yip
Jia-lian Yuan

Hungary
Karoly Arvai
Bácsi Róbert László
R'bert Bob
Szabolcs Barakonyi
Nóra Bege
Béli Balázs
Imre Benkö
Judit Berekai
Krisztián Bócsi
Gyula Czimbal
Bela Doka
Tivadar Domaniczky
András Fekete
Balazs Gardi
György Gáti
András Hajdu
Hajdú D. András
Peter Hapak
Norbert Hartyanyi
Marta Hegedus
Hernad Geza
Huszti Istvan
Peter Kollanyi
László Körber

Szilárd Koszticsák
Tamás Kovács
Anikó Kovács
Abel Krulik
Zsolt Kudich
Zoltan Molnar
Molnar Viktoria
Simon Móricz
Gábor Sándor Mórocz
Gyorgy Nemeth
Andras Peter Nemeth
Szilvia Mucsy
Istvan Polonyi
Tamas Revesz
Segesvari Csaba
Mark Simon
Balázs Simonyi
Soós Lajos
Gyula Sopronyi
Akos Stiller
Sandor H. Szabo
Bela Szandelszky
Lilla Szász
József L. Szentpéteri
Zsolt Szigetváry
Tamas Imre
Illyés Tibor
Zoltan Tombor
Gabor F. Toth
Zoltán Tuba
Zádor Peter

Iceland
Vilhelm Gunnarsson
Brynjar Gunnarsson
Thorkell Thorkelsson
Arni Torfason

India
Piyal Adhikary
Bharat Aggarwal
Aijaz Rahi
Ajilal
Srinivas Akella
Mukesh Gupta
A. Prathap
Aditya Anupkumar
Anand Bakshi
Pritam Bandyopadhyay
Shamik Banerjee
Shyamal Basu
Subhashis Basu
Salil Bera
Kamalendu Bhadra
Ashwini Bhatia
Mukesh Kamal
Subhamoy Bhattacharjee
Bijoy Kumar Jain
Biju Boro
Prasanta Biswas
Sawan Bohra
Kishor Kumar Bolar
Ranjan Basu
Rana Chakraborty
Amit Chakravarty
Ch. Vijaya Bhaskar
Jagadeesh
Sajal Chatterjee
Anindya Chattopadhyay
K.K. Choudhary
Ch. Narayana Rao
Rupak De Chowdhuri
Deshakalyan Chowdhury
Sebastian D'Souza
Dar Yasin
Javed Dar
Bikas Das
Saurabh Das
Sucheta Das
Sudipto Das
Sanjit Das
Vrindavan Lila Dasi
Arko Datta
Siddharth Babaji
Sumit Dayal
Rajib De
Mukunda De
Dasarath Deka
Mandar Deodhar
Uday Deolekar
Ranjit Deshmukh
Dharma Chandru, M
Deepak Sharma
Praveen Dixit
Nilayan Dutta
Subir Dutta

Diptendu Dutta
Faheem Qadri
Adrian Fisk
Pattabiraman
Uttam Ghosh
Manob Ghosh
Sayatan Ghosh
Ashish Shankar
Apoorva Guptay
Krishnendu Halder
Adeel Halim
Sachin Haralkar
G.K. Hegde
R. Irani
Ritika Jain
Jegannathaan N. Jakkam
N.P. Jayan
Sony Joseph
Rajesh Joshi
Fayaz Kabli
Rajanish Kakade
Aditya Kapoor
Sankha Kar
Soumik Kar
Harikrishna Katragadda
Bijumon Kavalloor
Mukhtar Khan
Praveen Khanna
Vikas Uddhav Khot
K.K. Santhosh
Girish Kingar
Manjunath Kiran
Ritu Raj Konwar
Pawan Kumar
Selvan Shiv Kumar
Sachin Kuray
Zishaan Akbar Latif
Atul Loke
Amit Madheshiya
Samir Madhukar Mohite
Manuj Makhija
Satish Malavade
Sudhanshu Malhotra
M. Ravindranath
Rafiq Maqbool
Max Martin
Uzma Mohsin
Manas Paran
Indranil Mukherjee
Paroma Mukherjee
Tauseef Mustafa
Prashant Nadkar
Udayan Nag
Rajen Nair
Debasish Nandy
Suresh Narayanan
Naresh Sharma
Anupam Nath
Ashok Nath Dey
Dev Nayak
Parvin Negi
Pitamber Newar
Anupam Nath
Gurinder Osan
Nick Oza
Hemant Padalkar Ravindra
P.V. Sunder Rao
Josekutty Panackal
Shailendra Pandey
Prashant Panjiar
Punit Paranjpe
Swapan Parekh
Ganesh Parida
Mahendra Parikh
Shriya Patil
Kunal Pradeep Patil
Manoj
S. Paul
Indranil Paul
Partha Paul
Vipin Pawar
Pal Pillai
Purushottam Diwakar
Ravi Posavanike
Vasant Prabhu
Chhandak Pradhan
Singh Prakash
Pramod Krishan Pushkarna
Altaf Qadri
Mustafa Quraishi
Appampalli Radhakrishna
Ashish Raje
R. Senthil Kumaran
Rama Madhu Gopal Rao
K. Ramesh Babu
Amit Rameshchandra

Nishant Ratnakar
R. Raveendran
Prashant Ravi
Nilanjan Ray
Manpreet Romana
Biswaranjan Rout
Sambit Priya Saha
Apoorva Salkade
Sajeesh Sankar
Suman Sarkar
Ruby Sarkar
Kayyur Sasi
Arijit Sen
Samik Sen
Bijoy Sengupta
Partha Sarathi Sengupta
Sakshi Shail
Divyakant Solanki
Shantanu Das
Subhash Sharma
Money Sharma
Tushar Sharma
Jayanta Shaw
Anand Shinde
Raju Shinde
Bandeep Singh
Prakash Singh
Dhiraj Singh
Sujan Singh
Raminder Pal Singh
Manish Sinha
Sanat Kumar Sinha
Ajit Solanki
Nitin Sonawane
Shekhar Soni
Arun Sreedhar
Gopinath S.
Subhendu Ghosh
Anantha Subramanyam.K.
P.V. Sujith
Manish Swarup
T. Srinivasa Reddy
Sanjay Sawant
Deepak Turbhekar
Harish Tyagi
Ritesh Ramchand
Uttamchandani
Vallabhadasu Madhava Rao
Manan Vatsyayana
Shriram Vernekar
Prashant Sawant
Prashanth Vishwanathan
Keshava Vitla
Peddi Raju Vudimudi
Himanshu Vyas
Danish Ismail

Indonesia
Yuyung Abdi
Ricky Adrian
Afriadi Hikmal
Yuniadhi Agung
Dita Alangkara
Nogo Agusto Alimin
M. Anshar
Farid Arifandi
Hasbi Azhar
Binsar Bakkara
Agung Kuncahya B.
Beawiharta
Sumaryanto Bronto
Budi N.D. Dharmawan
Riza Fathoni
Junaidi Gandy
Guslan Gumilang
Jongki Handianto
Fauzan Ijazah
Bagus Indahono
Mohamad Irfan
Bay Ismoyo
Mamuk Ismuntoro
Kemal Jufri
Pradeep Kocharekar
Feri Latief
P.J. Leo
Aris Liem
Ali Budiman Lo
Ali Lutfi
Mahatma Putra
Darmasetiawan
Mak Pak Kim
Theresia Meliana
Yusuf Achmad Muhammad
Ronny D. Musyihar
Made Nagi
Chalid Nasution

Nesterets Zhenya
Mikhail Palinchak
Sergiy Pasyuk
Ganna Smal
Anatoliy Stepanov
Sergei Supinsky
Olexander Techynskyy
Mila Teshaieva
Alexander Toker
Volodymyr Tverdokhlib
Ivan Tykhyi
Roman Vilenskiy
Alexander Zarajsky

United Arab Emirates
Hussain Al-Numairy
Jumana El Heloueh

United Kingdom
Amos Aikman
Koutaiba Al Janabi
Bryan Alexander
Brian Anderson
Platon
Cedric Arnold
Samuel Ashfield
Boris Austin
Jocelyn Bain Hogg
Jennifer Balcombe
James Ball
Roger Bamber
Steve Bardens
Jane Barlow
Russell Bates
Mahmuda Begum
Guy Bell
Piers Benatar
Martin Birchall
Andy Blackmore
Marcus Bleasdale
Chris Booth
Harry Borden
Shaun Botterill
Stuart Boulton
Tom Bourdon
David Brabyn
Henry Browne
Clive Brunskill
Tessa Bunney
Sisi Burn
Gary Calton
Tom Campbell
Richard Cannon
Angela Catlin
Peter Caton
James Chance
Grenville Charles
Wattie Cheung
Carlo Chinca
Daniel Chung
D.J. Clark
CJ Clarke
Bethany J Clarke
Felix Clay
Rose Clive
Nick Cobbing
Chris Collingridge
Katie Collins
Phil Coomes
Gareth Copley
Brendan Corr
Caroline Cortizo
Ted Cottrell
Vicki Couchman
Damon Coulter
Tom Coulton
Michael Crabtree
Georgina Cranston
Richard Crease
Alan Crowhurst
Nicholas Cunard
Ben Curtis
Simon Dack
Nick Danziger
Adam Dean
Percy Dean
Peter Dench
Euan Denholm
Adrian Dennis
Nigel Dickinson
Nigel Dickson
Aidan B Dockery
Kieran Dodds
Luke Duggleby
Andrew Duke
Giles Dulcy

Matt Dunham
Jude Edginton
Neville Elder
Jonathan Elderfield
Stuart Emmerson
Alixandra Fazzina
Tristan Fewings
Julian Finney
Steve Forrest
Stuart Forster
Tim Foster
Mike Fox
Stuart Freedman
Nell Freeman
Sam Frost
James Robert Fuller
Christopher Furlong
Robert Gallagher
Sean Gallagher
Andrew Garbutt
Stephen Garnett
Clive Gee
George Georgiou
John Giles
Paul Gilham
Martin Godwin
David Graham
David Graves
Johnny Green
Michael Grieve
Laurence Griffiths
Stuart Griffiths
Jon Guegan
Ben Gurr
Steve Hale
Andy Hall
Liza Hamlyn
Alex Handley
Sara Hannant
Paul Harding
A.L. Harrington
Graham Harrison
Lionel Healing
Richard Heathcote
Mark Henley
Scott Heppell
Paul Herrmann
Tim Hetherington
Mike Hewitt
Andrew Higgins
James Hill
Jack Hill
Paul Hilton
Liz Hingley
Stephen Hird
Alex Hodgkinson
Alex Hofford
Jim Holden
Kate Holt
Harvey Hook
Rip Hopkins
Scott Hornby
Julie Howden
David Howells
Richard Human
Richard Humphries
Jeremy Hunter
Jess Hurd
Jonathan Hyams
Caroline Irby
Chris Ison
Katherine Jack
Chris Jackson
Tom Jenkins
Richard Jones
Peter J. Jordan
Frantzesco Kangaris
Christian Keenan
Findlay Kember
Glyn Kirk
Colin Lane
Kalpesh Lathigra
Thomas Lay
David Levenson
Richard Lewis
Zute Lightfoot
Warren Little
Alex Livesey
Sharron Lovell
Mikal Ludlow
Michael Lusmore
Peter Macdiarmid
Luke Macgregor
Finlay MacKay
Alex MacNaughton
Toby Madden

Leo Maguire
David Maitland
Paul Marriott
Bob Martin
Guy Martin
Dylan Martinez
Leo Mason
Clive Mason
Jenny Matthews
Jamie McDonald
Iain McLean
Colin McPherson
Toby Melville
Doug Moir
Jeff Moore
Eddie Mulholland
Omar Mullick
Vincent Mundy
Zed Nelson
Ian Nicholson
Phil Noble
John Novis
Terry O'Neil
Jeff Overs
Fabio De Paola
Roger Parker
Peter Parks
Nigel Parry
Andrew Parsons
Adam Patterson
Mark Pearson
Gerry Penny
Marcus Perkins
Charles Pertwee
George Philipas
Christopher Pillitz
Tom Pilston
Olivier Pin-Fat
Christopher Pledger
James Pogson
Richard Pohle
Louis Porter
Jonathan Pow
Mike Powell
Andy Rain
Chris Ratcliffe
Lucy Ray
Simon Renilson
Ali Richards
Mark Richards
Martin Rickett
Kiran Ridley
Simon Roberts
Ben Roberts
Stuart Robinson
Karen Robinson
Nigel Roddis
David Rose
Mark David Runnacles
Joel Ryan
Honey Salvadori
Peter Sandground
David Sandison
Oli Scarff
Georgie
Mark Seager
John Sibley
Jamie Simpson
David Slater
Alex Smailes
Paul Smith
Toby Smith
Jamie Mcgregor
Yulianto
Lalage Snow
Carl De Souza
Tina Stallard
Ben Stansall
Darren Staples
Brian David Stevens
Dave Stewart
Jane Stockdale
Tom Stoddart
Lee Karen Stow
Chris Stowers
Will Strange
Justin Sutcliffe
Jeremy Sutton-Hibbert
Martin Sykes
Justin Tallis
Jason Tanner
Aaron Taylor
Edmond Terakopian
Andrew Testa
Hazel Thompson
Edward Thompson

Kurt Tong
Abbie Trayler-Smith
Amelia Troubridge
Francis Tsang
Bruno Vincent
Aubrey Wade
Brad Wakefield
James Wardell
Barrie Watts
Geoff Waugh
Richard Wayman
Haydn West
Mike Whelan
Edward Whitaker
David White
Amiran White
Neil White
Lewis Whyld
Kirsty Wigglesworth
James Williamson
Des Willie
Robert Wilson
Andrew Wong
Matt Writtle
Alexander Yallop
Andrew Yates
Stuart York
Dave Young

Uruguay
Leo Barizzoni
Leo Carreño
Martin Cerchiari
Gabriel Cusmir Cúneo
Julio Etchart
Quique Kierszenbaum
Pablo Rivara
Christian Rodriguez

USA
Mustafah Abdulaziz
John Abernathy
Fiona Aboud
Douglas Abuelo
Daniel Acker
Jenn Ackerman
Sam Adams
Lynsey Addario
Michelle V. Agins
Peter van Agtmael
Alaa al-Marjani
Micah Albert
Jim Albright, Jr
Maya Alleruzzo
Afton Almaraz
Monica Almeida
Kwaku Alston
Mary Altaffer
Kristen Alvanson
Kainaz Amaria
Elise Amendola
Patrick Andrade
Jason Andrew
Drew Angerer
Bryan Anselm
Ryan Anson
Jeff Antebi
Ron Antonelli
Mario Anzuoni
Joe Appel
Samatha Appleton
Michael Appleton
Scott J. Applewhite
Charles Rex Arbogast
Ricardo Arduengo
Roger Arnold
Jonathan Lucas Auch
Frank Augstein
Paul Avallone
Tony Avelar
Eyad Baba
Brian Baer
Frank W. Baker
Shawn Baldwin
Bill Bangham
David Walter Banks
Jeffrey Barbee
Rebecca Barger
Don Bartletti
Will Baxter
Liz O. Baylen
Juliana Beasley
Max Becherer
Robert Beck
Natalie Behring
Al Bello

Caroline Bennett
David Bergman
Ruediger Bergmann
Nina Berman
Alan Berner
John Biever
Keith Birmingham
Josh Birnbaum
Gene Blevins
Victor J. Blue
Gary Bogdon
Michael Bonfigli
Karen T. Borchers
Bie Bostrom
Rick Bowmer
Anna Boyiazis
Alex Brandon
M. Scott Brauer
William Bretzger
David Brody
Paula Bronstein
Kate Brooks
Nathaniel Brooks
Frederic J. Brown
Michael Christopher Brown
Tiffany Brown
Paul Brown
Robert Brown
Andrea Bruce
Stephanie Bruce
Cathy Bruegger
Brian van der Brug
Simon Bruty
Vernon Bryant
Paul Buck
Khue Bui
Robert F. Bukaty
Gregory Bull
Gerard Burkhart
David Burnett
David Butow
Alexandra Buxbaum
Renée C. Byer
Yoon S. Byun
Andrew Caballero-Reynolds
Tyler Cacek
Mary Calvert
Andrea Camuto
Zackary Canepari
Chris Carlson
J Carrier
Darren Carroll
BethAnn Carter-Horton
Antrim Caskey
Matthew Cavanaugh
Joe Cavaretta
Radhika Chalasani
Dominic Chavez
Barry Chin
Alan Chin
Nelson Ching
LiPo Ching
Paul Chinn
Andre Chung
Lorenzo Ciniglio
Mary Circelli
Daniel LeClair
Clark
Rich Clarkson
Jay Clendenin
Christina Clusiau
Jodi Cobb
Victor José Cobo
Carolyn Cole
Sam Comen
Fred R. Conrad
Forbes Conrad
Greg Constantine
Kathryn Cook
Thomas R. Cordova
Gary Coronado
Fabrizio Costantini
John Costello
Dean C.K. Cox
Andrew Craft
Bill Crandall
Ken Crawford
Silas Crews
Maisie Crow
Stephen Crowley
Ariana Cubillos
Julia Cumes
Anne Cusack
Michal Czerwonka
Scott Dalton
Mike Davis

Jamie De Pould
Sam Dean
Daron Dean
David Degner
Juan-Carlos Delgado
Danfung Dennis
Bryan Denton
Bryan Derbala
Chris Detrick
Charles Dharapak
Kevin Dietsch
Tom Dodge
Oliver Douliery
Larry Downing
Carolyn Drake
Rian Dundon
Melanie Dunea
Michael Eckels
Charles Eckert
Dan Eckstein
Aristide Economopoulos
Ron Edmonds
Debbie Egan-Chin
Matt Eich
Heather Eidson
Davin Ellicson
Sarah Elliott
Bruce Ely
Douglas Harrison Engle
Eric Engman
Jonathan Ernst
Gretchen Ertl
Peter Essick
Josh Estey
James Estrin
David Eulitt
Jim Evans
Rich-Joseph Facun
Timothy Fadek
Steven M. Falk
Christopher Farber
Patrick Farrell
Heather Fassio
Chris Faytok
Candace Feit
Gina Ferazzi
J. Ismael Fernandez Reyes
Gloria Ferniz
Jonathan Ferrey
Stephen Ferry
Rob Finch
Christopher Fitzgerald
Deanne Fitzmaurice
Lauren Fleishman
Derek Henry Flood
Floto
Kathleen Flynn
Peter Foley
Edmund D. Fountain
Tom Fox
Nikki Fox
Bill Frakes
Jamie Francis
Angel Franco
Brian L Frank
Danny Wilcox Frazier
Tim Freccia
Ruth Fremson
Gary Friedman
Misha Friedman
Nicole Frugé
Jessica Frykman
Ana Elisa Fuentes
David Furst
Sean Gallup
Preston Gannaway
Alex Garcia
Marco Garcia
David Gard
Christopher Gardner
Danielle Gardner
Elie Gardner
Mark Garfinkel
Scott Gaulin
Robert Gauthier
Eric Gay
Sharon Gekoski-Kimmel
Jim Gensheimer
Kevin German
Danny Ghitis
Sarah J. Glover
Don Goldman
David Goldman
Andrew Gombert
Chet Gordon
Arlene Gottfried

Earnie Grafton
Rebecca S. Gratz
Kyle Green
Stanley Greene
Lauren Greenfield
Lori Grinker
Norbert von der Groeben
Tim Gruber
Ng Han Guan
Justin Guariglia
Jorgen Gulliksen
CJ Gunther
Erol Gurian
Barry Gutierrez
Hans Gutknecht
David Guttenfelder
Carol Guzy
Rebecca Hale
Robert Hallinen
Mark M. Hancock
Andrew Hancock
Josh Haner
Andrew Harnik
Jessica Todd Harper
Andrew Harrer
Mark Edward Harris
Darren Hauck
Laura Heald
Sonya N. Hebert
Gregory Heisler
Todd Heisler
Sean Hemmerle
Andrew Henderson
Mark Henle
Denny Henry
Lauren Hermele
Tyler Hicks
Michael Hicks
Todd Hido
Erik Hill
Ethan Hill
Nicole V Hill
Eros Hoagland
Brendan Hoffman
Peter Hoffman
Jim Hollander
David S. Holloway
Chris Hondros
Kevin Horan
Brad Horrigan
Eugene Hoshiko
Aaron Huey
Sandy Huffaker
Kin Man Hui
Mark Humphrey
Jeff Hutchens
Thomas Hyde
John Iacono
Laura Inns
Kirk Irwin
Lance Iversen
Lisa Jack
Andre Jackson
Lawrence Jackson
Lucas Jackson
Jed Jacobsohn
Julie Jacobson
Jay Janner
Kenneth Jarecke
Janet Jarman
Cliff Jette
Sam Jones
Lou Jones
Bonnie Josephson
Allison Joyce
Jen Judge
Nikki Kahn
Greg S. Kahn
Mike Kamber
Kang Hyungwon
Doug Kanter
Anthony Karen
Ed Kashi
Ivan Kashinsky
Karen Kasmauski
Carolyn Kaster
Stephen M. Katz
Andrew Kaufman
Eric Kayne
Reseph Keiderling
Stephanie Keith
Mark W Kelley
Brenda Ann Kenneally
Mike Kepka
Laurence Kesterson
Carl Kulsgaard

Yunghi Kim
John Kimmich-Javier
Scott Kingsley
T.J. Kirkpatrick
Paul Kitagaki, Jr
Heinz Kluetmeier
David E. Klutho
Charles Knowles
Jim Korpi
Brooks Kraft
Benjamin Krain
Daniel Kramer
Lisa Krantz
Suzanne Kreiter
Elizabeth Kreutz
Krisanne Johnson
Andy Kropa
Sara Krulwich
Amelia Kunhardt
Jack Kurtz
Srinivas Kuruganti
Teru Kuwayama
Young Kwak
Brigitte Lacombe
Vincent Laforet
Tim Laman
Christopher LaMarca
Rod Lamkey, Jr.
Inez van Lamsweerde
Lauren Lancaster
Nancy Lane
Justin Lane
Jeremy M. Lange
Jerry Lara
Erika Larsen
Adrees Latif
Gillian Laub
David Lauer Read
Streeter Lecka
Chang W. Lee
Matthew J. Lee
Andy Levin
Heidi Levine
William Wilson Lewis III
Fang Liang
Jessica Brandi Lifland
Ariana Lindquist
Heather A. Lindquist
Brennan Linsley
Edward Linsmier
Wayne Liu
Fernando Llano
Jeremy Lock
John Lok
Rick Loomis
Joseph Michael Lopez
Dario Lopez Mills
Kevin Lorenzi
Jon Lowenstein
Benjamin Lowy
Pauline Lubens
Kirsten Luce
Amanda Lucidon
Gerd Ludwig
Hakan Ludwigson
Erik Lunsford
Matt Lutton
Patsy Lynch
Melissa Lyttle
Ehrin Macksey
Michael Macor
Narayan Mahon
Charlie Mahoney
David Maialetti
Todd Maisel
Jeff Mankie
Yanina Manolova
Rod Mar
Pete Marovich
Dan Marschka
Liz Martin
Michael Martin
Joel Martinez
Pablo Martinez Monsivais
AJ Mast
Sean Masterson
Tim Matsui
Matuschka
David Maung
Justin Maxon
Robert Maxwell
David Maxwell
Jimmy May
Peter McBride
Matt McClain
Michael McCollum

Cyrus McCrimmon
John McDonough
Michael Francis McElron
Stephen McGee
Stephanie McGehee
Ryan McGinley
David G. McIntyre
Scott McKiernan
Eric Mencher
Justin Merriman
Nhat V. Meyer
Sebastian Meyer
RJ Mickelson
Peter Read Miller
Matt Miller
Doug Mills
Lianne Milton
Donald Miralle, Jr.
Andrea Modica
Andrea Mohin
Genaro Molina
M. Scott Moon
John Moore
Jared Moossy
Christopher Morris
Toby Morris
James Morton
Laura Morton
Justin Mott
Hatem Moussa
Ozier Muhammad
Mark C. Murrmann
James Nachtwey
Adam Nadel
Matt Nager
Ana Nance
Sol Neelman
Mike Nelson
Scott Nelson
Greg Nelson
Les Neuhaus
Gregg Newton
Jehad Nga
Michael Nichols
Ian Nichols
Landon Nordeman
Kevin Nortz
John Nowak
Susan Ogrocki
Andy Olsen
Scott Olson
Charles Ommanney
Bruce Omori
Francine E. Orr
Kevin Oules
Darcy Padilla
Yana Paskova
Bryan Patrick
Bob Pearson
Rodrigo Peña
Hilda M. Perez
Lucian Perkins
Courtney Perry
Phil Peterson
Daryl Peveto
Joe Phelan
David J. Phillip
Holly Pickett
Chad Pilster
Spencer Platt
Suzanne Plunkett
James Pomerantz
Joshua Prezant
Jake Price
Joe Pugliese
Joe Raedle
Ramin Rahimian
Anacleto Rapping
Patrick Raycraft
Anne Rearick
Jim Reed
Barry Reeger
Tom Reese
Lara Jo Regan
Tim Revell
Gabrielle Revere
Damaso Reyes
Michael Reynolds
Helen H. Richardson
Charlie Riedel
Jeff Riedel
Jessica Rinaldi
Amanda Rivkin
Larry Roberts
Joshua Roberts

Julia L. Robinson
Michael Robinson Chávez
David Rochkind
Paul Rodriguez
Dana Romanoff
Vivian Ronay
David Root
Bob Rosato
Aaron Rosenblatt
Lance Rosenfield
Dustin Ross
Jessica Rotkiewicz
Michael Rubenstein
Dina Rudick
Benjamin Lee Rusnak
J.B. Russell
Andrew Russell
David L. Ryan
Sally Ryan
Anne Ryan
Don Rypka
Paul Sakuma
Horacio Salinas
Barbara L. Salisbury
Amy Sancetta
Paul Sancya
RJ Sangosti
Wally Santana
Courtney Sargent
Joel Sartore
Jonathan Saruk
Joel Satore
Stephan Savoia
Howard Schatz
Michael Schennum
Kristen Schmid Schurter
Chris Schneider
Alyssa Schukar
Paul D. Scott
Sarah Shatz
Callie Shell
Allison Shelley
Qilal Shen
Brian Shumway
Jacob Silberberg
Barton Silverman
Denny Simmons
Stephanie Sinclair
Luis Sinco
Keith Sirchio
Brian Skerry
Benjamin Sklar
Matt Slaby
Lynne Sladky
Matt Slocum
Dana Smillie
Brian Smith
Bryan Smith
Larry W. Smith
Allison V. Smith
Brian Snyder
Jared Soares
Brian Sokol
Armando Solares
Chuck Solomon
Chip Somodevilla
Fred Squillante
Jamie Squire
Tyler Stableford
Clayton Stalter
John Stanmeyer
Sally Stapleton
Susan Stava
Larry Steagall
Maggie Steber
Sharon Steinmann
George Steinmetz
Justin Stephens
Bert Stern
Ruaridh Stewart
Sean Stipp
Robert Stolarik
Carol Allen Storey
Scott Strazzante
Damian Strohmeyer
Bob Strong
Theo Stroomer
Anthony Suau
Sanjay Suchak
Justin Sullivan
Akira Suwa
Chitose Suzuki
Joseph Sywenkyj
Kate Szrom
Mat Szwajkos
Shannon Szwarc

Kayana Szymczak
Shannon Taggart
Ramin Talaie
Mario Tama
Teresa Tamura
Ross Taylor
Patrick Tehan
Mark J. Terrill
Shmuel Thaler
Robert Pingree Thayer
Eric Thayer
Mark Thiessen
Joshua Mark Thomas
Jeffrey Thompson
George Tiedemann
Al Tielemans
Lonnie Timmons III
John Tlumacki
Celia Tobin
Tara Todras-Whitehill
Amy Toensing
Jonathan Torgovnik
Daniel Traub
Kent Treptow
Erin Grace Trieb
Rob Tringali
Annie Tritt
Linda Troeller
Scout Tufankjian
Davis Turner
Susan Tusa
Chris Tyree
Jane Tyska
Gregory Urquiaga
Nuri Vallbona
John VanBeekum
Fernando Vergara
Vanessa Vick
José Luis Villegas
Ami Vitale
Stephen Voss
Dusan Vranic
Evan Vucci
Craig F. Walker
E. Jason Wambsgans
Paul William Warner
Warner
Jenn Warren
Lori Waselchuk
Lannis Waters
Guy Wathen
Susan Watts
Billy Weeks
Sandra Chen Weinstein
David H. Wells
Matthew West
Brad Westphal
Rodney White
James Whitlow Delano
Max Whittaker
Erin Wigger
John Wilcox
A.J. Wilhelm
Rick T. Wilking
Lisa Wiltse
Steve Winter
Damon Winter
Dan Winters
Michael S. Wirtz
Rhona Wise
Katherine Wolkoff
Michael Woods
Steven Worthy
Julia Xanthos
Craig A. Young
Reed Young
Michael Zajakowski
Mark Zaleski
Ariel Zambelich
Sheila Zhao
Andrew Zuckerman

Venezuela
José Becerra
Freddy Henriquez
Víctor Hernández
Juan Carlos Hernandez
Nilo Jimenez Barrozzi
Leo Liberman
Arnoldo Lopez
Gil Montaño
Edsau Olivares
Jacinto Oliveros
Luis Pire
Carlos Sanchez
Reynaldo Trombetta

Luis Turinese
Jimmy Villalta
Howard Yanes

Vietnam
Thi Tho
Doan Ky Thanh
Ho Anh Tien
Cong Ba
Le Quang Nhat
Luong Phu Huu
Mai Loc
Trung Nguyen Ngoc
Dzung Nguyen
Nam Du
Pham Ba Thinh
The Phong
Trinh Vo Trung Nghia
Vu Anh Tuan

Yemen
Mustafa Al-Ezzi Naji

Zambia
Salim Henry
Kelvin Kakanku
Thomas Nsama

Zimbabwe
Bold Hungwe
Annie Mpalume

Photos: Co de Kruijf / Hollandse Hoogte

Chair: MaryAnne Golon, USA,
consulting photography editor

Ayperi Karabuda Ecer, Sweden/Turkey,
vice president pictures Reuters

Akinbode Akinbiyi, Nigeria,
photographer, writer and curator

Volker Lensch, Germany,
head of photo department *Stern*

Patrick Baz, France/Lebanon,
regional photo-manager, the Middle
East, Agence France-Presse

Ricardo Mazalan, Argentina,
photographer The Associated Press

Peter Bialobrzeski, Germany,
photographer Laif

Arianna Rinaldo, Italy,
photo editor *D La Repubblica delle
Donne* and editor-in-chief *OjodePez*

Olivier Culmann, France,
photographer Tendance Floue

Sujong Song, South Korea,
freelance photo editor

Erin Elder, Canada,
digital media manager *The Globe
and Mail*

Secretary:
Daphné Anglès, France/USA,
European picture coordinator
The New York Times

Per Folkver, Denmark,
photo editor in chief *Politiken*

Secretary:
Stephen Mayes, UK,
managing director VII Photo Agency

David Friend, USA,
editor of creative development
Vanity Fair

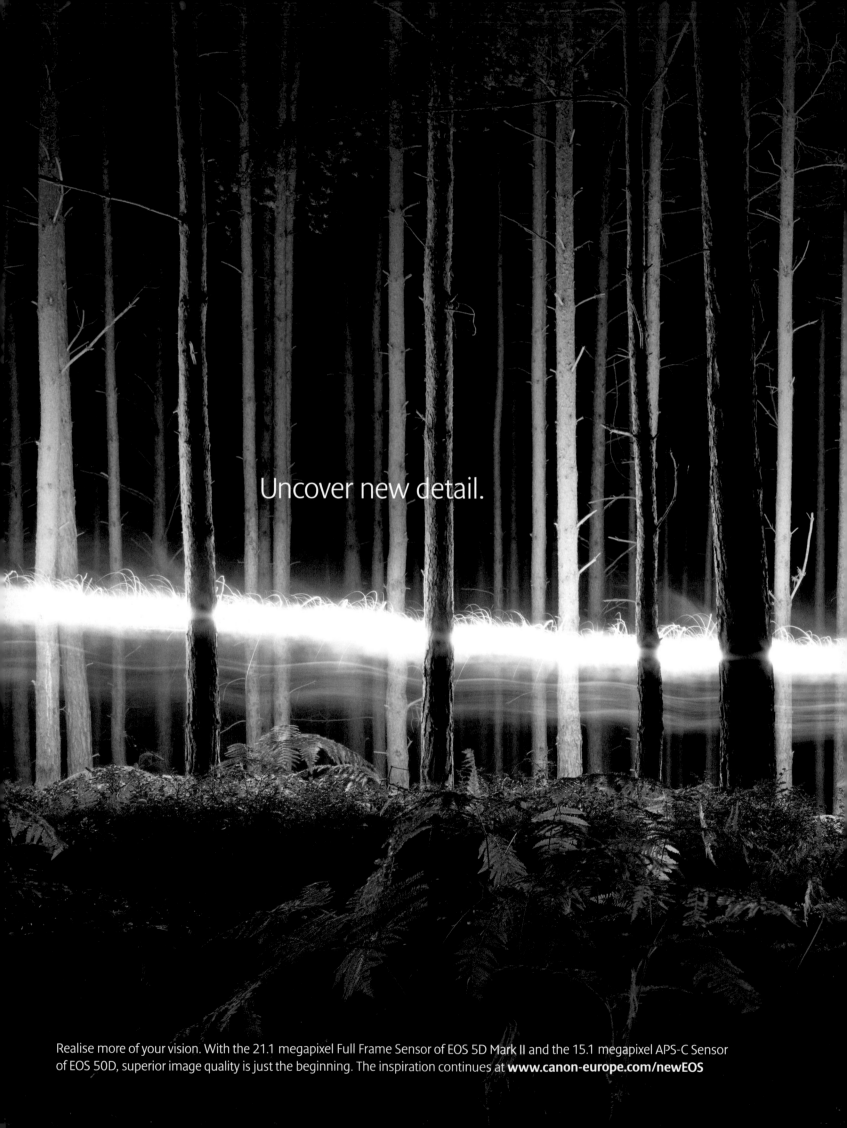

Uncover new detail.

Realise more of your vision. With the 21.1 megapixel Full Frame Sensor of EOS 5D Mark II and the 15.1 megapixel APS-C Sensor of EOS 50D, superior image quality is just the beginning. The inspiration continues at **www.canon-europe.com/newEOS**

beauty delivered by TNT

For many people tulips are the symbol of Holland. Many bulbs are transported by TNT, they bring joy to people across the globe.

2601635373

About World Press Photo

Art director
Teun van der Heijden
Advisors
Daphné Anglès
Stephen Mayes
Bas Vroege
Design
Heijdens Karwei
Production coordinator
Femke van der Valk
Picture coordinators
Wiebke Duchow
Nina Steinke
Roos Wijngaards
Captions and interview
Rodney Bolt
Editorial coordinators
Manja Kamman
Erik de Kruijf
Maaike Smulders
Editor
Kari Lundelin

Color management
Wim Schoenmaker
Kleurgamma Photolab, Amsterdam,
the Netherlands, www.kleurgamma.com

Paper
BVS 150 grams, cover 300 grams
Papierfabrik Scheufelen GmbH, Lenningen,
Germany, www.scheufelen.com
Lithography, printing and binding
Wachter GmbH, Bönnigheim, Germany,
www.wachter.de
Production supervisor
Maarten Schilt
Mariska Vogelenzang de Jong
Mets & Schilt Publishers, Amsterdam,
the Netherlands, www.metsenschilt.com

This book has been published under the auspices
of Stichting World Press Photo, Amsterdam,
the Netherlands.

Cover photograph
Anthony Suau, USA, for Time
*US Economy in Crisis: Following eviction, Detective
Robert Kole must ensure residents have moved out
of their home, Cleveland, Ohio, 26 March*
World Press Photo of the Year 2008

Back cover photograph
Heidi & Hans-Jürgen Koch, Germany, for Stern
Animal Eyes: Southern ground-hornbill

World Press Photo is an independent nonprofit organization, founded in the Netherlands in 1955. Its main aim is to internationally support and promote the work of professional press photographers.

Each year, World Press Photo invites press photographers throughout the world to participate in the World Press Photo Contest, the premier annual international competition in press photography. All photographs were judged in February 2009 in Amsterdam by an independent international jury composed of thirteen professionals recognized in the field of press photography.

Educational projects play an important role in World Press Photo's activities. The annual Joop Swart Masterclass is aimed at talented photographers at the start of their careers, and seminars and workshops open to individual photographers, photo agencies and picture editors are organized in developing countries.

For more information on World Press Photo, about the prizewinning images, the photographers and for an updated exhibition schedule, please visit: www.worldpressphoto.org